Own a Fraction, Earn a Fortune:

The Complete Guide to Co-investing in Art and Collectibles

How to Generate High Returns from Collectibles
Through Fractional Ownership

Michael Fox-Rabinovitz

Printed in New York, United States.

ISBN (paperback): 978-1-7358994-0-4
ISBN (ebook): 978-1-7358994-1-1
Library of Congress Control Number: 2020922008

Contents

1. Preface ... vii

2. Introduction .. 1

3. Asset Class Characteristics .. 11

 a. Value Drivers ... 12

 i. Intrinsic ... 12

 ii. Extrinsic ... 14

 b. Costs associated with holding physical assets 18

 c. Market players .. 23

4. Asset Categories ... 25

 A. Art ... 31

 i. Paintings ... 31

 ii. Sculpture ... 43

 B. Classical Collectibles ... 47

 i. Cars ... 47

 ii. Motorbikes .. 55

 iii. Watches .. 61

 iv. Alcohol ... 69

 1. Wine ... 69

 2. Whisky .. 76

 3. Cognac .. 84

 4. Champagne .. 89

 v. Numismatics ... 95

 1. Coins ... 95

 2. Banknotes ... 100

vi. Stamps .. 105

vii. Sports Memorabilia ... 111

viii. Trading cards .. 115

 1. Baseball ... 115

 2. Basketball .. 121

 3. Football ... 122

 4. Hockey .. 123

ix. Comics ... 127

x. Books ... 133

 1. Printed .. 133

 2. Manuscripts .. 139

xi. Maps .. 143

xii. Photographs .. 153

xiii. Handbags .. 157

C. Miscellaneous ... 161

 i. Gems .. 162

 ii. Jewelry .. 166

 iii. Cigars ... 170

 iv. Gaming cards ... 178

 v. Weapons ... 184

 a. Guns ... 184

 b. Swords .. 188

 vi. Wooden decoys ... 192

 vii. Autographs ... 195

 viii. Vinyl .. 200

5. Asset class metrics ... 207

6. Emerging collectibles ... 217

 i. Crypto collectibles ... 217

 ii. Virtual assets ... 220

 iii. Digital art .. 224

1. General..224

2. Virtual reality art ..225

3. Generative art...227

4. AI Art..228

7. Future collectible assets..229

i. Genetic art...229

ii. Experience transfers...230

iii. Emotion collections ...231

iv. Sensory collections ...231

v. Body augmentations...233

vi. Future transport ...233

vii. Androids ...233

viii. People tokenization ..234

ix. Dormant asset tokenization and liquidity234

8. Fractional ownership framework.............................237

i. Uses and benefits..237

ii. Tokenization vs securitization239

9. Democratization of rare asset ownership243

i. Benefits for sellers..243

ii. Benefits for buyers...246

10. Platforms function and features249

i. Core issues solved by platforms:250

ii. Key role of platforms:..253

iii. Fee models ..255

iv. Custom services: future functionality...................257

i. Asset gathering ...257

ii. Trading functionality......................................258

iii. Investor services..260

iv. Financing services ...263

11. Portfolio construction..265

 i. Investment philosophy...265

 ii. Investment selection process:266

 iii. Asset allocation framework.......................................271

 1. Collectible portfolio ...273

 2. Overall portfolio..276

12. Conclusions..277

13. Implementation and analysis challenges...........................299

14. Final thoughts ..303

15. Acknowledgments ..305

16. Author Biography...307

Preface

The 2020 coronavirus pandemic has sparked a wave of widespread panic, rapid sell-offs in global financial markets, and tremendous uncertainty about the shape of the world to come. In anticipation of recession, there was, as is often the case in uncertain times, a trend of people monetizing their collectible assets to make sure they are liquid in the event of a prolonged crisis. These treasures have not only served their key function of preserving and growing value over time, but also have proven to be a valuable device to weather the stormy conditions in times of uncertainty. Unique assets can be an invaluable tool in every investor's toolbox, but as of today, they still remain largely unknown, misunderstood, and underappreciated.

This book was conceived for a very practical purpose: **to help both individual and institutional investors understand the nuances and benefits of the collectible asset classes so they can make well informed financial choices and stay ahead of the curve by learning how to most effectively use collectibles to build wealth.** It describes the breadth of existing and emerging options for investing and allocating to this asset class and provides proven solutions on how to integrate exotic assets into a well thought out financial plan.

As investors, we desire certain characteristics in our portfolios. We value stability, security, and the income that comes from a constantly growing and well diversified wealth base. We dislike unpredictability, uncertainty, and lack of options in our investments. We pursue goals like stable and secure retirement, education, travel, and hobbies and understand that a solid all-weather portfolio is the key to obtaining and keeping all these benefits. The

information and tools you learn in this book will undoubtedly help you achieve all of these goals and empower you to continue to refine and improve your market savvy.

This book will appeal to secure and well-off readers searching for capital preservation, income potential, and asset growth strategies. It is also quite relevant for younger investors who have some disposable income and express openness to innovative ideas. It will demonstrate how anyone can create a more secure and lucrative portfolio with elements of capital preservation, income, and capital appreciation by exploring new avenues of profitably deploying assets and earning healthy returns while maintaining liquidity.

You will get the most value from this book if you are already actively thinking of ways to enhance your portfolio and wealth, and have a reasonable grasp of financial markets. This book can serve as a valuable reference for highly experienced investors as well, providing an overview of the various collectible investment options, as well as ways to identify, allocate, and track these investments.

Ultimately, this book will show you a way to achieve financial security and independence by prudently allocating capital and building a well-diversified portfolio. Understanding the nuances, benefits, and methods of investing in a unique set of assets will allow you, as an investor, to achieve your goal more effectively, faster, and with more safety, while retaining liquidity and generating income.

One of the biggest pitfalls of investing in collectibles is mixing sound financial judgment with emotion. You are buying to make a profit, and therefore you need to think with the head, not the heart. As I said in my November 12, 2019, interview with The Wall Street Journal, the goal is to buy "purely for the potential appreciation in their value. It doesn't matter if I like the assets or not."

Introduction

Throughout most of human history wealth creation, accumulation, and investing has been centered around acquisition of physical items. Most of our ancestors would consider investing in modern securities as exotic and a risky alternative to traditional ways of preserving and growing wealth. Tangible and portable assets like gold and jewelry inspired confidence by their appearance, rarity, and ability to store value. Treasures and land were the preferred investable assets, as well as a store of value and means of increasing wealth. Once wealth was acquired, it needed to be deployed, so capital worked just as hard as the owner who acquired it, but making that happen efficiently did not happen until the advent of liquid security markets, and the risk was often disproportionate to any possible rewards. In order to understand why the current view of the stock market as a safe and traditional investment is potentially flawed, we need to go back in history and see just how volatile and unpredictable this asset class has been.

Investing, as a means of growing wealth, is as old as human civilization. The history of investing can be traced back to the famous Code of Hammurabi, written around 1700 BC. However, growing wealth through conquest and corruption has been much more prevalent in the ancient world, thus making the art of investment much less relevant for many millennia. The concept of investing did not truly exist until stock markets of Medieval, Renaissance, and Enlightenment-era Europe brought it to the forefront of civilization in an organized and standardized way. Thus, when we talk about investing, we normally mean the establishment of a modern investment structure of stock trading, securities trading, and banking.

The merchants of Venice were trading government securities as early as the 13th century. Stock markets started in 1328 in Florence, and soon after expanded to nearby Italian cities of Pisa, Verona, and Genoa. Outside Italy, evidence of stock markets and stock market-like structures can be seen in German towns where local mine securities were sold at large fairs, and in French cities where municipal obligations were sold. Bruges, Flanders, Ghent, Rotterdam, and Antwerp in the Netherlands all hosted their own "stock" market systems in the 1400s and 1500s. All of these early "stock markets" had one thing missing: stocks. Although the infrastructure and institutions resembled today's stock markets, nobody was actually trading shares of companies. Instead, the markets dealt with the affairs of government, businesses, and individual debt.

The real history of modern-day stocks began in 1602 in Amsterdam, when the Amsterdam Stock Exchange was established by the Dutch East India Company, Verenigde Oostindische Compagnie, (VOC), the world's first multinational corporation and the first company to use a limited liability formula. The States General of the Netherlands granted the VOC a 21-year monopolistic charter over all Dutch trade in Asia and quasi-governmental powers of complete authority over trade defenses, war armaments, and political endeavors in Asia. The company was made up of merchants competing for trade in Asia, and to raise money, they sold shares of stock in the organization and paid dividends on them.

There was one simple reason why the East India Company became the first publicly traded company: demand for risk diversification. When the East Indies were first discovered to be a haven of riches and trade opportunities, explorers sailed there in large numbers, but only a few of these voyages ever returned home. The voyage to the precious resources in the West Indies was risky; ships were lost to pirates and disease, and fortunes were squandered. Stock issuance made possible the spreading of risk and dividends across a pool of investors, where risk was dispersed throughout the pool and each investor only suffered for a fraction of the total expense of the voyage. The Amsterdam Stock Exchange connected potential investors with investment

opportunities while simultaneously allowing businessmen to connect with willing investors. The market offered volume and liquidity, publicized value, broadcast availability, and lowered transaction costs. In short, it made investing easier and more standardized.

After 21 years, neither the VOC nor its shareholders saw a slowing down of Asian trade, so the States General of the Netherlands granted the corporation a second charter in the West Indies. This new charter gave the VOC additional years to stay in business but, in contrast to the first charter, outlined no plans for immediate liquidation, meaning that the money invested remained invested, and dividends were paid to investors to incentivize shareholding. Investors took to the secondary market of the newly constructed Amsterdam Stock Exchange to sell their shares to third parties. These "fixed" capital stock transactions amassed huge turnover rates, and made the stock exchange vastly more important. Thus, the modern securities market arose from this system of stock exchange.

Soon after the successful experiment of the Amsterdam Stock Exchange, other stock markets began to appear throughout Europe. The excitement over these new companies made many investors foolhardy. The First and Second Industrial Revolutions were responsible for introducing investing and banking to an enormous portion of the population. Instead of spending everything they owned on things like food and shelter, people had extra money they could save for the future. They bought shares in any company that came onto the market, and few bothered to investigate the companies in which they were investing. This led to a series of spectacular bubbles, a pattern that is very much alive today.

Most major stock markets have experienced crashes at some point in history. Stock market crashes are by nature preceded by speculative economic bubbles and occur when speculations are stretched far beyond the actual value of a stock. In England, such a financial scandal, known as the South Sea Bubble, took place in 1720. The South Sea Company had been set up in 1710 to trade with Spanish South America. The proposed size of

company profits was exaggerated, and the value of its stocks rose very high. These high stock prices encouraged the formation of other companies, many of which promoted farfetched schemes. In September 1720, South Sea stockholders lost faith in the company and began to sell their shares. Stockholders of other companies began to do the same, and the market crashed. These companies became known as "bubble companies" because their stock was often as empty and worthless as a bubble and the companies collapsed like burst bubbles.

Even though the fall of "bubble companies" made investors wary, investing as a way of growing wealth had become an established idea. The French stock market, the Paris Bourse, was set up in 1724, and the English stock market was established in 1773. In the 1800's, the rapid industrial growth that accompanied the Industrial Revolution helped stimulate stock markets everywhere. By investing in new companies or inventions, some people made and lost huge fortunes.

The Industrial Revolution was creating a new, increasingly affluent, middle class. While earlier business ventures had relied on a small number of banks, businessmen, and wealthy aristocrats for investment, a prospective railway company could interest a large, literate section of the population with savings to invest. New media such as newspapers and the emergence of the modern stock market made it easy for companies to promote themselves and provide the means for the general public to invest.

In 1825, the government had repealed the Bubble Act, brought in after the near-disastrous South Sea Bubble of 1720, that put close limits on the formation of new business ventures. With these limits removed, anyone could again invest money in a new company and railways were heavily promoted as a foolproof venture. Predictably, this did not end well.

Railway mania was the next instance of speculative frenzy to rock the United Kingdom in the 1840s. It followed a common pattern. As the price of railway shares increased, more and more money was poured in by speculators until the inevitable collapse. The UK was in the grips of a frenzy

that saw investors tripping over each other to pile into railway shares, bewitched by promises of a revolutionary mode of transport, a huge untapped market, and spectacular profit growth. Private firms hatched grandiose investment plans, submitted hundreds of bills to Parliament for new railway lines, and saw their share prices roughly double in the space of a few years.

The Government was obliging; in 1845, it authorized around 3,000 miles of track, roughly as much as the previous fifteen years combined. At its peak, railway investment surged to 7% of GDP, representing half of total investment in the economy at the time. It reached its zenith in 1846, when no fewer than 272 Acts of Parliament were passed, setting up new railway companies, with the proposed routes totaling 9,500 miles (15,300 km) of new railway.

As with other bubbles, the Railway Mania became a self-promoting cycle based purely on over-optimistic speculation. As the dozens of companies formed began to operate and their unviability became clear, investors began to realize that railways were not all as lucrative and as easy to build as they had been led to believe. On top of this, in late 1845, the Bank of England raised interest rates, and as banks began to re-invest in bonds, the money began to flow out of railways, undercutting the boom. As the share prices began to fall, investment stopped virtually overnight, leaving numerous companies without funding and numerous investors with no prospect of any return on their investment. The larger railway companies such as the Great Western Railway and the nascent Midland began to buy up strategic failed lines to expand their network. These lines could be purchased at a fraction of their real value as given a choice between a below-value offer for their shares or the total loss of their investment, shareholders naturally chose the former. Many middle class families on modest incomes had sunk their entire savings into new companies during the mania, and they lost everything when the speculation collapsed.

After World War I an increasing numbers of small investors began to invest heavily in the stock market. There was a huge rise in speculative stock

trading during the 1920's, and many people made fortunes. However, the Roaring Twenties came to an abrupt end in October 1929, when stock markets crashed and fortunes were wiped out overnight. The crash was followed by the Great Depression of the 1930's, a period of severe economic crisis throughout much of the world. After the end of World War II, small investors had again begun in stocks, and stock markets had been relatively stable for a time. A sharp fall in prices in 1987 led to another stock market crash. Initially, this frightened many people away from stock investments. But within a few months the market recovered and investor confidence returned.

The history of stock markets has been punctuated by periodic cycles of irrational exuberance followed by sharp and painful corrections that destroyed lives and wiped out wealth across a wide swath of investing public. Today, only 23% of those aged 18 to 37 say that the stock market is the best place to put money they won't need for ten years or more, and there's a good reason so many millennials are hesitant to put their savings into the stock market. Many have seen investments collapse twice within a period of a few short years; during the dot com crash of the early 2000's and the 2008 crisis.

Most modern financial advisers and money managers are comfortable with traditional investment vehicles, such as stocks, bonds, and real estate. However, as we just saw, traditional investments are by no means a safe haven, and an increasing number of savvy individuals are instead exploring collectibles such as art, stamps, wine, books, classic cars, and the like as an alternative avenue for profitable investing, diversification, and wealth building.

So what makes an investment a "collectible"?

A classical answer to this was given by a famous economist, David Ricardo, in his 1817 Treatise "On The Principles of Political Economy and Taxation". "There are some commodities, the value of which is determined by their scarcity alone. No labor can increase the quantity of such goods,

and therefore their value cannot be lowered by an increased supply. Some rare statues and pictures, scarce books and coins, wines of a peculiar quality, which can be made only from grapes grown on a particular soil, of which there is a very limited quantity, are all of this description. Their value is wholly independent of the quantity of labor originally necessary to produce them and varies with the varying wealth and inclinations of those who are desirous to possess them."

For a more modern version of the definition, we turn to a guru of fundamental valuation, Aswath Damodaran, who classifies collectibles as a limited supply asset that has no cash flows and is neither a raw material nor a medium of exchange. Instead, it can either have aesthetic value (painting) or an emotional attachment (baseball cards). Some collectibles are valuable because they are creations born of talent, skill, and fine workmanship (for example, paintings, sculpture, musical instruments, jewelry), where each item is inherently unique, and its value specific to that individual item. Other types of collectibles are valuable because they are rare or because scholars have attributed some significance to them (for example, coins, stamps, books, historical documents).

In order to understand the importance of this asset class we can turn to research by Baird Asset Management conducted in 2009, which defined three types of collectible buyers; the pure collectors, collector/investors, and investors for whom buying collectible assets is a pure financial game. In their report, they assume that the last two categories own 1/3 of the **total collectibles universe valued around $4.3 trillion, or around $1.5 trillion.** This estimation of direct investment into collectibles puts the value of collectibles viewed as financial assets on par with the $1.9 trillion invested in hedge funds and the $2.5 trillion invested in private equity funds.

Why invest in collectibles?

A substantial proportion of collectors hope for financial gains, citing investment as their primary motive for collecting. Once you have convinced

yourself of the need to add collectibles to your portfolio, what is the best way to think about selecting the right investments? The answer once again lies in history.

In the early seventeenth century, shells were bought by wealthy Dutch collectors craving aesthetically pleasing, unique, and exotic naturalia. Because of these preferences, collectors of seashells also often acquired tulips - novel, strange, beautifully colored flowers, and in the 1630s, a burst of demand led to a strong run-up in the prices of tulips. At least six companies were set up during this time to buy and sell these rare floral treasures, leading to the stratospheric rise and rapid fall of the tulip market in February of 1637. While the tulip craze had subsided, the public's appetite for exotic snail shells lingered for centuries. In 1796, the shell of a Carinaria Cristata snail sold for the small fortune of 299 guilders at auction in Amsterdam. At the same time a Johannes Vermeer painting that originated from the same estate, "Woman in Blue Reading a Letter", sold for about 40 guilders, as paintings were not thought to be nearly as valuable or rare as exotic natural objects. As late as 1881, the world famous "Girl with a Pearl Earring", albeit in poor condition, sold for about two guilders in Amsterdam, and it was not until a shift in fashion in the late twentieth century that "discovered" Vermeer's works became more valuable than nearly all other paintings produced in the seventeenth century. The history of seashells and tulips shows that investments in collectibles come with unique risks, over and above the price volatility that characterizes each marketplace. Although tulips continued to demand high prices until at least the early eighteenth century, changes in tastes and in supply slowly eroded their status. Similarly, there was a decline in seashell values in the nineteenth and twentieth century. In contrast, Vermeer's oil paintings are today considered priceless.

Over time, whole collecting categories can become more or less fashionable. At the end of nineteenth century astonishingly high prices were paid for silverware, and for tapestry in the early twentieth century. At the time, prices paid for the highest-quality "objets d'art" were many times those laid

out for the most expensive art works. Art only gradually became a more valuable collecting category, eventually leading to the price levels observed in recent decades. Wealth distributions also changed, with important consequences for collectibles prices. The world has witnessed the emergence of several emerging economies as global players over the last two decades, and changing wealth patterns and the corresponding changes in demand based on the cultural and regional affinities of these new collectors have had a significant impact on changes in relative art valuation.

The possibility of fakes is understandably a very important concern for collectible buyers, as it is authenticity and originality that gives the objects their allure, cachet, and, most importantly, value. In 2004, Christie's and Sotheby's both brought the same Gauguin painting to the market, only one of which was genuine (Bennett, 2004). In 2012, a Stradivarius violin dealer was found guilty of selling fake violins; a forestry expert who examined the instruments found that they had been made from trees felled after Stradivari's death (Paterson, 2012). By some estimates, 5% of fine wines sold at auction or on the secondary market are not what they claim to be, as full wine bottles are relabeled, and empty bottles are refilled with cheaper wine, a ruse made possible chiefly by the fact that many buyers wait years before opening their fraudulent bottles, if they open them at all.

Before we enter and explore in detail the magical world of collectibles investment, it is important to have a clear expectation of what you will get from this book.

You WILL learn:

- **what are the origins and history of the main collectible asset classes**
- **what are current emerging and future collectibles types and their characteristics**
- **what are the key value drivers: strategic (long term) and tactical (short term)**

- what are the costs of owning a physical asset
- who are the key players in the collectible market
- how fractional ownership of collectibles is democratizing access to the various asset classes
- what are the current and future platforms providing fractional access and secondary liquidity
- what features do platforms provide currently and what is in the pipeline
- why it is a smart move to incorporate collectibles into your balanced portfolio
- how to use a scoring framework to make an informed decision about assets

You will NOT learn:

- rigorous quantitative analysis of diversification benefits to the portfolio from incorporating collectibles
- in-depth history of each asset class
- tools to become a professional investor in a specific sub-asset class
- opinions on asset classes future prices or values
- specific investment, tax, or wealth management advice

The information in this book is useful and valuable for any serious, active, or even just curious investor. I am excited to take you on an exploration of the often strange world of collectible investments where dizzying prices are paid for rare objects, and fortune favors savvy, educated, and well-prepared investors. It is always a scary proposition to abandon the familiar set of options, but there is no extra reward without the will to venture into the unknown and come back victorious. As John Templeton once said, "If you want to have a better performance than the crowd, you must do things differently from the crowd."

Asset Class Characteristics

In collectible markets, most notably in art, there is no clear shared model as to how to value a particular piece. There are a multitude of factors that must be taken into account, and the factors are not weighted or interpreted the same way by all market participants, leading valuations to be very subjective and their derivation often unclear. Demand can be predicted accurately when there are many identical or similar objects; the more unique the item is, the more difficult it is to make a prediction about its valuation. In finance, the price of a financial asset is determined by the market, an index, and some specific factors. However, today there is no standardized valuation methodology for collectibles, and thus no guarantee that the fair price of an item is the result of an independent objective analysis.

Without an understanding of various possible drivers and developing a sense for which ones are key for evaluating each unique collectible segment, it is impossible to intelligently formulate an opinion and invest. So, the first step in our journey towards becoming comfortable and familiar with the subject matter is to learn what parameters drive value, how they are defined, and how they influence the value of the object in question. There are fundamental parameters that form the basis for making a long term value judgment, but there is also a host of other variables that can greatly affect the value on a short to medium term basis. Let's call these Intrinsic (factors inherent in the object) and Extrinsic (factors outside the object itself) and explore both sets.

Value Drivers

Intrinsic

Scarcity: Refers to something that exists in an amount too small to meet the demand for it. It is influenced by how often the object appears on the market, and how many of a particular object there are versus the demand for it. Scarcity always needs to be viewed relative to demand. Even though Picasso has painted prolifically, the demand for all his works greatly exceeds its supply. This parameter, together with rarity, is the major driver of value estimates. The more scarce the object is, the more valuable it becomes.

There are also secondary features that affect scarcity. For example, items that are more liquid are in greater demand helping increase the degree of scarcity, and indirectly driving the value up. Another example is the absolute price levels that serve as a signaling tool to illustrate the status and desirability of the piece. While on its own this parameter is not terribly meaningful (recall the Dutch tulip prices in the 17th century), in conjunction with other drivers, it provides an important data point that may signal or serve as a proxy for scarcity in the absence of other data points.

Rarity: Defines things that are no longer made and only exist in a limited amount, making them uncommon and hard to find. If something is rare, it will always be rare. The degree of rarity is determined by how many similar examples exist and in what condition, and this is one of the first, if not the first, criteria people associate with collectible assets. The general wisdom is the greater the rarity, the higher the value, provided that condition is good. Having a complete collection of all the items that can be defined as a unique set is closely related to rarity, while it is unarguably hard to find even one rare item, building a complete collection takes an immense amount of time, dedication, and resources, and is then orders of magnitude more rare, making the whole worth quite a bit more than the sum of its parts. Imagine at the extreme being the owner of a "Leonardo set", all the known works of

Leonardo da Vinci; or to be more realistic, a complete collection of all the vintages of a rare wine from the first time it was produced till today.

Provenance: Once an item has entered the secondary market, it has gained *provenance*, a French term for the history of ownership of a valuable object, an absolutely crucial parameter in evaluating the value of the asset. This record serves as a legally verifiable confirmation of the object's ownership history from Day One, helps to confirm its authenticity, and can be used as evidence that the person in possession of an item has the legal right to sell it. The documentation should include the name of every auction house, dealer, gallery, or collector who owned the piece, as well as physical proof of their right to sell it.

Exhibition history, publication in catalogue raisonne (a comprehensive, annotated listing of all the known artworks by an artist), and mention or reproduction in books or magazines are all an important part of the record, although on their own this does not significantly enhance commercial value. On the other hand, illustrious provenance greatly enhances the prestige of ownership and helps secure large premiums. If an item was owned by a celebrity, famous historical figure, an important collector, royalty, or a world class museum, the value of the object will be greatly enhanced.

Condition: Is a very important aspect of value, especially in the collectibles space where the difference in value between a pristine specimen and one that is even of slightly lesser quality can be several orders of magnitude. The state of the object, how and if it has been restored or otherwise adjusted from the original, and how well it has been preserved, matter a great deal across the entire collectible spectrum. The better the condition, the higher the value of the object. Condition should never be confused with quality. Quality is how the piece was made. Condition is how it has survived since then.

Historical importance: This metric is closely tied to both the provenance of the object and to the stature of its creator. If the piece was created by a recognized and admired master, has illustrious prior owners, or is directly tied to a historical event or figure, the item will command a substantial

premium relative to similar others. Collectibles, and especially art, are investments where a portion of value is derived from the social component. Owning a Picasso isn't just about the monetary value, it is about being the type of person who owns a Picasso. The more recognizable the item is, the broader will be its fame and appeal, and by extension, the bigger the set of interested buyers, translating into higher value of the object. Prestige of something that directly connects the item to past greatness serves to convey wealth, culture, and social status of the owner, as well as his ability to be in the trend and possibly a bit ahead of the curve.

The above set of parameters allows us to start building a base framework that can be used to evaluate any collectible investment with the understanding that there are some unique and idiosyncratic characteristics that are incremental to the broad categories above.

Next, we will augment the intrinsic value with a range of other variables that will help us further refine our understanding of the potential value of the asset. This is an important component of an investability scorecard framework that is used in evaluating and ranking opportunities within and across multiple sub asset classes.

Extrinsic

Supply/demand imbalance: Supply of scarce assets is limited, fixed, and declines over time due to various factors. Art can be lost, destroyed, or simply go into museum vaults not to be seen again for decades; consumables can be consumed; other collectibles can be damaged badly enough to drastically lower their value. Changes in demand are driven by tastes, social influences and trends, as well as lack of available substitutes. Following the emerging trends in demand relative to supply for a particular sub-asset class can help determine future price direction in the short term.

Globalization: Monitoring the continuingly increasing reach and interconnectedness of the global market for each category of rare collectibles

provides a powerful indicator of the timing and extent of future demand. While initially some asset class may have had only local exposure and demand, a wide range of appetites and open mindedness towards exotic investments around the world, coupled with increased purchasing power, has the power to heavily influence pricing by further exacerbating the supply/demand imbalances already present. This trend plays out on its own timeline for each asset type.

Demographic trends: There is the aging and death of a large number of collectors, whose heirs and estates do not have the same degree of appreciation for the aesthetic or emotional value of the collection, and thus are eager to monetize it. As a result, a large amount of assets that have been locked up for decades is coming to market, greatly increasing the supply and depressing prices in short to medium terms. Younger collectors' preferences are shifting to asset classes that were previously less covered, thus driving up the demand across classes less demanded in the past, as well as creating and growing demand for new and emerging forms of collectibles.

Affinity (national/ethnic): Some collectible purchases may be influenced by feelings of national or ethnic pride. As emerging economies (China, India, and Russia) became more prosperous, they have created a large number of extremely wealthy buyers. Prices for works that reflect their national heritage or cultural uniqueness have risen. This parameter is directly related to the emergence of the Ultra High Net Worth (UHNW) class which is willing and able to pay exorbitant prices for objects that reflect national importance and pride. Trends are unpredictable because they are not necessarily determined by logic or reason but can have a great impact on the valuation of certain types of work. In recent decades, the values of historic Russian and Chinese art have greatly benefited from increased wealth in those countries creating new and very rich collectors, as the values of Orientalist/Islamic art had earlier been boosted by Arab oil wealth.

Political uncertainty: In times of war, regime changes, or persistent instability, the demand for collectibles may bifurcate. Those items that are highly portable,

have global appeal, and are easily stored and transported, will be highly demanded as the core means of storing, preserving and transferring wealth. Items that cannot be easily moved or used may not be able to provide value, due to the high degree of uncertainty whether they will be destroyed, seized, or otherwise confined to its present location indefinitely.

Economic environment: At times of economic crisis, people can turn to their valuable assets as sources of liquidity and means of survival, especially if the downturn is an extended one. Thus, an excess supply comes on the market, depressing prices in short to medium term. On the flip side of the equation, when the markets are strong and investors have cash and growing incomes, this translates into more willingness and interest to procure relatively illiquid assets, and thus demand rises along with the prices.

Transaction motivations: Potentially important factors in valuation are the seller's reasons for selling a particular work and the buyer's reasons for buying. Sellers may be motivated by financial need, boredom with a particular artwork, desire to raise funds for a different purchase, death, debt, and divorce. Buyers may be motivated by market excitement, their collection plan, or buying to drive value up for themselves or for another person. Ascertaining the true motivation of the seller and urgency of the sale may help in acquiring an item for a lower price, thus realizing more value from the acquisition.

Regulations: Various international and domestic laws may affect how certain items are taxed, whether they can be exported, or traded. Positive tax treatment, ease of export, and ability to transact without legal constraints all positively impact asset price. Knowing the existing laws pertinent to the object in question, and monitoring them on ongoing basis can help spot future price trends.

Media coverage: The amount of media coverage of a certain object can have a strong short to medium term impact on its desirability and price. The broader the coverage, the more descriptive and insightful it is, the more media channels are involved, and the longer the coverage lasts, the more the desirability and the value of the asset increase.

Pop culture references: Related to media coverage effect, when an item is actively engrained in pop culture via tie ins with shows, songs, films, etc., it raises its visibility and recognizability profile, as well as positively impacts the prestige factor extended to it thus driving the value up.

Special events: One time or annual events like awards or exhibitions can raise the profile of an object making it temporarily more coveted, known and desired, spurring short term demand and driving the price up. Anniversaries are closely related to special events but are distinct in a sense that their timelines are known far in advance, and the build-up effect actually occurs leading up to the date, as opposed to after it, as in the case of exhibitions. The milestone anniversaries of creating the object, be it painting, comic book, record, or book, generate buzz and interest and have a medium to short term price appreciation effect.

Summary table:

VALUE DRIVERS
Intrinsic
Scarcity
Rarity
Provenance
Condition
Historical importance
Extrinsic
Supply/demand imbalance
Globalization
Demographic trends
Affinity
Political uncertainty
Economic environment
Transaction motivations
Regulations
Media coverage
Pop culture references
Special events

It is impossible to capture all the intricate nuances unique to each of the asset classes, especially the more esoteric ones that a dedicated professional may use to arrive at a valuation. The above list is by no means an exhaustive set of parameters used to assess the value and price appreciation potential for a collectible asset, but it can be used as basis for a scorecard providing a solid reference point for an investor to make an informed and educated decision about including an asset into his portfolio.

As discussed earlier, when dealing with physical assets, there are two main large costs that need to be taken into account in the final evaluation of the attractiveness of the investment: ownership costs and transaction costs. They will vary by sub-asset class, with baseball cards much easier to store and maintain than classic cars. The comprehensive overview below, even if not all-inclusive, covers the spectrum of costs associated with physically holding assets, and is important to appreciate and take into account as part of evaluation of the investment's attractiveness. In the new paradigm of fractional ownership, both transaction costs and ownership costs are partially absorbed by the platform as part of operational expenses, and partially shared by all the partial owners of the asset. As a result, these do not need to be taken into account in determining value in the fractional paradigm, thus greatly improving return profile of the investment by taking away a large portion of unnecessary cost.

Costs associated with holding physical assets

The cost of managing a collection can vary widely and can easily add up to between 1% and 5% of the value of the works, annually. The variation is due to the wide range of services that may or may not be required for a particular collection. The only things the value of the object affects are transaction costs and insurance. The rest of the costs are based on space and time.

Transaction costs: Relative to the price of the object, this is by far the largest and most immediate cost of ownership, and it is important to

understand the magnitude of this for all prospective buyers. Purchase fees in auctions are set on a sliding scale as a percentage of the "hammer price" depending on the value of the work. While these vary by location, as of 2019 in New York, the fee at Christie's is 25% on the value of purchases up to $300,000 ($400,000 at Sotheby's), 20% between $300,000 ($400,000) and $4 million and 13.5% on the portion of the price over $4 million (13.9% at Sotheby's). Buyers in the U.S. also pay a sales tax. Sellers' commissions range from 10% on the first $3,000 plus charges on shipping and photography to the low of 0% on anything higher than $3MM.

Authentication: This is the process of unequivocally confirming the object's authenticity, i.e. irrefutable proof that this is the genuine article it claims to be. In case of most collectibles the grading process encompasses both authentication and condition, so a separate authentication step is not necessary and is part of the grading fee. In the case of art, the act of authentication is equal parts art and science in itself. Most art dealers or sellers will not authenticate a painting that is too badly damaged, too faded, ripped, or one that has obvious stains.

Authentication is generally only provided by a specific scholar or committee that is widely recognized as the preeminent authority on an artist. The cost will vary depending upon the expert, their knowledge, and the level of research required. To cover all bases it's best to involve specialists in animal and plant DNA residue, high resolution digital images, and mathematical formulas. In a famous case in the UK, legal costs to establish authenticity of a Caravaggio painting, "The Cardsharps", ran over $7MM.

Authenticating a work of art is often difficult, and more difficult when the art is four or five hundred years old, as provenance is often limited or non-existent. The expert is left to rely almost entirely on expert opinion concerning the quality of the art, i.e. his judgment if the quality of the art being examined is of the quality expected of a painting by the particular artist. Provenance, the ownership history of an object, is essential to establishing authenticity and maintaining value. All art and collectible

objects should always be accompanied by documentation that provides the assurance that the work is genuine. For older works by more established artists, provenance can also confirm an artwork's authenticity through its past ownership. There are many in ways in which provenance can be verified, the most common one being a signed certificate of authenticity. Galleries provide information about past ownership on top of the certificate, as well as an original sales receipt. For more established artworks, an exhibition sticker attached to it, an appraisal, or documents by recognized experts discussing the work can provide additional provenance. Good provenance should contain information about its dimensions, media, date it was made and its title. Confirmation of a work's authenticity is the key determinant of the object's value and ensuring that the work is liquid/saleable.

Appraisal: There are four major reasons people seek an art appraisal: to investigate whether they have sufficient and proper insurance coverage for their collection; as part of estate and divorce settlements; considering a possible sale of the object; and considering a charitable donation where IRS may require an appraisal by a "qualified" appraisal, certified by a recognized appraisal organization.

To differentiate between the terms "appraisal" and "authentication", an appraisal assumes that the piece being appraised is authentic and takes place assuming this is the case, while an authentication is a formal and professional opinion that the work is genuine and created by the claimed artist. An appraiser specializing in the particular area of interest is the best choice. The appraisal fee depends on both the rate and the hours expended. The expert may be able to complete an appraisal in a few hours whereas it may take a general appraiser a week to complete the appraisal, thus ranging from $1,000 to $10,000+ depending on the complexity of the case.

Insurance: It is not uncommon to insure art and collectibles at slightly higher than fair market value, using the replacement cost, which is usually about 15% higher. Accurate appraisals of fair market value can be obtained from known,

trusted authorities in each asset class. In the case of art, for example, such an organization is the Art Dealers Association of America. The costs are around 0.25% of the price of the artwork on annual basis. The premium percentage depends on many factors, including the size of the collection, its security and location, and can also depend on the nature of the art. Same rates apply to artworks at any price, so a $100MM painting would carry an annual insurance bill of $250,000 and a $10,000 painting would run $25. Carrying a comprehensive insurance policy is vital to protecting the value of the investment, as to be able to process a claim it will be necessary to objectively prove what the item was worth. Good practice includes cataloguing the full collection, including date purchased, amount paid and any other important details; taking pictures of every piece and keeping them in a secure location; and keeping all receipts for old and new additions to the collection along with documentation for any prior formal appraisals received. A formal appraisal by an expert will help estimate how much insurance is needed, as well as back up any claim should there be an insurable loss. Insurers that offer protection for high-end artwork and other valuable collections include AXA Art Insurance Co. and Lloyd's of London. When comparing insurance policies, it is advisable to cover a wide range of losses, such as fire, theft, and breakage.

Storage: Proper care and storage are crucial to preserving the condition of collectible objects, and the exact formats and specifications vary greatly by sub asset class depending on the complexity of conditions and amount of space and location. Ensuring each item is stored correctly to preserve its condition helps maintains the full value of the asset over time.

Restoration: While this is mostly specific to paintings, it applies to other types of collectible objects, such as cars, motorcycles, and watches. For a painting, as soon as it is made it begins to age and needs care to keep it looking its best for the longest possible time. Restoration includes repairing paintings that have suffered paint loss, weakened canvas, tears, water damage, fire damage, and insect damage. The natural aging of the painting alone, in addition to the accumulation of dirt over the years, requires the attention of a trained painting conservator. Even if a painting is cared for and displayed properly, it

will still experience the effects of natural aging and dirt accumulation. The goal of the conservator is to stabilize the remaining original artwork and integrate any repairs in order to preserve the artist's original intent. A complicated tear in the canvas could cost up to $50,000 to be restored with museum quality micro-weave. A period frame from the same time as the artwork is a valuable antique itself and can cost $10,000 and up.

Maintenance: Humidity and temperature fluctuations that can ruin paint or render cracks in a sculpture require installation and ongoing operation of environmental monitoring equipment that can cost up to $1,500 a month for a large collection. There are other asset class specific requirements that demand very specific light, temperature, humidity, and other conditions that can only be provided by professional services specializing in a particular asset class, or by engaging in a massive construction project to build out the necessary space and acquire all the equipment needed, which can run into tens and hundreds of thousands of dollars.

Servicing: Documentation of all service and repair is an important element of preserving the asset and maintaining its value. This is mostly specific to mechanical collectibles like watches, cars, and motorcycles that have moving parts that need to be maintained and lubricated. Servicing of a mechanical watch from a good watchmaker implies disassembling, cleaning, oiling, and polishing the watch, with damaged components either fixed or replaced. The watchmaker will then reassemble the watch and adjust it in several positions to make sure it runs well. A common rule in the industry recommends a complete watch servicing every three to five years. In the car space, some modern vehicles can go 10,000 to 15,000 miles between oil changes, but older cars need oil changes at least every 3,000 miles. Where a modern vehicle might not need a routine tune-up or service for 25,000 miles, some older vehicles need to be checked and tuned up every 1,000 miles. Having a professional mechanic perform these services or repairs as needed will not only keep the car in top running shape but will also provide a paper trail of documentation that can help add resale value to the vehicle when sold.

Transport: Art and antiques are fragile and expensive, so proper transportation is crucial. Shipping prices are based on size and weight plus insurance, which is the biggest factor in shipping and ranges from 0.5% to 4% of asset value. As this is a rare necessity, and not an ongoing cost, it is unlikely to have a major impact on ownership expenses, unless the piece is constantly and extensively moved. Professional packing prices depend on the work's dimensions, but even for a small piece, one can expect to pay $650 for a double case, a fully alarmed air-ride van and two men. Extra security on a door-to-door journey with a security car following the van can run to $500 a day for a top asset protector.

Installation: Very large pieces of art, especially outdoor sculptures or constructs, as well as room size paintings, require special equipment, trained personnel and space to install and de-install the object. This is only applicable to a rather small subset of assets, and only in the painting and sculpture sub-asset class. These costs can be a large additional expense for the owner in the neighborhood of 0.5% of the object's price.

Market players

Collectors: Generally focused on particular works that represent their tastes, they are passionate about their purchases and willing to pay more for a desired object than a purely rational, financial investor would, and they have no clear maximum price in mind when going to an auction. This group is mostly reluctant sellers, only engaging in that activity grudgingly to create liquidity from necessity, if a selling opportunity is too good to pass up, or if they need to free up cash for an even more desired object.

Museums: Focused buyers, with some idiosyncratic acquisitions due to curators' tastes. The process of getting approval for a purchase is slow and multi layered involving many sign offs, which means they are not able to engage in time sensitive offerings and as a result will usually pay a premium for works they want. Generally reluctant to sell works, and those sold are normally lesser ones or not fitting the mandate.

Dealers: Play a critical role as buyers, sellers, and distribution channel. Dealers may purchase primary works directly from the artists or sell them on his behalf. They are also active in secondary markets, due to certain specialization and insider knowledge of the artist's work in the case of living artists, they are in best position to understand and manage the portfolio. They provide essential liquidity in the private market, as well as being active participants in auctions.

Auction houses: In the past, the great art academies turned out nearly every artist capable of selling their work, and those institutions, in turn, governed the display and sale of art. As artists began to realize the monetary potential of selling their work, the first auction house (The Stockholm Auction House) opened in 1674. Sotheby's made its introduction to the auction and art world in 1744, followed by Christie's in 1766. Auction houses are one of the biggest drivers of the art market, with sales at public auctions exceeding $29 billion last year.

Investors: Operate in conjunction with dealers financing a work until a buyer can be found or will speculatively buy and hold for a longer period ahead of an anticipated event or change in taste. They are not concerned with the aesthetic merits of the art, and unlike collectors, they have solid discipline around entry and exit points.

Funds: Investment partnerships structured like private equity funds charging management fees and carried interest, with investors absorbing the storage, transportation, and insurance costs. As allocators of capital and selectors of works these entities primarily focus on assessing the financial merits of their investments and frequently experience conflicts of interest issues from advisors who are dealers or auction specialists.

Now that you have a basic understanding of the nature of the collectible asset class including its key value drivers, associated costs, and major players in the market, the next step is to explore the nuances and intricacies of some of the most interesting, exciting, and most importantly, profitable asset classes in existence today and beyond.

Asset Categories

When we think of the world of collectible assets two things immediately come to mind: stratospheric prices and unbelievably lucky finds. Both are exciting to think about and create an aura of adventure and mystery around the world of art and collectibles. 2019 alone has seen some amazing treasures discovered in the most unexpected places and some world records shattered in multiple categories of assets. Collectibles are selling for ever-higher price tags, capturing the popular imagination. As antiques and collectibles have reached new heights of popularity in recent years, dozens of reality shows sprung up showing people finding obscure and highly valuable items that they will be able to resell at a steep profit.

Rare finds 2019:

- A coin buff purchased a cookie box filled with old coins for 50 cents at a flea market in Northern France. One of the coins turned out to be the 1776 Continental Dollar, the first pattern coin ever struck for the United States and one of less than 100 examples known to survive. After the piece has been authenticated and graded the value was estimated to be approximately $100,000.
- A Maryland woman bought an old piano for $25 at a garage sale. After realizing one of the pedals was sticking, she discovered a secret stash of 100 antique baseball cards, that were hidden there for around 80 years. One of those was a Babe Ruth rookie card, printed

in 1916 when he was still a young pitcher with the Boston Red Sox. The card almost doubled its original estimate to sell for $130,000.

- A man in the U.K picked up an ex-library copy of first edition of Harry Potter for just £1, although at the time he had no idea he was purchasing a future classic. Bloomsbury printed just 500 copies of the first edition, with 200 copies sent out to bookstores and the rest sold to schools and libraries around the U.K. When it was sold, that £1 investment had turned into a magical £34,200 ($41,350).

- A man found a tiny vase in a British charity store and bought it for £1, simply because he liked the design. It turned out that the Vase had originally been made for the Qianlong Emperor, who ruled China from 1735 until 1796, and featured his distinctive seal on the base. The buyer placed it up for sale, with a valuation of £80,000. The vase sold to an international collector for a stunning £484,000 ($621,300).

- An art collector saw a tiny wooden painting hanging on a kitchen wall above the stove in a tiny apartment on the outskirts of Paris. The owner couldn't remember where it had come from, but she assumed it was a worthless Russian religious icon passed down through the family. The small wooden panel was in fact the work of Italian painter Cimabue (c.1240 – 1302), a highly important artist described by historians as "the father of the Renaissance". Just 11 works by Cimabue were known to have survived and this was number 12. Paintings by Cimabue were so rare that none had ever appeared at auction before. As the only Cimabue work in private hands, and the only one ever likely to be offered for sale, the painting caused an international bidding war and sold for $26.85 million, making it the world's most expensive medieval artwork.

Price records 2019:

Whisky

A highly rare bottle of 1926 Macallan 60-year-old became the world's most expensive whisky at Sotheby's in October 2019. The bottle was one of only 40 produced at the Macallan distillery in Scotland, and left to age for 60 years in the now-legendary 'Cask 263' before being bottled in 1983. The bottle sold at Christie's surpassed all the other $1M+ whisky bottles, as it sold for a world record $1.86 million.

Guitar

1969 Black Fender Stratocaster is known simply as 'The Black Strat', which Gilmour used to record classic Pink Floyd albums such as The Dark Side of the Moon, Wish You Were Here, and The Wall. It was acquired for a world record $3,975,000 by Jim Irsay, owner of the Indianapolis Colts, who added it to his collection of famous instruments played by The Beatles, Bob Dylan, and Jerry Garcia

Marvel Comic

Marvel Comics #1 was first published in August 1939, and featured the debuts of characters such as the Human Torch and Namor the Sub-Mariner. For eight decades it remained in almost pristine condition, and is the world's finest-known copy, which meant wealthy collectors were fighting each other to own it. It eventually sold at Heritage Auctions for $1.26 million, making it the most expensive Marvel comic ever sold and one of only four comic books in history to fetch a seven-figure sum.

Sports Jersey

Just six Ruth game-worn Yankees jerseys are known to exist, including those in the Cooperstown Baseball Hall of Fame and other major collections. The last example to hit the auction block in 2012 sold for $4.4 million, a record that stood unbeaten until this year and the discovery of the new Ruth road jersey. Bearing Ruth's name still sewn into the collar, the prime piece of vintage grey flannel became the world's most expensive sports jersey with a final price of $5.64 million.

Watch

A one-of-a-kind Patek Philippe Grandmaster Chime watch described as "the most complicated wristwatch ever made" rewrote the record books when it sold at Christie's for a stunning $31 million. The Grandmaster Chime is the only one that will ever be made in stainless steel and has 20 complications, including a grande and petite sonnerie, a minute repeater, instantaneous perpetual calendar with a four-digit year display, second time zone, day/night indicator, day/date (on both dials), month, leap-year cycle, four-digit year display and 24-hour and minute subdial. The previous record for the world's most expensive watch (a pocket watch) was the Patek Philippe Henry Graves Jr. Supercomplication, which sold for $24-million at a Sotheby's auction in 2014. It was made in 1920.

Modern Art

"Rabbit," a 1986 stainless steel sculpture by artist Jeff Koons, sold to Robert E. Mnuchin, father of Treasury Secretary Steve Mnuchin, for $91.1 million, making it the most expensive work ever by a still-living artist.

These are amazing stories of rare and unusual finds, and sky high prices paid for very rare objects. It is exciting to read about them, perhaps even dream about one day discovering your own Leonardo in the cellar, but this is also the most

destructive and incorrect way to view the world of art and collectibles as an investor. The focus must be not on getting lucky or setting a new record, but on a careful, well researched, and highly disciplined approach to asset review, selection and ultimate disposal. You have to treat collectibles like any other investment to get the most monetary value from them.

There are many motivations for investing in collectibles, the main ones being capital appreciation, safe financial haven, portfolio diversification, social status and "joy of ownership" (albeit the last two are virtually non-existent in the fractional ownership paradigm). In a study of collectors after the 2008 crash, 74% said investment potential was driving their buying decisions. These items aren't just a hedge against the shocks of the larger market, but also relief from the head-spinning complexity of many more "regular" investments.

Many advisors and experts agree that, whatever a client's net worth, collectibles should comprise 5% -10 % of their portfolio. This is especially true for larger portfolios, usually owned by older clients, which offer more room to speculate with all alternative asset classes, including collectibles. Among those who collect, precious metals (49%), fine art (36%), precious jewelry (26%), stamps (22%), antiques (16%), automobiles (15%), and wine (12%), are the most coveted items. Roughly 40% of wealthy collectors don't know the full value of their collection; more than half (51%) have never had their collection appraised; 44% have not had their collection insured. While 81% of collectors plan to leave their collection to the next generation, only 35% of heirs are interested in keeping it.

When trading stocks, bonds, commodities, and currencies, investors have access to a wealth of information. In contrast, while there is some information available on collectibles, the amount of detail and price points is limited, especially for some of the rarer pieces and more obscure asset classes. As a result, some investors jump into collectibles, assuming they can make their fortune in a world filled with schemes, con artists, and frauds and in almost 100% of the cases they are very wrong and very broke by the time this exercise ends.

Investing in art and collectibles is not easy, especially if you want the items you purchase to retain value or appreciate over time. This alternative investment category requires developing a special understanding of the risks and having realistic expectations regarding return on investment. You will learn a bit of history of each asset class, understand price levels associated with the most desired items, and develop an appreciation for the levels of returns in each class. We will closely look at the commonalities among the parameters used to evaluate them, as well as idiosyncratic metrics unique to each particular sub-asset class.

By the time you are done, you will develop a concrete set of skills and tools required to evaluate each asset class as a whole, a framework to select the best options within an asset class, and a strategy to incorporate collectibles into your portfolio to achieve your medium and long term investment objectives.

Each asset chapter will contain the following sections:

- Asset class overview
- Historical performance
- Value metrics
- Top five highest priced examples

Art

Paintings

Asset class overview

Research by neurobiologist Semir Zeki of the University College in London found that viewing art triggers a surge of dopamine similar to that associated with romantic love. From drawings on the walls of prehistoric caves, to marvelous sculptures and paintings of the Renaissance, to modern graffiti, art has been an integral part of the human experience throughout our history. It is the most frequently talked about sector of the collectible space and has the largest share of wallet and mind of all collectible asset classes.

Plato considered the value of art to be dubious because it was just "mimesis", an imitation of reality. The value of art is based on collective intentionality; there is no intrinsic, objective value and only human stipulation and declaration create and sustain the commercial value.

For centuries, the ownership of fine art was limited to society's elite. Displaying a painting or sculpture in a private setting was physical evidence of one's status, influence, power, and wealth. The economic growth that began in the post-WWII years expanded the number of Ultra High Net Worth Individuals and transformed art from a niche market into a global one. While art investment has traditionally been a way to showcase an

individual's wealth and prestige, in recent times it widely became regarded as a unique and important investment asset class. Art and collectibles are increasingly playing a role in a well-balanced wealth portfolio, and both collectors and art professionals feel it offers a degree of safety and diversification in times of economic and political uncertainty.

Art is viewed as a financial product in many circles, just another investment. According to the Deloitte's Art & Finance Report for 2016, 73% of wealth managers said their clients want to include art and other collectible assets in their wealth reports in order to have a consolidated view of their wealth. Over a span of several decades, fine art's favorable investment characteristics, such as its ability to act as a store of wealth to hedge against inflation and currency devaluation, have made it an increasingly attractive asset class for wealthy families, knowledgeable collectors, and a growing number of professional wealth managers. Particularly, there has been a focus on "blue chip" artists whose works carry the highest price tags and have the largest collector base, and also have been consistent winners in a market often characterized by uneven and temperate growth. Collectible art is one of the most inflationary asset classes available to wealthy individuals, and thus while inflation may be a bane for the consumer, it is a boon for an asset owner. It provides a hedge against inflation and currency devaluation, has no geographical risk, and can be moved easily and insured against calamity risk. Additional dividends from loaning/donating display rights to art museums/galleries can also provide incremental value.

The value of objects is arbitrarily set by a loose collection of galleries, art critics, and consultants who determine prices and control buyers. The majority of sales are private, unreported transactions or are conducted in public auctions where dealers can rig prices by inflating bids. Many people think auction results and Internet price guides are sufficient to determine the value of a work of art, but these guides rarely tell the whole story. The evaluation of a specific work depends on numerous factors, including quality, condition, and evolving market conditions. Dealers can evaluate a work in the light of recent sales, both public and private. Raw price numbers

are useless unless interpreted with facts exclusive to each work of art, as well as the circumstances of the sale.

According to research by the Smithsonian American Art Museum, there are more than 400,000 artworks in public and private collections worldwide and more than 27,100 painters, sculptors, and illustrators in the United States alone, each one producing original pieces using a variety of media and surfaces. Just 0.2% of artists have work that sells for more than $10 million, according to the UBS and Art Basel report, but they are the ones dominating the market with 32% of the $60+ billion in art sales. It is estimated that the outstanding value of artwork globally is in excess of $3 trillion, and the global art market in 2019 stands at $64.1 billion with 40 million transactions taking place.

Fine art markets have been in continuous evolution expanding to new countries and new customers around the world. Today, they have reached a truly global dimension in the sense that nearly everywhere on earth people are buying and selling artwork every day and are moving around the world to find the desired item. Once a nation grows richer and its citizens reach a certain level of affluence, they start to buy art. This has been the general financial trend since the beginning of the industrial age. China is now third in term of sales of fine arts at auctions after the U.S. and the UK. The top three markets (United States, United Kingdom and China) accounted for 84% of total sales by value.

Liberalization of certain economies, including China, India, Russia, the Gulf states, and several countries in Eastern Europe, led to an art collection boom outside the US and Western Europe. Art has become a global industry bound up with luxury, fashion, and celebrity, attracting an expanded range of ultra-wealthy buyers who aggressively compete for works by brand-name artists. The reduction of auction sales experienced at the end of 2008 and in 2009 was not due to a reduction of demand but rather a reduction of supply. When the economy is healthy, art changes hands frequently and there's high liquidity. But when stock market investors sell their assets,

owners of expensive artworks usually don't resort to liquidating their holdings, thus keeping the value unchanged. Historically, slumps in the art market have been characterized more by a lack of liquidity and lower sales volumes than sharp declines in value or prices paid for important works.

Art is one of the biggest luxury asset holdings of UHNWIs, and over the long term, the highest earners are very influential in the price performance of this market. The large increase in billionaires is new and has an impact on the holding time of paintings they acquire; possibly 60 years may elapse before these paintings return to the market and are included in existing repeat sales indices.

Technological evolution strongly supports the positioning of art as a new asset class. It increases transparency as new market opportunities and business models in an internet and digital world emerge, such as online auction houses, online databases, online and real time market data dissemination, online catalogues and fairs, artist websites and new communication channels. More people are discovering that possessing prized paintings, prints, sculptures, and valuable collectibles is now within their reach. The online art market reached an estimated new high of $6 billion in 2018, representing 9% of the value of global sales. Based on a survey of five national markets in 2018, 93% of millennial High Net Worth (HNW) collectors reported that they had bought works of art or objects from an online platform, compared to a majority of baby boomers who had never bought art online before. Collectors from the millennial generation were considerably more active art buyers than others, making up just under half (45%) of high-end spenders ($1 million plus), underlining the importance of the spending power of this demographic.

The vast majority of art produced over the ages is lost, destroyed, or forgotten. It can also take generations for the art world to come to appreciate the genius of a particular artist. Vermeer, Gauguin, and Van Gogh were considered failures in their lifetimes. The rare pieces that survive generation after generation are the ones that capture and transmit the

essence of human experience, distinguished by the artist's skill, subject, and setting. These works are considered investment-grade art and fall into one of the following categories:

Masterpieces - Widely recognized works created by the world's greatest artists (or "Old Masters") and owned by museums and a few private collectors. When a piece becomes available for purchase, it often sells for tens or even hundreds of millions of dollars like a recently discovered Da Vinci, "Salvator Mundi," sold for $450.3 million in 2017.

Blue-Chips - Priced at $250,000 and up, these paintings are the product of established, well-recognized names in the art world whose works have won numerous awards and are featured in private museum shows. These artists are deceased, ensuring that the supply of their work is limited. Blue-chips are favored by the UHNWIs who engage consultants and regularly participate in major auctions.

Mid-Career Living Artists - Equivalent to a growth stock in securities, the works of this group have been recognized with awards and are usually found in private collections and a few museums. These artists are represented by the most-respected galleries, and prices for their works start around $50,000 but can reach into the millions.

Emerging Artists - This group is composed of younger artists just beginning their careers whose works typically sell for $10,000 or less. Collectors expect the most significant financial gains will arise from this group if they fulfill their early promise. While their art is not in museums, their potential is recognized by critics and art magazines.

Historical performance:

In 2018, Artprice launched its "blue-chip" Art Market index, Artprice100®, designed for financiers and investors. The new index ignores the most volatile artists (those most subject to the price impact of fashion and speculation) and focuses exclusively on the art market's "blue-chip" artists.

The index essentially identifies the 100 top-performing artists at auction over the previous five years who satisfy a key liquidity criterion (at least ten works of comparable quality sold each year). The weight of each artist is proportional to his/her annual auction turnover over the relevant period. Over 18 years, the Artprice100 grew by 360%, generating an average annual return of 8.9%, empirically showing the profitability of the art market's most stable segment.

The art market's low correlation is driven by demand resilience among the UHNW group, supply scarcity among blue chip artwork, and art's position as a global asset. Consequently, the relative financial insulation of the UHNWs during the COVID pandemic has translated into the continued resilience of the art market broadly, even in the face of significant headwinds elsewhere in the economy.

A Stanford working paper released in 2013, "Does It Pay to Invest in Art?" by Arthur G. Korteweg, Roman Kräussl, and Patrick Verwijmeren, pointed out that paintings with higher price appreciation are more likely to trade, strongly biasing estimates of returns. Looking at the entire art market, not just the market of art that actually sells, the study finds that a more realistic estimate of the returns from art investing is 6.5%, not the 9% found by uncorrected repeat sales regressions.

Value metrics:

Core: Scarcity, Rarity, Provenance, Condition, Historical importance

Unique: Artist, Quality, Subject Matter, Size

Scarcity: It is human nature to want things that others want, and desire them more when they are scarce. The most useful tool in determining just how many paintings an artist made of any particular type is the comprehensive listing of his entire output known as the "catalogue raisonné", which translated literally means "critical catalogue". The publication of a catalogue raisonné has a strong effect on the value of an

artist's work because it defines the supply empirically and provides the basis for reasonable assumptions regarding whether any particular work might be available. All works owned privately, including gifts promised but not yet given to museums, are potentially available, while those works that have been formally accessioned by public museums are off the market. The more works by an established artist that are in public museums, the smaller the supply for the market and the higher the value of those that do circulate.

The factors contributing to value in the art market are not fully understood, but from an economic perspective, the supply and demand for artworks from any particular artist, during his/her lifetime, should affect the price, with demand creating greater outputs, but also due to increase in demand scarcity and thus higher prices. The supply of the best works of art will always be limited and tends to appreciate in value over time, and this is especially true for deceased top artists where there is no new supply and some works are lost or bought by museums and collectors.

Rarity: The rarity of a given work is determined by how many similar examples exist and how frequently such works become available. One unique piece of art is considered more valuable than ten pieces of identical art. Relative availability real or imagined, of a particular artist's work not only justifies the price, but also suggests membership in an exclusive club of ownership, i.e. "The only other one like this is in the Louvre." Even in the contemporary world, where artists are still living, some pieces can be much harder to get than others. Claims of rarity have to be examined carefully because not only do artists often explore specific themes in a variety of media (paint, pastel, pencil, print), but total output varies widely from artist to artist. Monet, who lived until he was 86, painted virtually every day of his life, and produced 2,000 paintings. Van Gogh died at 37 having made 864 paintings. Pollock died at 44 having produced just 382 works on canvas.

There exists a phenomenon of rarity premium that high-net-worth individuals (HNWIs) are willing to pay in order to acquire paintings they view as unique and defined by a set of physical as well as intangible

characteristics. The "hype" in the art market in recent years has pushed up final prices to extraordinary levels, and rarity premium can be used to account for this phenomenon. Facing the risk that a painting will not appear on the market for decades, or perhaps never again, there exists a "rarity pressure" to pay an amount that exceeds the prior estimate. The influence of shrinking inventories combined with increased demand magnifies the effect of rarity over time and also creates a preference for the "spot" good rather than future ownership.

Provenance: Once a work of art has entered the secondary market, it has achieved a history of ownership, called "provenance", a French term for the history of ownership of a valuable object. The degree to which an appealing provenance may actually increase the value of a work is very difficult to determine accurately, but generally former ownership by a celebrated collector, past or present, lends more value to a work of modest or intermediate quality than a great work, which will achieve value on its own merits. The inclusion of an important dealer in the history of a work can significantly augment its provenance value.

A good provenance can also help establish authenticity, art-historical importance and title. Inclusion in significant publications or exhibitions may enhance a work's pedigree by documenting it and certifying scholarly approval.

Condition: Is not a straightforward metric for art, because although the majority of people prefer art pieces in pristine condition, some stylistically prefer pieces to look weathered or aged. Thus, artwork condition preference is determined by the specific owner or market. A certain amount of wear and tear and prior restoration might be expected with any Impressionist painting over a hundred years old, while similar conditions in a Minimalist painting dating from the 1960s might make it unsalable. With some artists or types of work, it may be impossible to find a piece in pristine condition. It is important to interpret the importance of condition in the context of an artist's oeuvre and make a considered judgment about the impact of condition on a given work's value.

The impact of condition on value is also a function of the culture and changing taste. Fifty years ago American buyers of Impressionist paintings liked them to be bright and shiny, which sometimes led to them being over cleaned and heavily varnished. Many galleries and even major museums automatically relined these paintings, gluing a second canvas to the back of the original, often using heat and wax in the process. Today buyers of Impressionist works will pay a premium for paintings that are not relined and have only modest restoration. A condition report itemizing the result of the physical examination of a work of art by a respected professional in the field can serve as a solid way of establishing condition. The stronger the credentials of the professional, the more weight is given to the condition report.

Historical Importance: Refers to the actual historical significance of the artwork itself, which can include an event or date it may have been created to commemorate, such as birth, death or victory; illustrious patron ordering it for himself or as a gift for an equally famous contemporary. Importance can also be viewed in terms of art history importance, i.e. the emergence of a certain style or movement, creative use of new pigments or materials, or a piece showing the transition and growth of an artist from one period to another.

Artist: The identity and reputation of the maker of the piece of art is an integral part of creating value. The best known names in the art world have achieved fame due to a combination of phenomenal technical skills, unique and powerful vision, and revolutionary creativity. A piece attributed to the master himself, or even someone from his school or circle is sure to command outsized value in the market.

Quality: This is the most subjective factor, referring to the distinct characteristics and attributes of the art piece. What many people who spend a lot of time looking at art do agree on is what separates a successful work of art from one that may be merely interesting or typical. Mastery of the medium, clarity of execution, and authority of expression are vital criteria applicable to all works of art, regardless of style or subject.

The art market functions as a big consensus marketing machine, so what people do is look at quality signals. Those signals can be what an important curator is saying about an artist, exhibitions in museums, or influential collectors buying similar works. Because everybody is looking at the same signals, at one point they start agreeing on who are the most desirable artists. Judgments of quality depend on knowledge and connoisseurship. Dealers are skilled at assessing the relative aesthetic merits of a given work, evaluating it both within the larger context of art history and within the specific context of the artist's oeuvre.

While the important works of an artist who achieves great popularity may be of the highest quality, the body of work of most artists includes a range of quality. Picasso mastered many different methods of expression, and in almost every period or style he produced works of mixed quality from the transcendent to the slapdash. Van Gogh agonized over every painting he made, while Renoir, who painted every day of a much longer life, let his dealers sell even his most modest and unsuccessful pieces, as well as his many acknowledged masterpieces.

Subject Matter: Is the scene or image shown on the art. Subject matter varies widely; it can be a simple black canvas or a detailed battle scene. At various times various subject matters were considered more desirable, with religious themes dominating early works, and preference shifting to portraits, landscapes and abstract themes over time. This is also a function of the art type; while for old masters painting a religious theme will be preferred, for a modern one an abstract one would be considered most desirable and valuable.

Size: Generally the bigger the better. There is a direct positive correlation between the size of an artwork and its value. It may indirectly signal the importance of the work, as the artist would have to spend considerably more time, effort and materials to design and craft a large painting and is more likely to make an extra effort to succeed in an important high profile commission.

Top Five highest priced examples

1-Leonardo da Vinci, Salvator Mundi, circa 1490–1500. - $450.3M

Prior to its sale at Christie's, the painting attracted a myriad of owners and price tags over the years: from selling for £45 at Sotheby's in 1958 to a $127.5 million purchase price by Russian billionaire Dmitry E. Rybolovlev in 2005, whose trust sold it at the 2017 auction.

2-Pablo Picasso, Les Femmes d'Alger ("Version O"), 1955. - $179.4M

This piece is one of Picasso's boldest and most notable from a series of paintings he produced between 1954 and 1955. It was in good condition at the time of sale, so it was a special find for anyone able to pay the price. Before the 2015 sale, it had last sold in November 1997 for $31.9 million to a collector from Saudi Arabia.

3-Amedeo Modigliani, Nu couché, 1917–18. - $170.4M

One of Modigliani's most notable paintings, it was produced in 1917 as part of a series of works credited today with the revitalization of the nude form in Modernist art.

4-Amedeo Modigliani, Nu couché (sur le côté gauche), 1917–18. - $157.2M

Produced around the same time as the previous auction record, this and other nudes by Modigliani were strikingly bold and even considered scandalous when they were originally painted.

5-Francis Bacon, Three Studies of Lucian Freud, 1969. - $142.4M

Three Studies of Lucian Freud is a 1969 oil-on-canvas triptych by the Irish-born British painter Francis Bacon, depicting artist Lucian Freud.

Sculpture

Asset class overview

Sculpture is an area of enormous variation, having been a medium for expression since pre-history. Collectors look for sculpture in all kinds of media and most are also valued as decorative pieces in the general market. Many are interested in sculpture for the way in which it occupies three dimensional space. Unlike two dimensional work, sculpture occupies floor space and is something that can be walked around and thus interacted with in a very tangible way. Sculpture generally entails work that has been literally crafted or molded from some kind of raw material. It is the craft skill, so often lacking in other elements of contemporary artistic production, that most impresses collectors.

Historical performance: Historical performance of this asset class closely correlates to the general art market and is rarely broken out separately in major pricing indices. For this reason, we can consider the performance metrics here to be similar to those in the "Paintings" section.

Value metrics:

Core: Scarcity, Rarity, Provenance, Condition, Historical importance

Unique: Artist, Quality, Subject matter, Size

Scarcity: The main thing about sculpture is that there is much less of it around than there is painting, printmaking, and photography. Essentially this means two things, it is harder to source and harder to find a market.

Once an artist whose works have been in demand dies, the price ought to rise, given the fact that no new works will be produced, and thus the scarcity level is increased.

Rarity: If there are multiple editions of a piece, that makes each version worth less, as it is no longer unique. Modern sculptors often create a series of limited pieces, which have built in rarity value due to a finite number are officially allowed. Completely unique classical pieces still command much greater premiums as being one of a kind and have an undeniable allure.

Provenance: As with all works of art, authenticity and ownership history add greatly to the value. The impact of these parameters is similar in magnitude and importance to paintings; the only exception being antique statues, where for obvious reasons exact ownership chain is often impossible to trace, and authenticity harder to prove.

Condition: For ancient and Renaissance works, which were made predominantly from marble and bronze, condition is key, but is somewhat subject to collector tastes. For bronzes, for example, the original patina of a piece will enhance its value greatly, particularly to collectors, so the care and cleaning of (or lack thereof) bronzes is crucial to anyone looking to sell. For marble pieces, the completeness of the piece, as well as quality and clarity of all features is key. In the case of modern sculptures, condition is less of an issue, as most are quite abstract and do not rely on specific materials to make a statement.

Historical importance: Some pieces that have been made to commemorate certain events, individuals or anniversaries carry an additional value due to being an integral and inextricable part of famous lives and historically significant occasions.

Artist: Strongest component of economic value is artworld's recognition of the artist's reputation as an acknowledged master of his craft. In this sense, this is no different from the world of paintings. Famous names translate to high prices.

Quality: Imaginative works, or those that challenged the viewer to look at objects in a new way, are prized in modern pieces. In classical sculpture the degree of artistry that transcends time, including details and movement, capture expressions, is key.

Subject matter: Figural sculpture with multiple components/figures tend to be desirable amongst collectors.

Size: As with paintings, while size does not guarantee a premium on its own, for the same artist a larger piece is more likely to be a more meaningful and powerful work relative to its smaller counterpart and thus command a higher price.

Top Five highest priced examples

1 – L'homme au doigt - $141.3M

Created in 1947 and cast in bronze, Alberto Giacometti created six casts and one artist's proof of the statue, four of which are in museums. Described as Giacometti's "most iconic and evocative sculpture", the auctioned piece is also believed to be the only one hand-painted by the artist, adding an additional level of rarity and expressive impact to the piece.

2 – L'homme qui marche I - $104.3M

The Walking Man is considered to be one of Giacometti's most important works and the pinnacle of his experimentation with the human form. Literally translated to 'The Walking Man', this piece was initially created for a public project by the Chase Manhattan Plaza in New York. After struggling with the project, Giacometti eventually abandoned the commission, taking his unfinished work. Shortly after this he decided to cast this sculpture in bronze and exhibit it, which he did at the Venice Biennale the following year.

3- Chariot –$100.9M

One of Alberto Giacometti's most important works, *Chariot* is a 145 cm tall sculpture that was sold at Sotheby's in 2014. The artist said that the image of the chariot came to him in a dream. The dream probably came from a hospital stay in 1938 where Giacometti saw nurses pushing their pharmacy trolleys around.

4- Rabbit - $91.1M

A 1986 sculpture of a large, silver reflective rabbit by Jeff Koons set a new record for the most expensive work sold by a living artist.

5- The Sophisticated Girl (Portrait of Nancy Cunard) - $71M

This unique work by Constantin Brancusi in polished bronze dates to 1932. Brancusi used Nancy Cunard, a legendary heiress of the roaring twenties, as his muse for the piece.

Classical Collectibles

Cars

On January 29, 1886, Carl Benz applied for a patent for his "vehicle powered by a gas engine". This patent number 37435 may be regarded as the birth certificate of the automobile. In July 1886, the newspapers reported on the first public outing of the three-wheeled Benz Patent Motor Car, model no. 1. In August 1886, using an improved version and without her husband's knowledge, Benz's wife Bertha and their two sons Eugen and Richard embarked on the first long-distance journey in automotive history. Cars in this era were thought to be a novelty item, and were not very useful as a passenger car.

Fast forwarding twenty years, the first production Model T was built on August 12, 1908, and left the factory at the Ford Piquette Avenue Plant in Detroit, Michigan on September 27, 1908. Ford Model T (colloquially best known as "Tin Lizzie") is generally regarded as the first affordable automobile, which made car travel available to middle-class Americans.

Historically speaking, classic cars have been a buoyant, liquid market, but one that requires discipline and deep knowledge of the underlying asset class. There is no fixed definition of a classic car. The common theme is of an older car of sufficient historical interest to be collectible and worth preserving or restoring. The Classic Car Club of America describes a CCCA

Classic as a "fine" or "distinctive" automobile, either American or foreign built, produced between 1915 and 1948. Antique Automobile Club of America (AACA) defines classic vehicles as fine or unusual domestic or foreign automobiles primarily built between and including the years 1925 and 1942.

An antique car is one that is over 45 years old (this is the definition used by the Antique Automobile Club of America). Like classic cars, an antique car should be as close to its original specification as possible, although modern spare parts will be permissible (because of the difficulty of obtaining rare original parts).

A vintage car, as a rule of thumb, is a car that was built before 1925, so it's a car from the very early days of motoring. Within this classification, are very early cars from what's known as the Brass Era, named for the brass fittings that were used as lights or radiators in the automobiles built between 1896 and 1915.

Over the years, investors have found value in various segments of the collector car industry, but there is an inherent risk as trends change and the industry evolves. As Generation X and millennial collectors enter their maximum income-earning years, the cars that are perceived and treated as collectibles are getting younger and younger and that's going to influence pricing for vehicles over the long-term. For younger collectors, who range from the oldest Gen Xers born in the mid-1960s through the oldest millennials born in the mid-1980s there has been a steady growth of younger enthusiasts who have an increased interest in the cars of their generations. Performance cars of the 1970s and 1980s, like the Corvettes, Mustangs, Camaros, Pontiacs, and Buicks, that have multigenerational appeal have all seen a rise in value.

Also rising in the market are some Japanese imports, exotics from the 1970s and 1980s like Porsches, Ferraris and Lamborghinis, and SUVs and pickups, like a 1941 Dodge Power Wagon that sold for $220,000 in 2019. Just like the baby boomers grew up in pickups and station wagons, which continue to be very popular, millennials have grown up with trucks and SUVs, that's

what they are comfortable in and one of the reasons that entire segment continues to grow.

Multiple factors can influence whether a car will become a classic as it ages or will simply be cheap, undesirable transportation. At the high end of the classic car market of more than $1 million, relatively obscure older brands dominate such as Hispano-Suiza and Delahaye, as well as names that are still well-known today, such as Rolls-Royce, Jaguar, Ferrari F40s, Shelby 427 Cobras, Corvette Stingrays, and Aston Martin DB5s, and collectors will pay a fortune for the right model in optimum condition.

Historical performance:

The market for classic cars has done better than collectibles such as coins and stamps over the past decade and has also beaten the broad stock index. Although enthusiasts have traded classic cars for over a century, investors have only been using indices to analyze this market for the past fifteen years or so. The Historic Automobile Group International (HAGI) tracks the collector car market with a number of indices, the broadest being the HAGI Top Index, which tracks vintage collectible cars from Porsche, Ferrari, Bugatti, Alfa Romeo and other brands. The Top Index was up almost 300% over 10 years, equating to about 11.5% annual yield thanks to increasing global wealth chasing a limited number of super-collectible cars.

Value metrics:

Core: Scarcity, Rarity, Provenance, Condition, Historical importance

Scarcity: Hard to obtain cars have a higher chance of appreciating in value. This is one of the most important factors that determine the value of classic cars, but it depends on several other factors to truly work in investor's favor. If the car wasn't popular even when it was new, it's unlikely to be popular among collectors down the road. On the flip side, scarcity can greatly increase the price of a car that was popular in its heyday. Often, older cars

are more valuable because they are scarcer than their newer variants, but this isn't always the case. Sometimes an older car is more valuable than its newer versions because it offers different features that are unavailable in their newer versions. This is the case with many older vehicles produced before modern emissions standards came into effect, which are generally more powerful than ones produced after this period.

Rarity: Is the big driver of classic car values. Knowing how many examples of a particular make, model, and year, were produced and how many are left can help estimate how rare a particular one is. Some of the most valuable cars in existence were produced in limited runs of just a few hundred vehicles or less. A car might have been produced in massive quantities but has a poor survival rate, making it rarer today than other cars that are traditionally considered rare, making it rarer than those built in much smaller numbers but with a high survival rate.

Year, make, model, production total, engine type, transmission type, interior color and paint color are all parameters that combine to define the rarity of a particular car. Limited production luxury vehicles in pristine condition, highly popular, less expensive vehicles where only a few are left can be very valuable, and extremely rare vehicles, even in rough condition are all cases of cars that may hold great value. Generally, an older version of the same make and model is worth more. Best bets are limited-production edition of a luxury or performance model that's currently popular and has a track record of being in-demand. One caveat is that the rarer the car, the higher the costs will be for parts and labor when fixing the car and maintaining it.

Top Five rarest:

1. Rolls-Royce 15 HP

The rarest car in the world today is the 1904 Rolls-Royce 15 HP, the first ever vehicle made by Charles Rolls and Henry Royce, back in 1904 in

Manchester. From six of those cars produced, only one still exists and you can see it in touring museums and automotive shows around the world. This first vehicle produced by this now famous luxury car manufacturer could reach the speed of 62 km per hour and marked the start of Rolls-Royce history.

2.1969/1970 Dodge Hemi Coronet R/T Convertible

With just four produced over the course of four years, the Dodge Hemi Coronet R/T Convertible is one of the rarest American muscle cars in the world. Only four of those cars were ordered with a 426 ci Hemi V8: two in 1967 and two in 1970. Even though there is nothing that makes this vehicle extraordinary in terms of appearance, compared to the normal Coronet convertible its scarcity is more than enough for it to be famous among car collectors.

3.Porsche 916

The 916 is one of the rarest vehicles in the world today. Produced in 1972, only 11 cars of this model were made and they were all prototypes. This model wouldn't have been so rare today if its price back then was not as high as $14,000, compared to $11,000 for a 911 of the same year.

4.Talbot Lago Grand Sport

Introduced in 1948, the Talbot Lago Grand Sport had two versions - racing and luxury. Only 12 cars from the luxury version were ever manufactured, which makes this vehicle extremely scarce and therefore of high interest among classic car lovers and collectors.

5.1921 Helica de Leyat

On the day that the 1921 Helica came out, the newspapers called it 'the plane without wings'. Made in France and designed by the French automobile manufacturer, Marcel Leyat, the 1921 Helica is famous for its extraordinary looks and originality. What makes this car absolutely unique is that it is powered by a huge propeller that resembles that of an aircraft,

rather than a normal engine. Only 30 of this 1921 Helica model were produced because of the model's unusual appearance and dangerously high speed. Currently all of the remaining Helicas are in private collections.

Provenance: Documents showing the vehicle's previous owners, maintenance and travels provide insight into how original the car is and how well it was maintained. A racing history adds to a car's allure, as does historical importance of models that pioneered new technology or raised the bar for consumer expectations. Association with a respected designer, racer or builder or prior celebrity ownership, especially if the individual is associated with cars, such as Steve McQueen, Paul Newman, or James Garner also helps increase value.

Condition: The vehicle should be roadworthy, the body should have no rust, the interior should be intact without tears in the upholstery, flooring or header fabric, the engine should run, and the car must match the original factory design as closely as possible. Other factors influencing value include the number of miles on the odometer and the amount of original equipment. For antique cars, the closer it is to pristine original condition, the more expensive it is. However, classic cars that have been restored to showroom-new condition using original or exact recreations of parts, paint, and bodywork could also be almost as valuable as one that is in original condition. A fully restored classic car is going to sell for a much higher price than one which is only partially restored.

Historical importance: In case of cars this metric is generally related to a particular model being the first one to have a certain feature, technology or functionality. Cars winning major races, driven by famous drivers or being the first of their kind to debut a feature or technology also benefit.

Top Five highest priced examples

1-1963 Ferrari 250 GTO, $70M

The Ferrari 250 GTO is the holy grail of car collectors and the one that won the 1964 Tour de France was sold to the founder of WeatherTech in 2018

in a private sale. Just 36 units were built between 1962 and 1964 to conform to strict racing regulations at the time and each buyer was personally approved by Enzo Ferrari. A 1962 record-breaking Ferrari GTO driven by Edoardo Lualdi-Gabardi to victory in the 1962 Italian GT Championship and one of seven with Series II coachwork sold earlier for $48.4 million.

2-1957 Ferrari 335 S Spider, $38.3M

Only four of these cars were ever made, contributing to its stratospheric price tag. Ferrari's workshop equipped the model with a 4.1-litre V12 engine, giving it a massive 400 horsepower and enabling it to reach a top speed of 190 miles per hour—unheard of at the time. The fact that it was driven by some of the world's best drivers including British Formula 1 champions Mike Hawthorne and Stirling Moss increases the price.

3-1956 Ferrari 290 MM, $30.45M

The MM in the Ferrari 290 MM stands for the Mille Miglia, a race for which it was designed and one that it won in 1956. Only four were made; three still exist. When Sotheby's put one of them up for sale in 2015, it sold for $28 million. Another 290 MM sold for $22 million in 2018.

4-1967 Ferrari 275 GTB/4S NART Spider, $30.38M

Out of its original planned production line of 25, only 10 of these Spiders were ever made. What makes this NART Spider so valuable is the car's unique blend of late-1950s Ferrari styling and advanced mechanical features. Almost the entire Maranello racing technology suite was applied to the NART Spider.

5-1954 Mercedes-Benz W196 Formula 1, $29.6M

Chassis number 00006/54 driven by Juan Manuel Fangio himself is the only example in private hands. Mercedes 2.5 liter, straight 8 was designed for direct fuel injection as used on the famous ME109 fighters of the

Luftwaffe. These cars totally dominated racing in the mid-1950s until the spectacular accident at Le Mans in 1955 killing 83 spectators in the deadliest crash in motorsport history.

Motorbikes

The first internal combustion, petroleum fueled motorcycle was the Daimler Reitwagen designed and built by the German inventors Gottlieb Daimler and Wilhelm Maybach in Bad Cannstatt, Germany in 1885. In England, Excelsior Motor Company, originally a bicycle manufacturing company based in Coventry, began production of their first motorcycle model in 1896. The first production motorcycle in the US was the Orient-Aster, built by Charles Metz in 1898 at his factory in Waltham, Massachusetts.

In the U.S., Indian began production in 1901 and Harley-Davidson was established two years later. By the outbreak of World War I, the largest motorcycle manufacturer in the world was Indian, producing over 20,000 bikes per year, but by 1920, Harley-Davidson was the leader, with their motorcycles being sold by dealers in 67 countries. In the 21st century, the motorcycle industry is mainly dominated by the Indian motorcycle industry and by Japanese motorcycle companies. In addition to the large capacity motorcycles, there is a large market in smaller capacity (less than 300 cc) bikes, mostly concentrated in Asian and African countries and produced in China and India. Top modern motorcycle companies are American Harley Davidson; Italian Ducati, Moto Guzzi and Aprilia; German BMW and KTM; Japanese Honda, Yamaha, Kawasaki, and Suzuki, and British Triumph.

Nostalgia is driving up the value of classic motorbikes, as a new class of collector vies for the models that eluded them in their youth, because globally, most motorcyclists are in their fifties and their children are leaving home. The classic car market has become a little flat, and classic car investors are also turning their

attention to classic motorcycles. Large number of classic car owners have motorcycle licenses but haven't really taken advantage of them. They have come to see bikes as being complementary to their cars and, because of their relative affordability, buy one or two to go in the garage and possibly to use occasionally. They are discovering they can fit five motorcycles into the same space as one classic car, which while not a primary purchase driver, is a consideration.

China, the largest motorcycle market on the planet, banned importation of classic motorcycle in 1997 to stimulate home grown motorcycle manufacturers. But since the 1st of January 2016, the country allowed import of classic motorcycles, wherever they are built. This will have a profound effect on the market, as everyone started their mobile life on a motorcycle in China. Investors in China are aggressively turning to this tangible asset, just as they have with other such markets.

Investing in classic motorcycles is very similar to investing in classic cars, however there are less vehicles available. The classic motorcycle market is about fifteen years behind the classic car market but it is starting to catch up quickly. Classic cars from the 1970s and 80s have been outperforming property and all other tangible assets over the last ten years according to Knight Frank's wealth report. Classic motorcycle prices of Japanese and Italian machines from this era are still about ten years behind those of classic cars. Many investors are starting to move from cars into motorcycles, driving prices upwards very quickly. Unlike classic cars, there is no left or right hand drive with classic motorcycles, which offers unfettered, full access to a truly global market. In addition to lower barriers, classic bikes offer other investment advantages compared to cars, more affordable, not needing as much storage space as cars, and maintenance more economic. They also tend to depreciate less due to the eventual use.

Historical performance: The returns in this fairly new asset class are hard to pin down, although there was an index launched by HAGI few years ago to track the space. For the purposes of conservative estimate, we can assume that the returns are similar to those of the classic car space, with a mental note to adjust up.

Value metrics:

Core: Scarcity, Rarity, Provenance, Condition, Historical importance

Scarcity: Is created by several factors, such as existing cult following, a machine that is high performance or a racing model with similar ones already showing up in important collections. There are a lot of classic car buyers looking to the undervalued classic motorcycle market, as they become aware of the value offered and the small number of vehicles available. The motorcycle market is not yet as known or crowded, but even a small portion of the buyers from the car world diversifying into motorcycles will easily push the prices of the most desirable classic motorcycles up much higher than the equivalent classic cars.

Rarity: To determine the degree of rarity, it is necessary to know the number made of a particular series of machine, whether the bike in question is a common or a rarer model, and whether any unusual finishes or colors were used. Year, make, model, production total, engine type, and paint color all need to be considered to determine how rare a particular specimen is.

Top Five rarest:

1-1916 Traub

This one specimen was found inside a building wall in Chicago in 1968. There are no leads as to who built this all-wooden 1000cc motorcycle and why they left it. But it is a machine that was way ahead of its time.

2-2020 Aprilia RSV4 RR Misano

The Aprilia RSV4 RR has a limited edition that is named after the Misano race track, where the manufacturer saw more than a few wins since 1987. Only 100 of these V4 superbikes will ever hit the road. So far, only three have been sold to anonymous buyers around the globe.

3-2013 Ducati 1199 Panigale S Senna

Ayrton Senna was a legend in Formula One and his tragic loss in 1994 was commemorated by many high-end manufacturers. Although 161 of these saw a limited-production run, the exclusive trim with red wheels was only built for a privileged few.

4-1989 Suzuki Bandit 250 Limited

The Suzuki 250 Bandit was something of a sensation for naked bikes. The Limited trim was equipped with upgraded exhaust and brakes, with no more than five exchanging hands in the last three decades.

5-1988 Kawasaki KR-1

The 1988 Kawasaki KR-1 became a legend the instant it left the production line. Altogether, less than 10,000 bikes of the KR series were produced. The 1988 KR-1 are close to extinct, with only six of these left in their pristine condition today.

Provenance: The story is everything, since it is the life of the machine, it is important to know who owned it and for how long. In the case of competition models, sporting success is certainly an endorsement of higher prices. All documentation supporting the vehicle's history is important from photos and press releases to receipts, certificates, and storage and maintenance records.

Condition: As with cars, if the vehicle was rarely used, has very low mileage and been well maintained with all original parts, the value will be the highest. If a bike is not original, its value diminishes considerably. It is extremely difficult, and expensive, to locate original components, and unless the machine is fully restored the value will decline.

Historical importance: If a bike competed favorably, or even better, won an important race or was driven by a racing legend, then it will be extremely attractive and command the highest prices.

Top Five highest priced examples

1 - 1951 Vincent Black Lightning -$929,000

This particular 1951 Vincent Black Lightning, one of only 19 surviving, was in its original form, completely unrestored and in healthy running condition.

2 – 1915 Cyclone Board Track Racer-$852,500

Only 12 Cyclones are known to exist, and this one was owned by Steve McQueen. The bike's remarkable design was bleeding edge at the time, Cyclones were rare even in their day, let alone one in such pristine condition a century later. Another example was sold for $551,200.

3-1907 Harley-Davidson "Strap Tank" Single -$715,000

This bike is one of the first 100 Harley-Davidsons ever built. Its serial number suggests it was the 37th bike made in 1907, making it the 94th Harley-Davidson overall, including the original two prototypes. It comes with an elegant patina that takes a 100 years to perfect, and all of its parts are original and in fantastic condition for a motorcycle of its age.

4- The 1942 Crocker V-Twin Big Tank – $704,000

Crocker, a company based in California, only produced 72 V-twin motorcycles and this example was one of them. Interestingly, this model was lucky to exist at all, since Crocker was actually limited to wartime restrictions and was unable to manufacturer any more models thanks to the war effort.

5- 1929 Brough Superior SS100 'Alpine Grand Sports'- $492,973

Vintage example in Alpine Grand Sports specification, boasting matching registration, frame and engine numbers – designed to honor the legendary Alpine Trial. Prior examples sold in November of 2012, in pristine condition with the correct engine and frame numbers, a record card from

the factory, and a full and well-documented ownership history went for $452,234 (£280,800), and before that in October 2010 for $448,156 (£286,000).

Watches

The timepiece has remained a constant companion to man from its initial invention. For decades, watches have been symbols of luxury, wealth, and personal taste. While it has changed drastically over time, a watch still demands intricate components and time to make, thus making it a valuable item. The first known wristwatch was made for Napoleon Bonaparte's sister Caroline Murat in 1810 by Swiss company Abraham-Louis Breguet. It started a 19th Century fashion for so-called wristlets – pocket watches that were adapted to be bracelets. Men who dared to wear these fashion accessories were ridiculed as 'wrist-watch boys' – effeminate dandies. Pocket watches were deemed impractical in the trenches, and manufacturers such as Rolex, Cartier, Omega and Longines adapted them to make wristwatches. The First World War turned the wristwatch into a military, practical tool designed to save lives; the phrase 'synchronize your watches' was coined for Armed Forces maneuvers.

In the last few years, a combination of investment potential and collector enthusiasm has led watches to become a thriving market, with an ever growing number of interested buyers. The industry expanded to include not only multimillion-dollar offerings, but also options at lower price ranges accessible to young and upcoming collectors. Timepieces are in a unique position against any other physical product in the known world. It is the only product with new and older models both increasing in price, despite the older model still being produced and superseded. When looking for a watch that will retain its value over time, it is important to look to the past and evaluate brands that have continued to perform throughout generations.

There is a very limited number of watch brands and models that will see an increase in value based solely on their scarcity or because they are recognized as proven classics.

Two luxury watch brands that lead the pack in producing future collectibles are Rolex and Patek Philippe. Many people like Rolex because its products function similarly to a stable currency; it's been said that you can trade your way home from anywhere in the world with a Rolex watch. A Patek Phillippe is considered more of a family heirloom, to be treasured and passed down to next generation for safekeeping, but it also commands global recognition and timeless appeal in stark contrast to modern smartwatches that become virtually worthless in a few years as new software developments make them obsolete.

Rolex is one of the most celebrated luxury brands of all time, recognized almost everywhere in the world, and has become synonymous with success and accomplishment. Its decades-long marketing strategy managed to position Rolex products not as mere tellers of time, but as trophies worn by winners. The company was originally founded as Wilsdorf and Davis by Hans Wilsdorf and Alfred Davis in London, England in 1905. Hans Wilsdorf died in 1960 and left no heirs, so a non-profit private trust (Hans Wilsdorf Foundation) owns and runs Rolex and its sister brand Tudor, reinvesting most of its earnings without the need to placate any short-term-minded shareholders. The company has vertically integrated itself over the years, meaning that almost everything imaginable required to design, prototype, manufacture, assemble, test, and service watches is done in-house.

Patek Philippe is one of the oldest watch manufacturers in the world with an uninterrupted watchmaking history since its founding. It produces ultra-high-end watches in much lower quantities, often packed with complications and fitted with intricately finished mechanical movements. Some Patek Philippe models even require an application process before purchasing, whereby only the most loyal customers are granted access. It was founded by a Polish watchmaker Antoni Patek and his partner Franciszek

Czapek as Patek, Czapek & Cie in Geneva on May 1, 1839. Patek Philippe has been owned by the Swiss Stern family since 1932, when Charles Stern acquired the company during the Great Depression. The firm popularized complications such as perpetual calendar, split-seconds hand, chronograph, and minute repeater in mechanical watches.

Aside from Rolex and Patek Philippe, Omega, Audemars Piguet, and Richard Mille have been thriving in recent years. The Omega Seamaster is widely known for being the James Bond watch, and the Omega Speedmaster Moonwatch made history as the first watch to be worn by an astronaut on the moon during the Apollo 11 voyage. Audemars Piguet Royal Oak has seen a steep increase in value over the course of the last five decades, and now this watch is one of the biggest icons in the luxury watch industry. Richard Mille, "the Hermes of watches" makes only 4,000 pieces a year, consistently goes up in value on the resale market, with some $100,000 models going up 20% to 30% every few months. Other top brands include F.P. Journe, Richard Mille, Vacheron Constantin, A. Lange & Sohne, Jaeger-LeCoultre, Breguet, Blancpain, Piaget, and Roger Dubuis. Luxury watches, for the people who love them, are more than fancy timepieces. They're also specimens of precision and craftsmanship and, if you pick the right ones, good investments. The watch market partly operates on an emotional level, which is why there is no precise formula for investing in timepieces.

Historical performance: The top end of this asset class has seen a steady and robust growth over time, and it is fully reasonable to expect that to continue. While there are not many reliable indices that reflect the market, a reasonable conservative assumption would be to expect 5-10% yearly appreciation from a group of top models from top brands.

Value metrics:

Core: Scarcity, Rarity, Provenance, Condition, Historical importance

Unique: Brand

Scarcity: Making a watch is a very time consuming process with extremely strict craftsmanship rules that requires entire teams of watchmakers and craftsmen to be involved in the creation of one single timepiece, bringing to the table skills such as enameling, engraving, setting gems and decorating dials. Due to these demanding standards and the degree of skill required, the supply of top models is understandably very scarce, and thus unable to keep up with constantly growing demand, putting continuous upward pressure on new and older pieces.

Vintage mechanical watches contain more than a hundred parts – mainspring, wheels, gears, levers and an escapement to help maintain the movement balance. There are also often a variety of jewel-lined bearings – used to reduce friction between the moving parts, thereby keeping the timepiece ticking along smoothly. Watches featuring complications beyond the simple display of hours, minutes, and seconds, are highly complex and require expert level craftsmen to create them. A typical date-display chronograph complication can contain up to 250 parts, while a complex complication watch may have over one thousand parts. The more complications in a watch, the more difficult it is to design, create, assemble, and repair.

Rarity: Unique dial or other design characteristic, small production number, and limited edition all make a specific watch rare. While most of the rarest watches in the world are predictably made by Rolex and Patek Phillippe, there are other known brands that produce spectacular limited edition timepieces worthy of praise. Watches that were manufactured by brands no longer in production have a notable financial value due to the small number of models that will now be in circulation. Tourbillon, a minute repeater and a perpetual calendar with moon-phase display are the three complications most highly prized by serious collectors of high-end watches.

Contrary to popular belief, watches made from precious metals aren't always the most valuable – the value of a watch depends on the scarcity and rarity of the materials used. It is important to recognize which materials are no

longer in circulation as watches that use such materials are rarer and therefore more valuable. For example, for watches produced after 1985, platinum is the most desirable material followed by a variety of different golds.

Provenance: Being seen on the wrists of a celebrity can do much to boost the demand of a luxury timepiece. For investors, that translates to higher returns, especially if they purchased their timepiece before the celebrity boosted its popularity. Watches that are associated with a compelling story often end up being more saleable than others. The best case scenario for a buyer is a 'box and paper' purchase, meaning that the timepiece's original papers and packaging are all included, authenticating its history and value. The original papers date the timepiece, like a birth certificate and Rolex, unlike many other watch brands, issues such papers with each timepiece. Rolex also has a reference number on every watch and Patek Philippe can even trace all cases and movement numbers to confirm if the watch was restored by their approved specialists.

Condition: Is a very important component of the watch's value. Collectors want a watch that has been looked after and had minimal refurbishment, with any servicing done by a competent watchmaker. A timepiece's true condition can be difficult to assess. Minor scratches, which can be carefully and safely removed, are not a major concern, but it is important to closely look at feel and shape of the watch, as well as to determine if there are any signs of a thinning or softened exterior. Another important consideration is how often the piece has been polished. Polishing might give the appearance of a new watch, but the exterior could become thin and softened as it must be ground away to the level of the deepest scratches, causing them to disappear and changing the original character and shape, thus diminishing its value.

The timepiece's originality is another important consideration to make when investing. While brand new hands or dials may appear beautiful and desirable, collectors seek originality above all other considerations. Thus a

piece must be as original as possible, even if it does not shine quite as brightly as a piece with brand new components. Over the years watches can be subject to wear and tear damage, but collectors prefer watches that show their honest age and originality such a faded patina on the watches dial and luminous paint on the dial and hands.

Historical importance: There are many watches directly associated with iconic events such as the moon landing for Omega Speedmaster, for example. Other watches that have been worn in unusual circumstances, made to commemorate a certain historically significant event, or are the first to feature a certain complication or feature also become part of history.

Brand: How popular a brand is matters a great deal for the value of the watch. No matter how exquisite the craftsmanship, the value of a watch over time depends on how much demand there is for it. For this reason it's best to stick to the brands that are known as being investor-friendly, i.e. well-known names like Rolex, Patek Philippe, Omega, Audemars Piguet, Vacheron Constantin, Ulysse Nardin, Jaeger-LeCoultre, Breguet, Blancpain, Panerai, F.P. Journe, Richard Mille, A. Lange & Sohne, Piaget, and Roger Dubuis.

Top Five highest priced examples

There are a number of spectacular watches, whose value derives from being works of art and jewelry, as opposed to mechanical marvels. They are not included in the overall rankings in order to keep the representation pure, but it is still interesting to note them and the stratospheric prices they command.

Graff Diamonds Hallucination - $55M

Graff Diamonds The Fascination - $40M

Jaeger-LeCoultre Joaillerie 101 Manchette – $26M

Chopard 201-Carat Watch – $25M

Jacob & Co. Billionaire Watch – $18M

There are also some outstanding examples of pocket watches, which are absolute mechanical marvels, but should not be compared to modern wristwatch examples, as they represent a special and somewhat archaic variation.

Breguet No. 160 – $30M

The original version of this watch was allegedly commissioned for Marie Antoinette by one of her lovers. Abraham-Louis Breguet began working on the watch in 1782, and Marie Antoinette was executed before its completion in 1827 by Breguet's son. The watch included every known complication at the time, including a thermometer, chime, and perpetual calendar.

Patek Philippe Supercomplication – $24M

This gold pocket watch was created in 1933 by Patek Philippe for banker Henry Graves Jr. The watch took five years to design and build and features 24 complications, including a perpetual calendar, sunrise and sunset times, and a celestial calendar from Graves' apartment on Fifth Avenue in New York.

Vacheron Constantin 57260 – $10M

Including 57 complications, 2826 individual components, and 242 jewels, Vacheron Constantin's 57260 watch is a technological and artistic feat. This watch took 8 years to design and create, and is estimated to have been commissioned for $10 million for a private client.

The wristwatch list is below, with three of the top five examples being Patek Phillippe and two Rolex:

1-Patek Philippe Ref. 6300A-010 Grandmaster Chime - $31.2M

This is a unique stainless steel version of a timepiece introduced in 2014 to mark the watchmaker's 175th anniversary. The double-face reversible watch boasts 1,366 movement components and 214 case components and features 20 complications, including a perpetual calendar, a minute repeater, a second time zone, a leap year cycle and esoteric chiming mechanisms known as grand and petite sonneries.

2-Paul Newman's Rolex Daytona – $17.8M

A gift to Paul Newman from his wife actress Joanne Woodward. Art deco in style, the 1968 Daytona reference 6239 was engraved with "Drive Carefully, Me" by wife and actress Joanne Woodward. Paul went on to gift the watch to his daughter's boyfriend at the time, who donated a sizable amount of the sale to the Nell Newman Foundation.

3-Patek Philippe Ref. 1518 – $11.1M

Patek Philippe produced the 1518 model in 1941, making it the first perpetual calendar chronograph wristwatch ever produced in a series.

4-Patek Philippe Ref. 2523 - $9M

A unique 18k pink gold two-crown world time wristwatch with 24-hour indication and double-signed blue enamel dial manufactured in 1953. The watch is the only known reference 2523 to feature both Patek Philippe's signature and that of the prestigious Milan retailer Gobbi.

5-Rolex Cosmograph Daytona Ref. 6265/9 "The Unicorn" - $5.9M

For one lucky customer, Rolex created a one-off unique masterpiece – a Cosmograph cased in 18K white gold. This watch with black dial and bark finished bracelet was manufactured in 1970 and delivered in 1971, made upon special order for a German retailer.

Alcohol

Wine

The earliest known traces of wine are from Georgia (c. 6000 BC), Iran (Persia) (c. 5000BC), and Sicily (c. 4000 BC). Wine reached the Balkans by 4500 BC and was consumed and celebrated in ancient Greece, Thrace, and Rome. Excavations at a site in Greece called Dikili Tash have revealed grape pips and empty skins, direct-dated to between 4400–4000 BC, the earliest example to date in the Aegean. By the Roman period, and likely spread by Roman expansion, viticulture reached most of the Mediterranean area and Western Europe, and wine became a highly valued economic and cultural commodity. By the end of the first century BC, it had become a major speculative and commercial product.

In medieval Europe, the Roman Catholic Church supported wine because the clergy required it for the Mass. Monks in France made wine for years, aging it in caves. Later, the descendants of the sacramental wine were refined for a more palatable taste. This gave rise to modern viticulture in French wine, Italian wine, and Spanish wine, and these wine grape traditions were later brought into the New World.

Today, for anyone who knows wine, French is the must-have and French Bordeaux is the absolute pinnacle of that category. The history of the Bordeaux wine region dates back to the ancient Romans who brought the first vines to France in around 500 BC. The apex is the "Premier Crus", or First Growth wines, based on a classification system begun in 1855 that

created a ranking of importance and that's still in place today with only five brands on the list: Haut-Brion, Lafite-Rothschild, Latour, Margaux, and Mouton Rothschild, which was elevated from Second Growth to the status of a First Growth in 1973.

The fine wine secondary market hovers at about $5 billion, a fraction of the $302 billion global wine market. It is global in terms of demand, but the supply of investment grade wine is concentrated to a few key areas and extremely limited, with approximately 50 producers worldwide considered to be investment grade wine, about 1% of all wine that is produced in the world. The vast majority comes from noted European wine regions, chiefly Bordeaux, Champagne, Burgundy, and Rhone in France, and Tuscany and Piedmont in Italy. A handful of Spanish, German, Austrian, American, and Australian vintners produce investment-grade wine as well.

Wine is not typically a fast turnaround investment. Once you invest, expect to wait a minimum of five years before selling. For a short term portfolio the en primeur market, which refers to the opportunity to invest in wines while still in the barrels, is an interesting option. Wine experts recommend buying en primeur for wines with very limited quantities and that will become unavailable/difficult to buy after they are released.

Rapid economic growth in Russia, China, India, and other areas of the developing world has dramatically expanded the ranks of the wealthy there. These newly empowered elites see wine both as a legitimate investment and as a status symbol, driving global demand. Fine wine is considered a "Veblen good", meaning that as the price rises the demand will increase as well, seemingly contradicting the basic law of supply and demand. Other items typically classified as Veblen goods include fine art, sports memorabilia, and classic cars. Fine wines are a status symbol because everything that went into a certain wine, like weather conditions, year produced, and production methods can never be replicated.

One example of the best of the best is the world's most expensive wine, Domaine de la Romanee-Conti (DRC), which sells for about $19,000 per

bottle. It comes from a single vineyard of the same name in the heart of the Cote d'Or in Burgundy. The vineyard encompasses just 4.47 acres of Pinot Noir vines, and this small size combined with low-yield, high-quality grapes results in a wine that's forever in demand.

Historical performance: Wine has been a remarkably strong asset class historically, and this trend is continuing. The best performing wines Liv-Ex index increased by an average of 147% over a 10 year period for a 9.5% annual return, and as demand grows and supply remains the same or dwindles, these numbers are only likely to improve. In 2008, in the midst of the financial crisis, the Liv-ex Fine Wine 1000 dipped just below a 0% annual return, as the MSCI World Stock Index plummeted to a negative 38% return.

Value metrics:

Core: Scarcity, Rarity, Provenance

Unique: Region, Vintage, Age, Brand, Rating

Scarcity: A wine that is in limited production is a good indicator that the wine will maintain its scarcity. All investment-grade wine labels are constrained by limited production, primarily as a result of the restrictive classification system and zoning laws imposed upon the top wine producers. Few investment grade wines are produced in quantities above 20,000 cases (one case is equivalent to twelve 750 ml bottles).

Rarity: Rarer vintage wines are more preferable than more common vintages because they're more sought after. As wine is a consumable good, when some of the top bottles are opened (which admittedly does not happen often), the remaining ones become even rarer.

Top Five rarest:

1- 2004 Penfolds Block 42 Kalimna Cabernet Sauvignon Ampoule

With just twelve ampoules released in 2012, the 2004 Penfolds Block 42 Kalimna Cabernet Sauvignon is the rarest wine you can buy. Block 42 from the Barossa Valley is a rare wine, with Penfolds having released it just a handful of times since 1953. The Ampoule, with its exquisite detailing and craftsmanship, makes this rare wine even rarer.

2-Egon Muller Scharzhofberger Riesling Trockenbeerenauslese

The Egon Muller Schartzhof winery produces this sweet wine in select years. If the harvest isn't exceptional, Scharzhofberger Riesling Trockenbeerenauslese doesn't make an appearance. This uncommon yet exceptional wine first appeared in 1959 and sells on average for $13,500, putting it near the top of the world's most expensive wine list.

3-Massandra Sherry de la Frontera 1775

In 2001, a bottle of the Massandra Sherry de la Frontera 1775 was sold at a Sotheby's auction for $43,500 in London, making it the most expensive bottle of Sherry in the world. The wine was produced by the Massandra Winery, located in the Republic of Crimea, which is home to an extensive collection of valuable Russian and European wines. In 1922, after the Russian Revolution, the winery was nationalized and its cellars became a protected institution.

4-Rüdesheimer Apostelwein 1727

The Apostelwein 1727 comes from the famous 12 Apostles' cellar in the Bremer Ratskeller located in Bremen, Germany. The wine comes from 12 barrels of wines in vintages of 1683, 1717, and 1727, which were reduced in number due to evaporation – when there was only one barrel left, the wine was bottled in the 1960s. The most expensive bottle of the Apostelwein 1727, valued at $200,000, belongs to the Graycliff hotel in Nassau and is

one of the most rare wines in the world. The wine is supposedly still drinkable due to its high sugar content.

5-Tokaji from the Royal Saxon Cellars 1690

This bottle of Tokaji, dated between 1650 – 1690, was sold for an undisclosed amount in a 1927 auction that took place in the Saxon capital Dresden. During the auction, 62 bottles of Tokaji from the Royal cellar of Augustus II were sold. This wine is believed to be the oldest intact Tokaji bottle and was certified as authentic by the Foundation of the House of Wettin, which administrated the heritage of the former Saxon monarchy.

Provenance: Components of provenance are certificate of authenticity from the winemaker, long-term ownership and storage records including graphs of temperature and humidity conditions over time, and analysis confirming that what's in the bottle matches what's on the label. Full sealed case in its original packaging is more likely to bring in a higher profit in most instances, unless this is a wine of which there are only a few bottles in circulation. In 2017, for example, a single, specially-created bottle of California cabernet sauvignon sold at auction for $350,000. Cases of wine need to be in their original wooden case (OWC) and form a complete set, as opposed to an assembled case of wines made up of bottles from various sources. Verifiable provenance makes the difference between a wine that's worth $2,000 and one that's worth $20,000 or more.

Region: Regions that have a reputation for consistently producing high-quality vintages will result in wine investments that carry a higher price point. Trends in wine investment can influence which regions are "hot" at any given time, but Bordeaux's dominance has eroded over time from 95% of trades in 2010 to about 60% today, according to Liv-ex. Burgundy comes next, followed by Champagne, Tuscany, Piedmont, and the Rhône valley.

Vintage: Is a major factor why certain wines rise in price while others remain at typical market value. Grapes from exceptional vintages have exceptional qualities, where everything comes together in harmony to create an exquisite wine: weather

conditions, grape composition, soil quality, ambient temperature, sunlight and terroir. When it comes to Bordeaux wines, there is a distinction between left and right bank chateaus, with slightly different years producing the best vintages, and also between recent and ancient vintages that are more than 50 years old.

For example, for wines from the Left Bank (Margaux, Pauillac, Saint Julien, Saint Estephe, Pessac Leognan and Haut Medoc) for the past 30 years, the top five vintages are 2009, 2016, 2018, 2010, 2015; while the same list for Right Bank wines (Pomerol and Saint Emilion) looks slightly different 2009, 2015, 2018, 2010, 2005. For ancient vintages a similar story emerges with Left bank top years being 1961, 1959, 1955, 1953, 1949 and Right Bank 1964, 1961, 1959, 1955, 1953.

Age: The idea that wine improves with age dates back to the 18th century, when a series of innovations made extended aging possible, sulfur introduced as a preservative, corks became available to use as stoppers and the production of bottles was standardized in 1775 so that they could lay flat. Fine wine becomes more expensive with age, typically because older wines require decades of aging to reach such complexity. It acquires a characteristic rich taste, which is highly appreciated by true connoisseurs of expensive beverages. The wine must reach peak maturity, often simply described as "peak" or "peaking," at least ten years after bottling and be able to age (while remaining pleasurable to drink) for at least 25 years, with most non-investment wines peaking within one year of bottling. There are four characteristics that define an age-worthy wine: acidity, tannin content, alcohol level and residual sugar. Wines with higher acidity, higher tannin content, lower alcohol level and higher residual sugar tend to last longer.

Brand: Investment-grade wines must be produced by wineries or vintners with impeccable reputations. Generally, this measure favors established wineries over newer entrants. When buying wines from regions other than Burgundy and Bordeaux it is important to buy flagship wines as successful wineries that have made a name for their respective region, as they are more likely to sell 10+ years down the line.

Cru Classé status is a good indicator of brand power. Cru is "a vineyard or group of vineyards, especially one of recognized quality". Grand Cru Classe, the very highest classification of French wine, refers to the Wine Official Classification of 1855 by declaration of Emperor Napoleon III, which states that the wines of Bordeaux should be ranked and given status according to their reputation and/or vineyards which made exceptional wines throughout many years. Haut-Brion, Lafite-Rothschild, Latour, Margaux and Mouton Rothschild are the marquee brands, other notable ones are Cheval Blanc, Ausone, and Petrus.

Rating: Fine wine quality cannot be ascertained before consumption and buyers must rely on expert opinions regarding quality and maturation prospects. Investment-grade wine must be rated "classic" or equivalent by one or more noted wine publications, such as "Wine Advocate" or "Wine Spectator", confirming its superb quality. Wine critics rate wine on a scale from 1 to 100, with "Classic" equating to an average of 95 points or better. Historically, American critic Robert Parker, founder of Wine Advocate, held the greatest influence over the price of wine, where his score 'upgrade' could result in rapidly rising prices. Since his retirement in 2016, several other critics have become increasingly powerful in the fine wine investment world but none possess Parker's former power, and their role now resembles that of equities analysts, prices generally move only when consensus exists. Important names for Bordeaux include Neal Martin and Antonio Galloni (Vinous), James Suckling, Lisa Perotti-Brown (Wine Advocate), James Molesworth (Wine Spectator), Jane Anson of Decanter and Jancis Robinson.

Top Five highest priced examples

1-Domaine de la Romanée-Conti Romanée-Conti Grand Cru $558,000 (second example sold for $496,000)

The Romanée-Conti, with 4.5 acres, is considered their best vineyard and is where the grapes used at the Domaine de la Romanée-Conti Grand Cru

come from. Legendary vines of the Romanee Conti were destroyed by Phylloxera in 1946 and just 600 bottles could be manufactured before the vineyards could sell wine again in 1952. In 2019 a 12 bottle case of 1990 vintage sold for $350,000 or $29,000 per bottle.

2-Domaine Leroy Musigny Grand Cru $551,314

Under the direction of Lalou Bize-Leroy, Domaine Leroy produces some of the best red Burgundies. All of the farming is biodynamic.

3-Screaming Eagle Cabernet Sauvignon 1992 – $500,000

Thanks to the rarity and the small quantities of wine produced from here, the wine has achieved cult status.

4-Jeroboam of Chateau Mouton-Rotschild 1945 – $310,700

Coming from the vineyards of Nathaniel Rothschild who bought the estate in 1853, today these wines are among the most valued in the world. The 'V' in the 1945 label indicates the victory of the Allied forces in the Second World War, and this is considered one of the best vintages of the last century.

5-1947 Cheval Blanc – $304,375

The 1947 Chateau Cheval Blanc is considered by many to be the best Bordeaux ever made. Chateau Cheval Blanc is one of the most prestigious winemakers in the world and has been the recipient of the super-exclusive Premier Grand Cru Classe (A) rank in the Classification of Saint-Emilion wine in 2012.

Whisky

The origin of whisky began over 1,000 years ago when distillation made the migration from mainland Europe into Scotland and Ireland with traveling monks. Scottish and Irish monasteries, lacking the vineyards and grapes of

the continent, turned to fermenting grain mash, resulting in the first distillations of modern whisky. The first written record of 'whisky' appears in the Irish Annals of Clonmacnoise, where it is was written that the head of a clan died after *"taking a surfeit* (excessive amount) *of aqua vitae"* at Christmas. Scotland has a long, rich tradition of making world class whisky, with the first known mention of the liquid found in tax records dating back to Exchequer Rolls of 1494 when King James IV of Scotland directed a Scottish bureaucrat to grant "8 bolls of malt for Friar John Cor wherewith to make *aquavitae*." The Latin *aquavitae* became translated into Gaelic as *uisge beatha* and later Anglicized to "whiskey." Given its place in Scottish history as an iconic heritage product, in order to be labeled as Scotch, it must be produced at a distillery in Scotland, aged in oak barrels that remain in Scotland during maturation for a minimum of three years with only Scottish water added to the distillate prior to maturation and bottling. Caramel is the only additive that is permitted, and it is used primarily for coloring. In 1780 there were only eight legal distilleries in operation, but as of 2019, that number stood at 133 Scotch whisky distilleries in Scotland, 126 malt and 7 grain, many operating continuously since the 19th century and 1.3 billion bottles of this world-famous spirit are exported each year.

Scotch whisky is divided into five distinct categories: single malt, single grain, blended malt, blended grain, and blended. However, the market for investable whisky is almost exclusively single malts. The word 'single' in single malt whisky means that the liquid has been produced at one, single distillery. This does not mean that the liquid comes from a single barrel or cask, as usually a very large numbers of barrels are blended together so, a single malt whisky is technically a mixture of different barrels, of varying ages, 'blended' together. The age stated on a bottle speaks of the youngest whisky in the mix. Single malt must be made using only malted barley as a grain that can come from anywhere, but the single malt is defined by the country in which it's made. In Japan, distillers import and use barley from the United Kingdom but if it's distilled and matured at a single distillery in Japan, then it's a Japanese single malt.

Investment in old, rare and exclusive bottles of whisky is booming. Traditional collectors, professional investors, and curious connoisseurs are creating an almost perfect bull market where demand consistently exceeds supply. Some of the most sought after bottles have tiny volumes released globally, so getting hold of them can be a huge challenge, irrespective of one's budget. In October 2019, a private U.S.-based individual, nicknamed 'The Ultimate Whisky Collector', sold one of the world's most impressive collections that featured 394 lots including 467 bottles and nine casks for almost $10 million, the highest amount ever paid for a collection of whisky at auction.

Other whiskeys (spelled with an "e" everywhere but Scotland, Canada, and Japan) have also enjoyed a hefty rise in value. Japanese whisky is the latest discovery for whisky connoisseurs and the growing popularity is leading to increasing prices for the rarest varieties. Japanese distilleries aged stock is currently running dangerously low, forcing some of the most well-known distilleries to discontinue sales of their aged product, as they simply didn't make enough new whiskey 10, 15, 17 years ago. The initial explosion of Japanese whisky started with an award given by legendary whiskey connoisseur Jim Murray in 2014. Up to that point no one paid serious attention to Japanese whiskys, but that changed rapidly in subsequent years.

The World's Most Expensive collection belongs to Vietnam resident Viet Nguyen Dinh Tuan with a 535 bottle collection valued at over $13,900,000 US dollars. This collection of old whiskies was recently confirmed by Guinness World Records to be the most valuable in existence and includes everything from a 1926 Macallan Fine and Rare to one of the oldest Bowmore releases known to exist, and is even more remarkable knowing that Tuan has only been a whisky collector since 1996.

Historical performance: Interest in whisky and therefore its price levels have been on the rise for some time and is currently one of the hottest investment areas in collectibles. The top whisky indices returned 5% last year, but an average of 20% annual profit over the last ten years, a strong trend that looks likely to continue for some time.

Value metrics:

Core: Scarcity, Rarity

Unique: Age, Brand, Rating, Batch

Scarcity: A really good bottle produced at a certain time will never be produced again, and that creates scarcity of a great product. Many leading distillers produce special limited editions of their very finest whisky, which become collectors' items. Distillers themselves have to contend with forced scarcity from aging due to the dual phenomena of "angel's share", a loss of about 2% of the total volume of each given barrel every year due to evaporation, and "devil's cut", where a certain amount of whiskey is absorbed by the wood of the casks depending on the porosity of the wood used.

Each Scotch producing region has its own unique flavor profiles and has its diehard followers, splitting the available universe into even smaller preference based ones and increasing scarcity in each segment. There are six recognized regions: Speyside, Highlands, Islands, Lowlands, Islay, and Campbelltown.

Whiskies from the region:

Speyside: Macallan, Glenfiddich, Glenlivet, Balvenie, Aberlour, Tomintoul, and Glen Moray.

Highlands: Glenmorangie, Dalmore, Tullibardine, Glengoyne, Ardmore, Dalwhinnie, Oban.

Islands: Highland Park Arran, Mull, Jura, Skye, Orkney, Talisker, Tobermory, Jura.

Lowlands: Auchentoshan, Glenkinchie, Strathclyde.

Islay: Laphroaig, Lagavulin, Kilchoman, Caol Ila, Bunnahabhain, Bruichladdich, Bowmore and Ardbeg.

Campbelltown: Springbank, Glengyle, Glen Scotia.

Rarity: The rarer a whisky is, the more collectible it will be. Limited runs that are in short supply or limited editions from established makers tend to be popular. Then there are bottles from so-called "silent distilleries" that have closed down and have been staggering releases of long-kept casks to capitalize on their rarity. Vintages from the 1960s and 1970s or earlier are highly valued, because there are so few of them around. While a single malt whisky can be released with thousands of bottles available, a single cask will yield around 200-600 bottles, depending on the size, which usually makes single cask releases much rarer and more expensive.

Collectible ranges of whiskies are big business with whisky investors. Distilleries deliberately release series of special editions that, across the years, form a collection, and owning a full run of one of those series increases the value of each bottle in the set. In addition, whisky collections can be made up of each year from a specific distillery, each regional type, or even a bottle from every distillery.

Top Five rarest:

1.**Dalmore 62** - The rare whiskey is known to be more than a century old and dates back to the mid-19th century. The decanter that houses the whiskey is made of platinum and crystal, while the wooden mold that is used to create the decanter took over 100 hours to be handcrafted. In May 2020, Dalmore 62 the Mackenzie, and Dalmore 62 the Cromarty were sold for $271,000 each.

2.**Dalmore 64 Trinitas** - A blend of some of the rage vintages, Dalmore 64 Trinitas features whiskeys that are preserved since 1939, 1926, 1878, and 1868. Just three bottles of this precious whiskey are known to have ever been made, out of which only one is available for sale.

3.**Glenfiddich Janet Sheed Roberts Reserve** – Glenfiddich Janet Sheed Roberts Reserve 1955 is made of barley, pear and heather and is quite rare with only 11 bottles of this whiskey known to have ever been made.

4.Springbank 1919 - One of the few bottles of whiskey that is more than 50 years old, Springbank 1919 was once listed in the Guinness Book of World Records as the most expensive whiskey in the world.

5.The Macallan 1926 Fine & Rare - The Macallan 1926 is the oldest and the earliest release of Macallan's Fine & Rare collection. Very few bottles of this vintage are known to be released each year.

Age: The true art of whiskey is in the aging. Introducing the un-aged whiskey to oak barrels, and later finishing aging in some form of wine barrel like sherry or port introduces color, complexity, aroma, and other characteristics as the whiskey seeps in and out of the porous wood. Each barrel will produce different whiskey based upon duration, location, temperature, air, and many other variables. An "age statement" refers to the least amount of time that the whiskey is certified to have aged but it can include whiskeys that have been aged longer.

Whisky doesn't age once it's been bottled, so maturing whisky for longer is certain to increase its value, as aged product is harder to find than standard whiskies. A 30-year-old bottle kept sealed for 100 years will still be 30 years old, which is different from wine which alters over time, so collectors and investors are assured that the flavor won't change as long it goes untouched. It is very stable in the bottle and can easily last a hundred years given proper care. Fill level is a good indication of the condition of bottled whisky, and something to check for when evaluating bottles.

Brand: Whiskey collectors will look for bottles that come from a sought-after brand, as much of the demand is driven by how good the whisky is. Just because a whisky is a collector-aimed, limited edition, doesn't mean it'll keep its value. Bottling from established brands like Macallan, Dalmore, Ardbeg, Bowmore, Highland Park, The Balvenie, or Glenmorangie tend to sell consistently at auction, as well as those of lesser produced Scotches such as Mortlach, St. Magdalene, and Glenfarclas. The top Japanese brands like Yamazaki, Karuizawa, Nikka, Suntory and Hibiki are also solid perennial bets.

Rating: Whiskys that receive stellar marks from multiple recognized critics command higher value. Recently awarded whiskys become more valuable and collectible upon receipt of the award. Whisky is generally ranked on a 100 point system by critics from top publications like Whisky Advocate, where 95-100 is a great whisky and 90-94 points is an outstanding whisky of superior character and style. Ratings below that are not outstanding or investment grade whiskys and are not recommended as investments.

Batch: Whisky is an intricate drink, as it can take very little to change the flavor of the liquid and different batches will offer up different flavors. Each batch of whisky is likely to taste slightly different to the last, meaning that once a specific batch is gone, it'll be near impossible to find a whisky that tastes just the same. The first batch of a certain expression will have different notes to any succeeding it. This does not mean that the main flavor profile will change, but simply that certain notes will be emphasized over others. Scotch's flavor is dependent on the casks it's aged in. There's a wide range of oak casks used for Scotch, most casks coming from either America, used for aging bourbon, or Europe, used for fortified wine. Traditionally, Scotch whisky have used ex-wine casks that were shipped into Britain to be bottled over there, and when the casks were emptied, the Scotch distillers would use them.

The alcohol content is important to consider as it too has an effect on the final flavor. It is a legal requirement that Scotch is bottled at 40% or above, and so most whiskies are bottled at somewhere between 40-50%, and diluted with water to reach that strength. Single-cask whiskies (not vatted from a number of different casks) are very desirable and the value of cask strength whiskies, which are usually 50-60% alcohol instead of the standard 40%, is likely to appreciate more.

The more time whisky spends in the barrels, the more it matures. After the first stage of maturation (called subtractive maturation), the wood from the barrels eventually adds its flavors to the spirit inside of it (called additive maturation). And the longer it ages in barrels, the longer compounds in the

whisky and compounds in the wood interact. Wood behaves more like an ingredient than a tool, imparting nuanced and complex flavors. It affects whisky massively as it ages, and each year will have more of an effect, with a tipping point at around 12 years, but even after that, the flavor will change. The level of char on a cask introduces smoky flavors and affects the amount of tannins in the wood, bringing out more vanilla flavors. Wood filters out sulfur and other chemicals, and so a younger dram will have more of these flavors than an older one.

Top Five highest priced examples

1,2,3. Macallan 1926 60 Year Old Cask 263- $1.9M, $1.5M and $1.1M

The Macallan 1926 from legendary cask number 263 is known as the "holy grail" of whisky. The cask, which was distilled in 1926 and bottled in 1986 following a 60-year maturation period in Sherry-seasoned European oak casks, produced only 40 bottles. Twelve were given to artist Peter Blake to design, and another 12 were set aside for artist Valerio Adami, with one bottle hand-painted by an Irish artist Michael Dillon. The cask 263 batch has produced six record-setting bottles beginning in 1986 when one sold in New York for $6,411, setting the Guinness record for "The World's Most Expensive Spirit." In October 2019, a bottle was sold for $1.9M, with the previous record of $1.5M for the Michael Dillon painted bottle in November 2018, and prior to that another bottle from the same cask sold for $1.1M.

4- The Macallan M - $628,205

The 6 liter bottle of The Macallan M is one of the oldest and most expensive whiskeys in the world, aged in Spanish Oak for 25 to over 75 years.

5-TheMacallan 64 in Lalique Cire Perdue - $464,000

The drink is comprised of three different types of whiskeys from 1942,

1945, and 1946 that are aged in Spanish oak barrels. The decanter that houses this whiskey is unique and was exclusively designed by the iconic French glassmaker Lalique.

Cognac

The term 'cognac' first became known in the early 16th century and referred to wines from around the town of that name in the center of the Charente region that were reduced by distillation in order to preserve them and make them easier to transport. Farmers grew grapes for wines that were shipped along the Charente River in France to the port of La Rochelle, where they were bartered for goods brought in by English, Irish and Dutch traders. Often the weak and acidic wines would become rancid and traders learned to reduce them by boiling them in pot stills. The strong wines were stored in oak casks which enhanced their flavor and gave them color. In those days the distillers sold most of their cognac to buyers who blended and bottled the cognac and sold it under their own names.

Cognac must be from the delineated appellation in western France situated north of Right Bank Bordeaux and south of Pays Nantais Loire running along the Atlantic Ocean and extending eastward toward the Massif Central foothills. Similar to other geographically indicated French products, to be called Cognac, it must be from Cognac. Cognacs produced before the late nineteenth century are completely different from those produced afterwards. An outbreak of the phylloxera vastatrix, a tiny yellow bug which feasts off the roots of vines around 1872-1874 destroyed not just the cognac vines descended from rootstock originally planted in Roman times, but all those across Europe. After much work in America, a phylloxera-resistant variety of root was discovered, but the pre-phylloxera flavor, which exhibits drier and more organic flavors, will never be reproduced again.

White grape called "ugni blanc" is the predominant cognac grape variety used today, but folle blanche, colombard, sémillon, montils and folignanare are also permitted. These grapes come from six crus: Grand Champagne,

Petite Champagne, Borderies, Fins Bois, Bons Bois and Bois Ordinaires. Grande Champagne is widely regarded to be the best cru, with the greatest complexity and aging potential. Premier cru cognacs are slow in aging and naturally aged cognacs will take fifty or more years in cask to develop their natural qualities. Petite Champagne is similar in quality and a close second, with the Borderies known for their quality at a younger age, with remaining three crus generally used to produce a more mundane eau-de-vie.

After the alcoholic fermentation is complete, the wines also undergo a process that slightly reduces the acidity called malolactic fermentation, where tart malic acid in wine is converted to creamier tasting lactic acid. The eau de vie is aged in oak casks of various sizes, often from Tronçais or the Limousin forest. During the aging period, the spirit can be transferred from cask to cask or cellar to cellar. Cellars may be humid or dry, impacting the amount of evaporation (known as Angel's Share, just as with whisky). French cellars used to house cognac are typically quite small, perhaps only housing a couple of hundred barrels. Most are also old and damp, often old stores or farm buildings, perhaps old chapels or buildings that would normally be thought unsuitable for storing such valuable spirits. Many do not even have a proper floor, just the earth, perhaps where animals have been kept during cold winter months, but it is these old buildings that provide the finest conditions for cognac aging.

Good barrel aging extracts the useful substances from the oak barrels. Tannins form around 5% of these substances but others, including lignin and hemi-cellulose, are also useful. As these substances gradually dissolve in the maturing spirit, they impart the agreeable sweetness found in some older cognacs. It is therefore very important that much like with whisky, cognac spends as much time as possible in contact with these useful elements found in the wood. When an eau de vie has been perfectly matured, it may wait in a wicker-covered glass demijohn for retention until it becomes part of a blend where cellar masters, master blenders and teams of tasters in committee gather together to taste a number of eau de vie samples and determine blends. This is a very small and elite group. At Courvoisier for

example, only six master blenders have overseen the process over the course of the last 200 years.

With blending, eau de vies incorporated into a Cognac can come from a wide range of ages and are categorized based on the minimum age of the eau de vies in the blend. The current legally defined categories of Cognac include:

- V.S.: Eau de vies with a minimum age of 2 years. Also known as Very Special or Three Stars.
- V.S.O.P.: Eau de vies with a minimum age of 4 years. Also known as Very Superior Old Pale or Reserve.
- Napoleon (since April 2018): Eau de vies with a minimum age of 6 years.
- X.O.: Eau de vies with a minimum age of 10 years. Also known as Extra Old.
- Hors d'âge (Beyond Age): designation equal to XO, but in practice used by producers to market a high-quality product beyond the official age scale.

Close to 200 cognac producers exist. A large percentage comes from only four producers: Courvoisier (owned by Beam Suntory), Hennessy (LVMH), Martell (Pernod Ricard), and Rémy Martin (Rémy Cointreau). Other brands meeting the AOC criteria for cognac include: Bache-Gabrielsen/Dupuy, Braastad, Camus, La Fontaine de La Pouyade, Château Fontpinot, Delamain, Pierre Ferrand, Frapin, Gautier, Hine, Marcel Ragnaud, Moyet, Otard, Meukow, and Cognac Croizet.

Historical performance: As no recognized index tracking cognac exists, a conservative assumption would be to assume similar returns to wine (with an eye on possible closer likeness to whisky, putting the expected return from high end product at around 10% annual).

Value metrics:

Core: Scarcity, Rarity, Provenance, Condition, Historical importance

Unique: Age, Brand, Rating

Scarcity: Strict definitions of what is considered cognac including location produced and the cru type, introduce a built in supply cap. Also, as with other consumables, a number of high end bottles get consumed every year, making the remaining supply more and more scarce with each passing year.

Rarity: When a year produced an extraordinary quality cognac, small quantities are set aside to be bottled as a single vintage. These are the most coveted and collectible bottles. Limited editions are a good bet, as in general, the smaller the run, the more likely a limited edition is to go up in value. Older bottles, such as those that were produced in the pre-phylloxera era, will always be super rare. The taste of these eaux-de-vies is very different to that which is produced today, making them sought after by collectors over the world.

Provenance: Illustrious ownership adds value. For example Croizet Cognac Leonie 1858, a legendary bottle among cognac connoisseurs, is said to have been opened by Eisenhower while he was planning the D-day invasion, this association making the remaining examples even more valuable.

Age: Some form of age statement will provide the clearest indication of quality, and therefore value, since age and value are inextricably linked. Cognac does not continue to age once bottled, so storing a bottle for 10 years will not make it any older as the contents will remain the same age as they were when they left the barrel, much like with whisky. When properly stored, a bottle of Cognac has an indefinite shelf life, even after it has been opened, although in that case the contents may begin to evaporate slowly and some flavor may be lost over time. Any cognac with a date is sought after, with one of the most collectible vintages being 1811, a so-called 'comet year' when the appearance of a comet was thought to benefit the

grape harvest. There are many other rare and sought-after vintages, such as 1805 for the Battle of Trafalgar, 1815 for the Battle of Waterloo, 1812 for the Battle of Borodino, and 1781 for the Battle of Yorktown.

Brand: The Big Four of Cognac are Hennessy, Remy Martin, Martell, and Courvoisier. Some of the largest brands formed quite early. Martell, the oldest continually operational Cognac brand, with a history stretching back to 1715, recently celebrated its 300th anniversary; and Hennessy, with its own history stretching to 1765, celebrated its 250th. Rémy Martin brand's history stretches back to 1724, and Courvoisier 1809. Today, Hennessy is by far the largest distiller, accounting for roughly 46% of all Cognac production, followed by Martell, Rémy Martin and Courvoisier. There are many great smaller houses and it is still possible to find rare old bottles going back to the 19th century.

Rating: Bottles receiving awards at championships, such as Double Gold medals are valued higher, as are those receiving grades of 90 or higher from Wine Enthusiast, Spirit Journal or BTI (Beverage Testing Institute).

Top Five highest priced examples

1. Henri IV Dudognon Heritage Cognac Grande Champagne - $2M

This cognac comes from the Dudognon family, who have been in the business since 1776. The Cognac itself has aged in the barrel for more than a century, but it's the bottle that accounts for the majority of this hefty price tag. The most expensive bottle of cognac in history comes bottled in crystal, it is 24-karat gold dipped with Sterling platinum, and features 6,500 certified cut diamonds as decoration.

2-1801 Massougnes - $289,000

What makes this cognac a priced possession is its incredible rarity, coupled with age. Its supplies are reported to have dried up about ten years ago, and the appearance of any new bottles on the market is a unique and special occasion.

3-1805 Massougnes - $260,400 (prior price for a similar bottle was $182,000)

This Cognac was created in the very same year as the Battle of Trafalgar and belonged to Comtesse de la Bourdeliere, Marie-Antoinette des Allees, the last remaining direct descendant of King Louis VII, whose family owns the former Cognac producing Massougnes estate.

4. Hennessy Beaute du Siecle -$194, 927

This bottle of cognac features exceptional work and craftsmanship with decanter designed by French artist Jean-Michel Othoniel.

5. Croizet Cognac Leonie 1858 - $156,760

A bottle of cognac just like the one that sold in 2011 is said to have been taken out of France during World War II and opened by President Eisenhower.

Champagne

The name Champagne comes from the Latin "Campania" that refers to the similarities between the rolling hills of the province and the Italian countryside of Campania south of Rome. During the Middle Ages, the wines of the Champagne region were various shades of light red to pale pink as a bitter rivalry developed between the Champenois and their Burgundian neighbors to the south. Eventually their attention moved to produce white wines in an attempt to distinguish themselves from their Burgundian rivals. Cold winter temperatures in Champagne prematurely halted fermentation in the cellars, leaving dormant yeast cells that would awaken in the warmth of spring and start fermenting again, with one of the byproducts of fermentation being the release of carbon dioxide gas, that got trapped inside the wine, causing bottles to explode and creating havoc in the cellars. If the bottle somehow survived, the wine was found to contain bubbles, something that the early Champenois were horrified to see, considering it a fault.

While the Champenois and their French clients preferred their Champagne to be pale and still, the British were developing a taste for the unique bubbly wine as the sparkling version of Champagne continued to grow in popularity, especially among the wealthy and royal. Following the death of Louis XIV of France in 1715, the court of Philippe II, Duke of Orléans made the sparkling version of Champagne a favorite among the French nobility, and more Champenois wine makers attempted to make their wines sparkle deliberately. The Champagne method associated with the name of Dom Pierre Pérignon, who was a pioneer in the field in the late seventeenth century, aimed to control the process of making the wine bubbly and making the bottles strong enough to withstand the pressure. In the 19th century these obstacles were overcome, and the modern Champagne wine industry took form, largely thanks to advances by the house of Veuve Clicquot in the development of the méthode champenoise.

The first fermentation begins in the same way as any wine, converting the natural sugar in the grapes into alcohol while the resultant carbon dioxide is allowed to escape. After primary fermentation, blending, and bottling, a second alcoholic fermentation occurs in the bottle, where the blended wine is put in bottles along with yeast and a small amount of sugar, stopped with a crown cap, and stored in a wine cellar horizontally for at least three years for exceptional (milesime) vintages. The primary grapes used in Champagne are Pinot Noir, Pinot Meunier and Chardonnay and they must be grown in the Champagne region. Of course, the wine has to be produced according to the rules of the Comité Interprofessionnel du vin de Champagne.

Champagne has extremely broad recognition as a luxury good; even for those for whom other fine wine is of no interest, champagne is synonymous with high end celebration. Traditionally Champagne has been considered a celebration drink, but the finest examples have increasingly gained a reputation as serious wines. Unlike the great wines of Bordeaux, the leading wines of Champagne are aged for around a decade before release so they are ready to drink as soon as they hit the market. The leading Champagne houses produce two cuvees, or Champagne styles, non-vintage and vintage.

Vintage Champagnes come from a single harvest selected only in good to great years, such as 1988, 1990, 1996, 1999, 2002 and 2004. Instead of 15 months aging on lees, Vintage Champagnes have a minimum of 36 months, although the leading vintage Champagnes tend to be aged for much longer before being released to the market, resulting in the Champagnes having much longer contact with the lees, where they derive their biscuit, brioche and nutty flavors that gives the Champagne more complexity, while protecting it so it develops more depth, and also smaller, more refined bubbles.

The Champagne market over the last five years has been driven primarily by the increasing development of the demand pool from general High Net Worth growth and maturing Asian consumption-driven demand. As a result, secondary market volumes of Champagne are now 7-10% of total fine wine volumes, vs. 1-2% five years ago, with demand rising from 50 million bottles in the 1970's to over 300 million bottles today. Vintage Champagne offers relative affordability and reliability in comparison to wine. The average price of a case (champagne for investment must be bought in full cases) of Vintage Champagne is $2,000 compared to $30,000 for high end Burgundy. Champagne therefore offers first time investors a lower entry point, and seasoned investors value for money when expanding their portfolios.

Historical performance: The price of high end champagne has been steadily increasing over time, and while not as valuable as classical investment grade wines, the returns should be similar to it, and there is a separate index tracking it, with expected returns in the 7% range.

Value metrics:

Core: Scarcity, Rarity, Provenance

Unique: Age, Brand, Vintage year, Rating

Scarcity: There is never more wine than at release, and as the product matures it becomes more desirable over time. New markets are stretching production and the houses cannot increase their output to meet this

demand. A significant portion of any new vintage release is consumed within two-three years of release at nightclubs, restaurants, hotels, the retail industry, creating scarcity much faster than for regular wines.

Rarity: Vintage Champagne is not produced every year so they are immediately smaller in volume, in higher demand for quality driven consumers and become rarer as the vintage is consumed. Older or more rare Vintage Champagnes of exceptional craftsmanship of very limited initial production quantities are highly prized such as Veuve Clicquot's Cave de Priveé Champagne from 1975 or Krug Clos d'Ambonnay 1996.

Age: Like Bordeaux, Champagne boasts true age-worthiness, as the best examples are capable of aging and, crucially, improving for at least 20-30 years from the point of release. Vintage Champagne displays a premium, considerably increasing in value as it ages, signaling that younger vintages will reach the equivalent price of similar quality older vintages with age, and while this is a natural reflection of increasing scarcity due to consumption, it also results from the fact that some older vintages like 1990 and 1996 were universally considered to be exceptional.

Brand: Brand power is very important in this space, as the best known brands will command higher prices due to their reputation for consistency and quality. Leading vintage prestige cuvees are Krug Brut, Louis Roederer, Cristal, Moet & Chandon, Dom Perignon, Taittinger, Comtes de Champagne, and Salon Mensil.

Vintage year: Only Vintage Champagne from the very best years of a small number of key producers can be considered investment grade. In the very best years Vintage Champagne will be produced with grapes from only that year by the vineyard. The year itself is important with 1985, 1988, 1990, 1996, 2002, 2004 universally considered to be exceptional. Once a vintage is made it can never be remade and once released to market each vintage is steadily consumed, meaning that as the quality improves, the supply decreases, creating an inverse supply curve.

Rating: Can influence value but newly published scores do not, due to the much more significant supply of younger Vintage Champagnes. Wine Spectator, along with other reputable publications in the business produces rating on a 100 point scale, with scores over 95 being exceptional.

Top Five highest priced examples:

1-1907 Heidsieck – $275,000

Found in 1997 on a shipwreck in the ocean, intended originally for the last tsar of Russia, Nicholas II.

2-1996 Dom Perignon Rose Gold Methuselah – $49,000

Only 35 of this bottle were ever sold; it is plated gold, and you receive the equivalent of six liters.

3-1820 Juglar Cuvee – $43,500

The House of Juglar ceased to exist in the 1840s, but this is one spirited bottle that overcame sea limbo after a shipwreck.

4-1959 Dom Perignon – $42,350

In 1971, the Shah of Iran ordered several bottles of the first vintage of Dom Pérignon Rosé to beserved in Persepolis at the lavish festivities celebrating the 2500th anniversary of the founding of the Persian Empire by Cyrus the Great. Only 306 bottles of the 1959 Rosé Vintage were ever produced—and they were never officially sold.

5-1841 Veuve Clicquot – $34,000

Veuve Clicquot remains an elite brand today, but an 1841 bottle from a Baltic Sea shipwreck is ultra-rare.

Numismatics

Coins

Coins begin to appear in the archaeological record about 650 BC. Scholars disagree on exactly where the first coins were minted, but the ancient civilizations in Anatolia (modern day Turkey), Greece, India, and China are all likely candidates. The development of minted coinage in which the weight and metal composition were certified by a government represented a significant advance in the development of commerce. While many people use numismatics as a general term to refer only to the study of coins, this word actually refers to the study of all kinds of money, including paper bills and other related objects.

Coin collecting has existed since ancient times. In the 14th century, modern day appreciation and collection of coins began and an active coin market developed. At that time coin collecting was an interest only of the privileged class and was thus called the "Hobby of Kings". In these early days, coin collecting was very much associated with art collecting, and coins were valued as much or more for attractive or interesting imagery, as they were for scarcity or historic significance.

In the 17th and 18th centuries, numismatics developed as an academic discipline. Collectors became notably more systematic in their approach to building collections, and study of the intricacies of history and coin manufacture became more formalized. Scholars started to publish extensive numismatic studies and large public and private collections were amassed. It

is also at about this time that coin collecting spread to the emerging middle class. More than a simple hobby, coin collecting was a mark of sophistication and wealth.

In the 19th century, collectors broadened their horizons to include not only ancient coins but exotic coins and foreign currencies as well. Books on collecting were published, making the research accumulated in prior centuries available to the general public. Collecting societies emerged in Europe and North America. These societies cultivated not only the trade of coins, but the exchange of information, bringing collectors together and publishing journals.

Throughout the 20th century collecting became more and more systematized. Coin conventions and shows began to appear, and a network of professional dealers emerged. Identification and price guides became available and a formal system of coin grading emerged allowing coins to be bought and sold much like commodities, and viewed as an investment vehicle. In 1986, third-party grading services leveled the playing field by verifying the authenticity and defining standard coin grades, removing much of the authenticity risk involved in the purchase of rare coins, while not guaranteeing the value.

Historical performance: This asset class has been a long term staple of collectible market and is widely followed globally, supporting ongoing interest and producing robust returns in the 10% annual range.

Value metrics:

Core: Scarcity, Rarity, Provenance, Condition, Historical significance

Scarcity: Coins derive their value from two principal sources. The first is the physical metal contained in the coin, which is also known as its bullion value. Because many collectible coins are made from precious metals such as gold or silver, they carry a certain amount of intrinsic value as stores of these metals. The second source of value in a coin is its collector or numismatic

value. This factor applies mostly to antique and rare coins, and is quite a bit harder to determine than bullion value. Ultimately, a coin's collector value depends on buyer sentiment. The fewer examples of a coin that were minted, for instance, the higher its collector value is likely to be due to a shortage of supply. Although the bullion value of the metal is still factored into the overall price of these coins, their scarcity makes up the bulk of their final cost.

Rarity: Typically, rare dates and mint marks are two of the largest contributing factors to a coin's numismatic value. Rare minting errors can also add to the value of a coin. There is value in collecting complete set of rare coins in various types. It can be across "design types" within a denomination, and also across all the denominations, such as dimes, quarters, half dollars, and $1, $2, $5, $10 and $20 gold coins, etc. There are other themes that can be used such as first-year-of-issue examples for each series or key dates, which are the scarcest and most expensive coins in a particular series.

Provenance: Ownership by a notable collector or historical personality will enhance the value of the object. Confirming authenticity is absolutely crucial, thus an expert opinion is a must, along with a record of prior ownership as far as possible. Examples that are easily traceable via multiple transactions in renowned venues will be most desirable.

Condition: A coin's condition plays a major role in collector value, since buyers who value coins for their numismatic appeal tend to pay much larger sums for coins that are close to uncirculated condition than those that have obviously seen regular use.

All investment quality rare coins are certified by either Professional Coin Grading Service (PCGS) or Numismatic Guarantee Corporation (NGC). Both grade on the internationally accepted Sheldon grading scale of 1 to 70, which was first used in the United States in the late 1940s, with 3 strike types (Mint, Special and Specimen). Upon grading, these two services place the coins in a sealed and tamper-proof plastic slab. There are two other

third-party coin grading services, ANACS and Independent Coin Grading (ICG) but the rare coin market does not recognize them as major players.

Determining the grade of a Mint State coin can be broken down into four distinct areas, each with varying degrees of importance in determining the final grade between MS-60 and MS-70. The categories that determine the grade of a mint state coin are:

Surface preservation: Carries the most amount of weight when determining the Mint State grade of a coin. Numismatists define it as the number of imperfections or flaws that are on the surface of the coin.

Strike: A well-struck coin from new coin dies will exhibit the most delicate details of the design in all areas on the coin. The following two variables determine the quality of the strike: die state (degree of wear and fatigue on the die) and striking pressure (higher pressure resulting in better details on the struck coin).

Luster: The result of the high pressure used in striking a coin when the metal moves into the lower recesses of the die. This process produces microscopic striations (very tiny parallel grooves) that reflect light back to the viewer in a unique crossing pattern.

Eye appeal: The most subjective part of grading Mint State coins is the characteristic known as "eye appeal". Eye appeal is the overall appearance of a coin to a collector, and what may be beautiful to one coin collector may be ugly to another. Two coins may appear to be identical, and may even have the same grade from the same grading service, but there will be subtle differences that will make one coin look better than the other. This usually accounts for the coin with the better eye appeal having a higher price.

Historical significance: Coins tied to important historical events, anniversaries, or other memorable firsts have an additional value increase on top of rarity premium.

Top Five highest priced examples:

1.Flowing Hair Silver/Copper Dollar (1794/5) - $10M

This was the very first silver coin to be minted and issued by the U.S. Federal Government. Coin collectors have managed to preserve this historic and highly valuable coin for more than 200 years, which adds even more value to the coin's story and price tag.

2-Double Eagle (1933) - $7.6M

In 1933 almost 500,000 twenty-dollar gold pieces were minted, and almost immediately recalled from the general public and melted by the mint, due to the then President, Franklin Roosevelt, banning anyone from owning gold. But a small amount of 1993 dated Double Eagles escaped from the mint's vaults. It's still illegal to own one of these coins, and if you're found with one, it will be seized immediately. However, one private owner managed to acquire a coin, which was originally owned by King Farouk of Egypt and was then forced to sell the coin and split the proceeds with the U.S mint.

3-Saint-Gaudens Double Eagle (1907) - $7.6M

The Saint-Gaudens Double Eagle 1907 is a coin that proved to be more difficult to produce in large quantities than expected. The U.S Mint's chief engraver chose to remove the words, "In God We Trust" from the coin, but this did not go down well with Congress.

4-Brasher Doubloon (1787) - $7.4M

The 1787 Brasher Doubloon was the result of one man's goal to convince the New York State to use copper coins instead of gold. However, the State did not agree with Ephraim Brasher's plan. Mr. Brasher, a New York silversmith, who lived next door to George Washington, ignored the state and struck the copper coins as well as a small batch of gold Doubloons, this unique piece being one of just seven that were minted in 22-carat gold. This particular example is the only one to have Brasher's hallmark initials

punched on the eagle's breast; the others, including one in the Smithsonian, have "EB" stamped on the eagle's wing. Los Angeles-based PCAG is currently offering the coin privately at an asking price of $15 million.

5-Edward III Florin (1343) - $6.8M

The coin is approximately 670 years old and it's one of only three of the same coins to have survived the centuries thus far. Known as a "double leopard," it had a face value of about six shillings when it was circulated throughout December 1343, to July 1344, in medieval England. Not only is this coin one of the most expensive coins in the world, but it's also one of the rarest, and it's highly likely that no other identical coins will ever be found.

Banknotes

The first true banknotes from Europe were issued in Sweden in 1661. Much debate accompanied the issue, with some officials and merchants predicting paper money would herald the downfall of the country's monetary system. To overcome such objections, the monetary authorities issued the banknotes with no fewer than 16 certifying endorsements from prominent and trustworthy officials all signed individually by hand. Backed by the government's guarantee to redeem the banknotes, they were an immediate success, replacing the necessity to carry large, heavy, easily stolen, quantities of gold or silver.

The first bank to initiate the permanent issue of banknotes was the Bank of England established in 1694 to raise money for the funding of the war against France. The bank began issuing notes initially handwritten to a precise amount and issued on deposit or as a loan in 1695, with the promise to pay the bearer the value of the note on demand. There was a gradual move toward the issuance of fixed denomination notes, and by 1745, standardized printed notes ranging from £20 to £1,000 were being printed. In the United States, there were early attempts at establishing a central bank in 1791 and 1816, but it was only in 1862 that the federal government of the United States began to print banknotes.

Commercial banks in the United States had legally issued banknotes before there was a national currency; however, these became subject to government authorization from 1863 to 1932. In a small number of countries, private banknote issue continues to this day. For example, by virtue of the complex constitutional setup in the United Kingdom, certain commercial banks in two of the state's four constituent countries (Scotland and Northern Ireland), continue to print their own banknotes for domestic circulation, even though they are not fiat money or legal tender elsewhere.

There are many banknote types that can be collected, from inflation money (Weimar Republic, Zimbabwe and Venezuela) to specific countries, banks or themes (ships, music, animals, etc.).

Historical performance: The banknote market is nearly as robust as the coin market but has its own unique dynamics and thus a separate set of returns. While no generally recognized index exists, general price levels and auction trends point to returns similar to coin market in the 10% annual range.

Value metrics:

Core: Scarcity, Rarity, Provenance, Condition, Historical importance

Scarcity: Older notes are generally worth more, as they're less likely to have survived, but age isn't the only factor that determines a banknote's scarcity. The initial amount of notes printed and have survived till today is a good indicator of supply, while the degree of their desirability relative to that is what drives scarcity here.

Rarity: Banknote collectors look out for low serial numbers (such as AA01) or interesting serial numbers, such as '123456', as well as unusual errors such as an extra flap of paper on a banknote. All these factors can dramatically increase value, provided their condition is good.

Provenance: Famous past owners, much like the case with all collectibles, adds rarity and value to the bill. However beyond grading and authentication,

this particular parameter is not terribly significant in this space.

Condition: Third-party grading services such as PCGS (Professional Coin Grading Service), NGC (Numismatic Guarantee Corporation), and PMG (Paper Money Guaranty), will identify and grade notes, using the same 70 point grading system used to grade coins, pioneered by well-known numismatist Dr. William Sheldon in 1948. There are nine standard international grades for banknotes which are connected to the core grading scale: UNC (60-70), AU (50-59), EF (40-49), VF (20-39), F (12-20), VG (8-11), G (4-10), Fair (2-3), Poor (1).

Historical importance: First ever issue by country, first denomination of its kind, or any other number of things that give a certain piece of currency a historical angle, thus creating importance by associating it with the occasion and raising its value.

Top Five highest priced examples:

1-1890 Grand Watermelon Bill - $3.2M

There are only seven known "Grand Watermelon" notes today, which makes it one of the rarest and most sought-after pieces in American paper currency. Despite its playful name, which comes from the fact that the large zeros on the note look like watermelons, this note is an icon of American financial history and is known worldwide.

2-1891 Red Seal $1,000 Bill - $2.5M

This note is believed to be only one of two in existence. It features a portrait of U.S. General George Meade, a man once described as "a damned old goggle-eyed snapping turtle".

3-1882 $500 Gold Certificate - $1.4M

This is the only $500 1882 Federal Reserve gold certificate in existence, besides another specimen at the Smithsonian Institution. It was one of the

first banknotes printed in the United States, discovered following the execution of a turn of the century banker's will. The banker had a near mint collection of banknotes, some of them dating back to the Civil War.

4-1924 Australian £1,000 Banknote - $1.2M

This is the only known note to be outside of a museum since 1988 when it was last sold for €72,959.

5-Australia 1918 First £1 Banknote – $1.1M

This very first Australian one pound note was discovered languishing in a storeroom at the National Library in Canberra, much to the chief librarian's delight.

Stamps

Babylonian and Egyptian scribes often personally carried messages for their masters, and the Romans had a highly developed system of message carriers. Before 1550 in Europe, in the late Middle Ages and early Renaissance, the transport of messages was a privilege and an individual, contractual affair, with payment by negotiation. The main reason for the rise of an organized postal service was the emergence of commerce.

A schoolmaster from England, Sir Rowland Hill, invented the first adhesive postage stamp in 1837, an act for which he was knighted. On May 6, 1840, the first issued postage stamp, the British Penny Black stamp was released. In addition to the most common rectangular shape, stamps have been printed in geometric (circular, triangular, and pentagonal) and irregular shapes. The United States issued its first circular stamp in 2000 as a hologram of the Earth. Sierra Leone and Tonga have issued stamps in the shapes of fruit. Stamps are most commonly made from paper designed specifically for them and are printed in sheets, rolls or small booklets. Less commonly, postage stamps are made of materials other than paper, such as embossed foil. For investment potential, as a general rule, investors should stick to established, responsible countries such as United States, Canada, Western Europe, the British Commonwealth, and Japan. These countries have a strong base of native collectors, who have created an intrinsic demand for their indigenous stamps through strong and weak economic times. Investment grade stamps represent an infinitesimally small percentage of the collectible stamps available.

Investing in stamps is referred to as Philatelic investing, and in a 2007 interview, Mike Hall of Stanley Gibbons estimated that about $1 billion of rare stamps trade annually in the $10 billion-a-year stamp market. Stamps are among the most portable of tangible investments, easily transported over national borders. There are millions of enthusiastic stamp collectors around the world creating a global marketplace. New collectors continue to join the community from the growing middle classes in emerging markets. One of the highest profile collectors is billionaire Bill Gross who owns one of the world's largest stamp collections. He reportedly spent $50 to $100 million of his $2.2 billion fortune buying stamps. Gross sold part of his stamp collection in 2010, revealing gains better than the stock market. In 2000, he bought $2.5 million worth of rare British stamps and sold them for $9.1 million in 2007.

Very subtle differences in color, perforation, overprinting, and the like may be what differentiates a valuable stamp from a common one. Shoe designer Stuart Weitzman paid $9.5 million in 2014 for an 1856 British Guiana One-Cent Magenta, the only known example in existence. A delivery of stamps from London to British Guiana in 1856 had been delayed and so the 1c Magenta was created in limited numbers to ensure continued trade and communication on the island. Both the symbolic colony's Latin motto and the fact that there is only one known to exist make this stamp a real rarity. This is the one stamp missing from the $100MM stamp collection of Queen Elizabeth II. Though her collection includes multiple rare and valuable finds, this is one famous stamp she needs as the final piece to complete her collection of British Imperial stamps related to the United Kingdom and the British Commonwealth.

Historical performance:

A March 2018 survey found that stamps valued above $1,000 returned on average 3.2% per year, with high priced stamps having an appreciation rate of more than twice the rate for stamps below $1,000. The Stanley Gibbons index puts the long term average returns in the last 10 years as about 5%.

Value metrics:

Core: Scarcity, Rarity, Provenance, Condition, Historical importance

Scarcity: Depends on the number available on the philatelic market at any given time. There are several hundred quality investment stamps in United States philately, with perhaps a few thousand worldwide, and only a small portion of them are on the market at any given time. There is a finite supply of classic stamps, and population reports produced by grading firms like PSE help estimate this.

Rarity: Means that there are a small number of surviving examples, even better if the initial production was very limited as well, or they are unique. Stamps that are flawed in some way are valued, as in this market, mistakes can be highly profitable from the famous "Prussian Blue" to rare, modern-day errors. Rarity of the postmark on a used stamp is an additional factor contributing to the rarity of a particular stamp.

Provenance: Certificate of authenticity from a reputable authority is required, and the item preferably has a documented history. Grading services, like PSE, also provide certificates of authenticity. A key tool used to evaluate the investable stamps universe is the Scott catalogue, the dominant catalogue in the United States, that has great influence over what is and is not considered to be a valid postage stamp. The dominance of Scott is such that U.S. collectors know many of the numbers by heart, and dealers need only mention the number in their price lists, and the lack of a Scott listing means that most American dealers will refuse to trade in such stamps.

Condition: Is one of the most important factors in determining the value of a stamp, as a damaged stamp is worth only a fraction of one in fine condition. Many factors influence the condition of a stamp, from the margins around it (early stamps were cut by postmasters and had no perforations) to the gum on the back, to freshness of color. Stamps should appear new, with the designs, including outer frame lines, complete without abrasions. The stamp's gum needs to be preserved or, if used, neatly

canceled. Non-perforated stamps should have margins without the designs on all sides, while rouletted or perforated stamps should exhibit intact designs. Stamps are perishable, and can be affected by light, heat, and humidity, and must be stored in a proper place.

The use of grading to describe the relative quality of a stamp has been going on since the very beginning of stamp collecting in the mid to late 1800's. Beginning in 1987, a system was developed to finally begin standardizing the terminology and numerical grading of postage stamps. The stamps are graded on 5-100 scale, from Poor to Superb Gem, with PSE (Professional Stamp Experts) being the industry leader. In 2017 a new competitor ASG (Authenticated Stamps Guarantee), a subsidiary of CCG (Certified Collectibles Group), which includes seven of the world's leading expert services companies for coins, paper money, comic books, stamps and other collectibles, came on the scene and has been the major force in philately world.

The grade of a stamp is a combination of two principal components, soundness (the presence or absence of faults) and centering (the balance among the four margins). A third component, eye appeal (color, impression, cancellation) allows room for some adjustment after the basic grade is determined, and for mint (unused) stamps, a notation is made of the gum condition. Authenticated and graded stamps are sealed in tamper-evident display cases along with information about the stamp, including the Scott catalogue number, color, year of issue, denomination, overall numeric grade, philatelic description, unique control number, and bar code identification number, that appear on an archival paper insert that is secure within the display case.

Historical importance: The anniversary of a certain event tied to the stamp's issuance date or theme, status of being a first of its kind for a given country or region, or unique reason behind issuance all contribute are some of the possible features that make the stamp even more valuable.

Top Five highest priced examples:

1-British Guiana 1856 1¢ Magenta – $9.5M

The world's most valuable stamp and then some, the British Guiana 1856 1 cent magenta is the only known example in existence. A delivery of stamps from London to British Guiana in 1856 had been delayed and so the 1c Magenta was created in limited numbers to ensure continued trade and communication on the island. Both the symbolic colony's Latin motto and the fact that there is only one known to exist make this stamp a real rarity.

2-China 1897 Small One Dollar Red Revenues – $3.8M each

China's Red Revenue stamps are renowned for fetching astronomical prices, and the rare 'Small One Dollar' series is the most sought-after. The original block of four, considered the crown jewel of Chinese philately, sold for $15.2 million in 2009.

3-USA 1868 1¢ Benjamin Franklin Z Grill – $3M

The 1868 Benjamin Franklin Z Grill is the rarest and most valuable of all US postage stamps. This example, which belongs to storied collector William H. Gross and is listed in the Scott Catalogue for $3 million , is only one of two in existence.

4-Sweden 1855 3sk Treskilling Yellow – $2.3M

This 19th-century Swedish stamp is the only example known to exist. This Treskilling (three schilling) was printed in yellow rather than the usual blue-green, and quality control failed to pick up the error at the time.

5-China 1968 The Whole Country is Red – $2M

This Chinese stamp was recalled within a day of issue after it was discovered that Taiwan was incorrectly printed in white. One of just nine in existence, this is a pristine unused example.

Sports Memorabilia

Sports memorabilia has become increasingly popular and valuable in recent years and is a market that continues to grow. While sporting mementos, keepsakes, and autograph collecting have been fairly commonplace since the 1920s and 30s, memorabilia only really became serious business during the 1980s, coinciding with sports teams first selling jerseys. From this came the sale of used/signed shirts, and from that, a real market for memorabilia opened up.

The market for sports memorabilia is estimated to be $10 billion globally, with several billion in the United States. Growth in sports memorabilia collecting has been a function of a collision of demographics, economics, and technology. For decades, players routinely gave away their autographs and their gear, including balls, bats and jerseys, but it wasn't until the 1980s, when the first baby boomers were reaching middle age that large amounts of money poured into the sports memorabilia market, especially for baseball-related items, which make up about 70% of the vintage market. Authenticators began to verify the legitimacy of items and sports leagues have also been authenticating game-used bats, balls, jerseys and other items. Authentication created consumer confidence and consumer confidence created higher prices.

Serious collectors began paying five-, six- and even seven-figure sums for scarce items, like jerseys worn by Babe Ruth, Joe DiMaggio, and others, and ballplayers like Pete Rose were paid thousands of dollars to appear at autograph signings. Demand for game-used items, such as balls and jerseys,

is particularly intense, with the market strongest for baseball items. Numerous factors explain the price run-up for sports memorabilia over the past decade, including the growing wealth of baby boomers, the entrance of millennials into the market, and increased interest from foreigners. The wave of foreign players who have entered the National Basketball Association over the past 20 years, such as Yao Ming of China, and Luka Doncic of Slovenia, has drawn non-Americans to NBA memorabilia.

Classics never go out of style. A baseball signed by Babe Ruth will always be valuable and will become even more valuable over time. The most valuable signatures are currently from Magic Johnson, Michael Jordan, Usain Bolt, Roger Federer, and Muhammad Ali. In soccer it is Messi, Neymar, Ronaldo, and legendary footballer Johan Cruyff. In motorsports it is Valentino Rossi, Michael Schumacher, and Ayrton Senna, who shine the most.

Historical performance: The performance of sports memorabilia has been on a strong upward trajectory with average annual returns in the 12-13% range.

Value metrics:

Core: Scarcity, Rarity, Provenance, Condition, Historical importance

Unique: Brand

Scarcity: If there are only a few of a particular item on the market, or there is no possibility of creating more, then the price will reflect that scarcity. If a famous athlete is rumored to quit the business, this could be a good moment to start collecting autographs and other memorabilia, for their legacy will not change but the demand will definitely rise once the athlete quits the game. Other occasions that can influence scarcity are winning a championship, or the death of an athlete, the first leading to increased demand, the second to predictably finite supply.

Rarity: Some items were created in very limited quantities, thus making any examples of them quite rare. Another contributor to rarity is the player temperament and behavioral patterns. For example, Tiger Woods is not

known to be keen on signing memorabilia for fans, so a Tiger Woods signed golf ball is very valuable due to its rarity. In contrast, Babe Ruth, baseball's biggest titan, signed his name frequently for almost anyone who asked, thus making items bearing his signature scarce, but not very rare.

Provenance: Items need to be certified as being authentic, both the object and any autographs it bears. All the major grading agencies (PSA, BGS, SGC), discussed in greater detail in the baseball card section, have divisions that deal with authenticating and condition review for memorabilia items, so an item certified by one of them as being in top condition is key.

Condition: Items need to be pristine or 'museum quality' to command the highest value. As part of the grading process this feature is addressed along with several other parameters. Authentication is done by specialized memorabilia arms of PSA and BGS, as well as MEARS (Memorabilia Evaluation And Research Services) founded in 2004, which grades on a scale from 1 to 10, with A10 being the best possible grade representing 100% documented and authenticated item. For autograph authentication, James Spence Authentication (JSA) is sometimes used, with the most coveted being Witnessed Protection Program (WPP) designation that guarantees that an authenticator from JSA personally witnessed the autograph being applied by the signer.

Historical importance: Being worn or used in a championship game, to set a record or in a major athletic event are all characteristics to look for.

Brand: Signed balls or jerseys from truly famous players will fetch more than similar items from players who didn't establish (or haven't yet gained) an all-star reputation.

Top Five highest priced examples:

1-Babe Ruth 1920 Jersey - $5.64M

The 1920 Yankees jersey is the earliest known jersey worn by The Bambino. The jersey was originally a part of the Babe Ruth Birthplace Museum in

Baltimore but was bought at an auction by rare sports memorabilia mogul Joshua Leland Evans. The previous record for this item was for $4.4 Million, technically giving it both 1st and 2nd places on the list.

2-James Naismith's 1891 Rules of Basketball - $4.3M

Basketball inventor James Naismith wrote the thirteen rules of basketball in 1891 to entertain athletes at the International YMCA Training School in Springfield, MA. His students needed an indoor game that would help them stay in shape during the harsh winters but couldn't be too rough for fear of injuries affecting the spring seasons.

3-Mark McGwire's 70th Home Run Ball - $3M

Mark McGwire set a record for 70 home runs in a single season while playing for the St. Louis Cardinals. The 70th run, pitched by Billy Wagner of the Houston Astros, propelled him to record breaking status.

4-Paul Henderson 1972 Jersey - $1.275M

Paul Henderson wore what would become the most expensive hockey jersey ever sold during the Canadian victory over the Soviet Union team in the first Summit Series. Representing the Toronto Maple Leafs, Henderson made the winning play with only 34 seconds left in the game. Canada ended up winning seven out of the eight games in the series, and Henderson became a national hero.

5-Babe Ruth 1923 First Yankee Stadium Home Run Bat - $1.265M

Babe Ruth achieved his own dreams by hitting the first home run in the first game played at the brand new Yankee Stadium. And, as only fate could dictate, the Yankees were playing against their rivals and Ruth's former team, the Boston Red Sox.

Trading cards

Baseball

Trading card collecting is one of the oldest mainstream categories in the collectibles trade. Started in 1875, manufacturers would include a collectible trading card that depicted a well-known person or athlete with their product. In 1948, Bowman Gum released the first set of black and white baseball cards to moderate success. This caused competitor Topps to release its first set of baseball cards in 1952 (the one now known for including the coveted Mickey Mantle rookie card). By 1956, with sales of baseball cards increasing, Topps Chewing Gum Company purchased Bowman Gum and it was this development that gave rise to baseball card collecting as we now know it. Baseball card collecting made heavy strides from the late 1950s to the mid-1980s. Massive print runs during the late 80's and early 90's killed the value of most post-1980's cards, as the supply of cards was increasing much faster that the demand for them. When supply increased to ridiculous levels and demand started to wane, the bottom fell out of the market.

Experienced collectors buying for investment have learned from previous mistakes and are no longer buying new mass-produced products for speculative investment. Instead, they have turned their attention to heavy hitters of the past that are third-party graded and scarce. The card market didn't fall apart in 2008, and while housing prices were in free-fall and major financial institutions were going out of business, baseball cards investors as a whole decided that their prized cards would be the last thing to sell.

Everyone collected cards in the 80s and 90s and every day collectors from the past are rediscovering the hobby. The number of card collectors has been steadily increasing the past few years, and more people in the market means more demand. The introduction of serial numbered cards in modern times has built scarcity into card issues, guaranteeing that print runs are limited. For some card brands, such as National Treasures, Flawless, and Immaculate, every card is serial numbered. Key cards in those sets stand the best chance to increase in value because they are protected from overprinting.

The driving force in turning a card hobby into an investment opportunity has been the acceptance of recognized grading system providers for the condition of the cards. PSA and BGS, the two premier grading firms in the space, will rate any card and give it a grade which assesses a card's condition and, in most cases, determines its price.

Baseball dominates card collecting, but other sports also have their share of the card market, usually with cards of the sport's best players. Each of the four major sports leagues signed "exclusive" trading-card deals with just one card manufacturer. Both the NBA and the NFL's current card partner is Panini America; Upper Deck has the license for the NHL, and Topps for MLB.

Historical performance: Prices have risen for collectible trading cards. Over the past decade, as the Standard & Poor's 500 stock index has roared back from the 2008 crash, an index of the top 100 baseball cards has done even better. PWCC Top 100 Index yielded a 10-year return on investment of 264% for an annual return on 13.4%.

Value metrics:

Core: Scarcity, Rarity, Condition, Historical importance

Unique: Brand

Scarcity: Grading adds scarcity, because the extreme degree of difficulty involved in obtaining a PSA 10 or BGS 9.5 graded card, or any other high

grade ensures that the amount of available product is always severely limited. PSA and BGS disclose how many cards they grade at each level, giving everyone an understanding of the total population size (especially for older cards, where it can be expected that most excellent condition cards have been graded by now) which is extremely beneficial for estimating scarcity. For most cards, autographs add value via limited supply, and collectors like to chase key autographed cards in every new release. For the investor, autographed cards create an additional degree of scarcity and better future price appreciation potential, as players, especially well established ones, are only going to sign a limited number of autographs per year and in their lifetime.

Rarity: Earlier, rarer cards are worth more, because there are just fewer of them left, and when coupled with those that had limited or interrupted production or suffered from various printing defects, the result is extreme rarity. Even an overprinted card may be super rare in a gem mint form.

Condition: The advent of professional grading companies such as PSA, BGS and SGC brought a well-defined grading and authentication system. On July 7, 2020 CCG (Certified Collectibles Group), a long-time major player in grading services for coins, paper money, and comic books has announced its entry into the trading card grading via a newly formed subsidiary CSG (Certified Sports Guaranty).

PSA (Professional Sports Authenticator) is a division of Collector's Universe, a large corporation traded on the Nasdaq stock exchange, that gained fame for the creation of PCGS, a highly reputable coin grading company founded in 1985. Launched in 1991, they have processed over 30 million cards and collectibles with a cumulative value of over a billion dollars, including some of the most expensive cards ever sold at auction. PSA grades cards with a single grade on a 10-point scale in whole-number increments, with the highest grade being PSA 10 Gem Mint: a basically perfect, well-centered card with sharp corners and edges and a clean surface. Cards are graded based on four factors: Centering, Corners, Edges, and Surface. They give each attribute a grade of 1-10, and then combine those to

give the card a final grade of 1-10. PSA also has 'qualifiers' that can be added to a numbered grade when an item meets all of the criteria for a particular grade but may still have one significant flaw.

Beckett, the established market leader of monthly price guide magazines, founded BGS (Beckett Grading Service) in 1999. BGS grades on a 10-point scale but in half-point increments used for examples that may fall in-between two levels, and with a final grade that is a composite of four separate subgrades for centering, corners, edges, and surface. A BGS 9.5 Gem Mint is essentially a perfect card and effectively equivalent to a PSA 10 Gem Mint, though BGS technically does have another level in the rare BGS 10 Pristine grade. Beckett Media launched an autograph authentication company, Beckett Authentication Services, in 2016. For autographed cards, Beckett includes an additional, separate grade for the autograph, where PSA does not. BGS 9.5 Gem Mint card and PSA 10 Gem Mint example of the same card will carry the same valuation. These two companies are the established leaders in this space, and while there are other competitors, PSA- and BGS-graded cards warrant high premiums well in excess of ungraded book value because of these companies' strong brands and tough grading standards. The third major player is SGC (Sportscard Guaranty Corporation) established in 1998. Their cards are not worth as much PSA or BGS graded ones. There is a new fourth entrant CSG, a subsidiary of the grading space giant CCG, that will begin operation in 2020.

Historical importance: The importance of a card itself is closely tied to the player as well as some unique circumstances, like being the first edition of a famous player's rookie card or a special commemorative edition or a rare and unusual format.

Brand: There are some iconic players who remain popular with collectors over time: Ty Cobb, Babe Ruth, Lou Gehrig, Cy Young, Honus Wagner, Willie Mays, Jackie Robinson, Ted Williams, Mickey Mantle, Joe DiMaggio and Roberto Clemente. The player's place on all-time best list and the player's team status and reputation also figure into assessing this variable.

Top Five highest priced examples:

1-1909 T206 "Jumbo" Honus Wagner - $3.12M

This PSA 5 graded card is one of only about 50 known copies in existence. The "Jumbo Wagner" earned its nickname due to a mis-cut that makes the card larger in size (2 11/16" in height instead of the standard 2 5/8") and gives it a slightly wider white border. The PSA 8 graded "Gretzky" T206 Wagner, previously owned by NHL "Great One" Wayne Gretzky, held the previous sales-price record of $2.8 million. Wagner himself is the reason for the card's rarity, as the Pittsburgh Pirates star barred the American Tobacco Company from continuing production of the card, either because he didn't want children to buy cigarettes to acquire his card or because he wanted to get paid more for his likeness.

2-1952 Topps #311 Mickey Mantle - $2.88M

PSA 9 graded card is one of six copies of this grade of the most recognizable sports card in the entire hobby, and it last changed hands for $282,588 in 2006. The first Mantle card ever issued by Topps, it came out the same year that "The Mick" won his second of seven World Series rings with the Bronx Bombers, hitting 23 home runs. Being a "high number" card (cards 311 – 407 in the set) means that fewer Mickey Mantle rookie cards were printed than the average 1952 Topps baseball card in the first place, and many high number cards were famously dumped into the ocean leaving even less of them in existence. To date, about 150 have been graded as a 7 or higher by PSA, SGC, and Beckett. There also exist three gem mint PSA 10 cards that may be worth $10 million each, but the current owners reportedly refused to sell even at that price.

3-Mike Trout Rookie Card -$922,500

This copy of the card has a Gem Mint 9.5 grade from Beckett Grading. The signature received a grade of 10. This 2009 Bowman Chrome Draft Mike Trout Red Refractor Autograph, sold for more than double the price of

$400,000 two years ago. With five copies, the Red Refractor is the second rarest version of Trout's top card (this particular card is 5/5). 2009 Bowman Chrome Draft has his first autograph in a MLB uniform.

4-1951 Bowman Mickey Mantle - $750,000

PSA 9 graded example of Mantle's official rookie card. This incredibly important card is beautiful in design, depicting nice artwork of Mantle ready at the bat. A PSA 9 mint condition 1951 Bowman #253 Mickey Mantle previously sold for $588,000. This card has several unique features, with Mantle wearing No. 6, instead of his famed No. 7 and the horizontal layout is one of only 39 printed that way in the 324-card set.

5-1916 Sporting News Babe Ruth - $717,000

This PSA 7 graded card shows a young Ruth in a Boston Red Sox uniform before they traded him to the rival New York Yankees. A higher PSA from the same M101-5 set (or from the nearly identical M101-4 set) would be expected to command over $1 million. The 1916 Ruth was "a collectible business card", as Chicago-based printer Felix Mendelsohn ran off the cards with blank backs, which enabled businesses to add their own advertising to the back. This card, the key to the 200-card M101-5 set, is often found off-center and features a variety of advertising backs, although most existing copies exhibit blank backs. There were as many as 16 businesses advertised, but The Sporting News reverse is the most coveted.

5.1-1914 Baltimore News Babe Ruth - $575,000

This PSA 2 graded version of "pre-rookie" card of Ruth is one of the rarest cards in the hobby with only 10 copies known to exist and can be found with either blue or red borders. In early 1914, Jack Dunn of the minor league Baltimore Orioles signed Ruth to a professional baseball contract. Financial problems would cause Dunn to sell Ruth's contract to the Boston Red Sox later that year.

Basketball

Top Five highest priced examples:

1-Lebron James - $1.845M

This rookie card has broken the record for modern day trading cards as the most expensive basketball card ever and the first ever card to cross $1M. Only 23 of the LBJ 2003-04 Upper Deck Exquisite cards were made, the James card, #14 in the set graded BGS 9.5 (10 autograph score for perfect legibility and lossless quality) is in Gem Mint condition, signed by James in blue ink and contains a patch of jersey from his rookie season with Cavaliers. It was originally sold in a pack of 4 that went for $125.

2- MICHAEL JORDAN, LEBRON JAMES - $900,000

This super rare 2003-04 Upper Deck Exquisite Collection All-NBA Access LeBron James/Michael Jordan Dual Patches 1/1 BGS rated NM-MT+ 8.5 card is the second most expensive basketball card ever, and one of the most expensive in history, with only 3 other cards selling at $900,000 or more.

3-1969-70 Lew Alcindor Rookie Card - $501,900

Dating to a time before Lew Alcindor changed his name to Kareem Abdul-Jabbar, this is one of only two cards in existence given the 10 Gem Mint rating by PSA. A second PSA 10 Alcindor/Abdul-Jabbar rookie card was sold earlier for "only" $240,000.

4-George Mikan RC – $403,664

This is a PSA 10 graded example of the legendary center, who was the game's first unstoppable big man and set the bar for other big men like Wilt Chamberlain and Bill Russell who would soon follow.

5-Michael Jordan - $350,100

Chicago Bulls legend's 1997-98 Precious Metal Gems (PMG) Green card is one of only 10 ever made, and one of only 3 believed by experts to be in circulation. It is also the only card to be authenticated by the Professional Sports Authenticator (PSA) service, but not given a grade, although the foil embossed collectible appears to be in excellent condition.

Football

1-1958 Topps Jim Brown Rookie Card - $358,500

It is one of only five examples to reach PSA 9, with none graded higher. With over 3,493 Jim Brown's submitted to PSA so far, it's no surprise to see only five were found in mint condition. 1958 Topps cards are notorious for having slightly off-center borders and smooth corners, which all prohibit high grades. "Jimmy" is widely considered the greatest fullback to ever set foot on the gridiron.

2-1957 Topps Bart Starr Rookie Card-$288,000

Bart Starr is the first quarterback to win a Super Bowl. He is also the first player to be a Super Bowl MVP. Because he is the first, his rookie cards are highly collectible. Furthermore, playing during the Vince Lombardi era with the Green Bay Packers winning three consecutive league championships, makes them even more sought after. This is the only known '57 Bart Starr rookie card in a PSA 9 grade, a PSA 8 copy can be purchased for roughly $7,500. As of today, PSA has authenticated and graded just 1,760 of these cards. Of those submitted, only three managed to make the mint 9 grade with none found in gem mint condition. Having just three PSA mint 9 copies in existence makes this one of the most valuable and rare football cards ever printed.

3-1965 Topps Joe Namath Rookie Card-$264,000

In their '65 set, Topps printed what is known as the "tall boy" size measuring in at roughly 2 1/2" wide by 5" tall. This PSA 9 graded card is a pristine example, as the majority of these cards grade out in PSA 5 and PSA 6 conditions, because these cards are so tall, and susceptible to bending.

4-2000 Playoff Contenders Tom Brady Rookie Card (Autograph) - $168,000

One of two autograph rookie cards on this list, PSA 9 graded Tom Brady's 2000 Playoff Contenders Championship Ticket has become red hot after he's racked up six Super Bowl championships. 167 of these have been graded and authenticated by PSA, with only 14 being found in gem mint 10 condition.

5-1957 Topps Johnny Unitas Rookie Card-$167,300

Johnny Unitas was a quarterback for the Baltimore Colts from 1956 to 1973. Unitas led the Colts to NFL titles in 1958 and '59, helped them win Super Bowl V, was chosen to five all-league teams and was Player of the Year three times. 3,229 Unitas rookies have been submitted to PSA for grading, and just 8 were declared to be in mint 9 condition. Print snow and centering are usually the two key factors that prevent the card from attaining high grade status.

Hockey

Top Five highest priced examples:

1-Wayne Gretzky: 1979 O-Pee-Chee - $465,000

This is 1 of only 2 PSA 10 GM rated rookie cards of hockey's greatest player inducted into the Hockey Hall of Fame in 1999. Gretzky held more than 60 NHL records from regular season, playoff and All-Star play and is the

only player in history to reach 200 points in a season, and he did it four times. This card, which is tougher than its Topps counterpart, has to contend with a few major condition obstacles including chipping along the blue border, print defects, and severe rough-cuts, making PSA Mint 9 or better examples very hard to come by.

2-Bobby Hull: 1958 Topps - $150,000

This is a PSA 9 graded card, the only recognized rookie card of the Golden Jet and the key to the 1958 Topps set. Bobby Hull was one of the most powerful slapshot artists the sport has ever seen, being clocked routinely in the 115-120 mph range. Many of the Hull rookies are found with 70/30 centering or worse due to being placed in the bottom corner of the 1958 Topps uncut sheet, resulting in the centering issue. As the last card in the set, the Hull rookie has long been considered a condition rarity.

3-Bobby Orr: 1966 Topps - $125,000

A PSA 9 graded example of this card, this is the only recognized rookie card of hockey's most legendary defenseman inducted into the Hockey Hall of Fame in 1979. This card, like cards from the 1955 Bowman baseball set, is surrounded by brown borders and susceptible to chipping.

4-Georges Vezina: 1911 Imperial Tobacco - $75,000

This PSA 8 graded card is the only recognized rookie card of the man whose name is synonymous with goal-tending excellence. He is actually the person the most outstanding goaltender annual NHL award trophy is named after, and a part of the inaugural Hockey Hall of Fame class of 1945.

5-Gordie Howe: 1951 Parkhurst - $75,000

This PSA 9 graded example is the only recognized rookie card of Mr. Hockey and the key to the set. Gordie Howe, who made his debut at the age of 18 in 1946, held virtually every offensive record until a guy named Wayne Gretzky came along. This card suffers from the typical condition

obstacles associated with the issue and is very elusive in PSA NM-MT 8 or better condition.

Summary table all sports:

Highest value objects (complete list of top 10 can be seen at http://michaelfoxrabinovitz.com/toplists under Trading Cards)

Objects	Baseball	Basketball	Football	Hockey	TOTAL
1	$3,120,000	$1,845,000	$358,000	$465,000	**$5,788,000**
2	$2,880,000	$900,000	$288,000	$150,000	**$4,218,000**
3	$922,000	$502,000	$264,000	$125,000	**$1,813,000**
4	$750,000	$403,000	$168,000	$75,000	**$1,396,000**
5	$717,000	$350,000	$167,000	$75,000	**$1,309,000**
6	$716,000	$312,000	$72,000	$25,000	**$1,125,000**
7	$700,000	$237,000	$72,000	$15,000	**$1,024,000**
8	$667,000	$130,000	$66,000	$14,000	**$877,000**
9	$660,000	$125,000	$46,000	$13,000	**$844,000**
10	$612,000	$115,000	$45,000	$12,000	**$784,000**
TOTAL	**$11,744,000**	**$4,919,000**	**$1,546,000**	**$969,000**	**$19,178,000**

Comics

Although comics have origins in 18th century Japan, comic books were first popularized in the United States and the United Kingdom during the 1930s. The first modern comic book, Famous Funnies, was released in the US in 1933 and was a reprinting of earlier newspaper humor comic strips, which had established many of the story-telling devices used in comics. The term "comic book" derives from American comic books once being a compilation of comic strips of a humorous tone; however, this practice was replaced by featuring stories of all genres. Comics are a billion-dollar industry with annual sales of graphic novels and periodical comics in the U.S. and Canada of over $1 billion not including all the spin-off industries and products. Considering all the movies, toys, and games added to the mix, the comic book industry is a very big business.

Fueled by the prevalence of top-grossing movies featuring comic book superheroes, interest in comic books is on the rise. In 2017, five of the 10 highest-grossing movies were superhero stories and the popularity of comic conventions continues to grow. Comic-book conventions around the world consistently draw crowds of 30,000 to 150,000, and New York Comic Con set a new record for attendance for a pop culture event in North America, with over 200,000 tickets sold in 2017. A number of Baby Boomers started selling off their collections, and as a result of this trend, all kinds of rarities are appearing on the market for the first time in decades, presenting new opportunities for savvy investors.

The most legendary collection of all time is known as the "Edgar Church

Collection" famed for holding the highest quality copies of many Golden Age comic books, including the best known copy of Action Comics #1 believed to be a 9.4 to a 9.6, but not yet confirmed as the current owner refuses to get any of his books graded. Edgar Church was a comics collector and artist who worked for the telephone company in Colorado illustrating commercial telephone book advertisements. The collection of comic books that he amassed, also known as the "Mile High collection", due to being bought in 1977 by Chuck Rozanski of Mile High Comics, is the most famous and valuable comic book collection known to surface in the history of comic book collecting, consisting of between 18,000 and 22,000 comic books.

Historical performance: High end of the comic book market is extremely vibrant and has been on fire in the last decade earning around 14% annually.

Value metrics:

Core: Scarcity, Rarity, Condition

Unique: Age, Brand, Events

Scarcity: As no more vintage comic books are created, there is a true scarcity of good examples, especially those in top condition. Print run size can be an additional indicator of scarcity, with those with most desirable characters and small print runs being in high demand. As many were discarded, forgotten, or read to the point of deterioration, there is a degree of scarcity arising from the material being in use, especially for older books which are more fragile and more likely to have been damaged or destroyed over time.

Rarity: Comic books that are generally considered rare include first issues, first appearance of a popular character or a superhero, death of a popular character issues, and special variants. A comic doesn't have to be actually very rare to be valuable. For example, Incredible Hulk #181 is a very in-demand book, even though it's not at all rare, but the first appearance of

Wolverine has made it quite a valuable comic. Wolverine's first appearance is on the last page and last panel of Incredible Hulk #180 but issue #181 is the more sought after and valued copy. There are plenty of rare comics which are not very valuable, simply because not many people want to collect them. Pristine condition greatly contributes to rarity as well, sometimes by orders of magnitude. Also valuable are those that represent an artist or writer's first professional publication.

Condition: Pristine condition is a requirement for a truly valuable comic. They are graded on a 10 point scale, with investment quality ones being from 8.0 VERY FINE (VF), which is an excellent copy with outstanding eye appeal with minimal surface wear to 10.0 GEM MINT (GM), an exceptional example with no surface wear and no interior autographs or owner signatures. Truly mint condition comics, even from as recently as the 1980s, are very hard to come by.

CGC was the very first company to grade and slab comic books beginning in 2000. It is the premier comic book grading company and CGC grading will normally fetch a slightly higher price at auction for top dollar graded books. CBCS, started in 2014, has been rising in popularity as an alternative to CGC. The main attractant to CBCS is that they offer signature verification services where signed comic books signatures can be authenticated. CBCS has an equally good reputation compared to CGC, so it mostly boils down to a matter of preference.

Many of the early strip reprint comics, as well as many modern graphic novels and collections, were published with hard covers and dust jackets, which can also suffer damage common to comic book covers and may even be absent on some copies if removed by a previous owner or lost. The condition of the dust jacket is graded independently of the book and can add from 20% to 50% to the value depending on the rarity of the book, the earlier the book, the greater the percentage.

Age: Publication history of comics is divided into four different ages: Golden Age (1938-1955), Silver Age (1956-1972), Bronze Age (1973-

1985), and Modern Age (1986-present). Like other collectibles, the older the comic book collection, the higher the value. Almost all comic books have the retail price at the time of publication on the cover, with earlier vintage ones, 10c, 12c, 15c, 20c, or 25c . Most comics with a price of 30c or higher on the cover are later vintage.

Brand: An obscure title may be valuable to a few diehard collectors, but for investment to truly grow in value, the purchase should have a wide fan base. Classic titles by Spider-Man and Superman are the kind of investment that will grow in value over time. Comic books are about more than the "blue chip" characters: Superman, Hulk, Batman, Spider-Man, Iron Man, Captain America, Flash, Green Lantern, The Avengers, Thor and X-Men. Some heroes from the Golden Age (1930s-1950s), including Catman, Black Terror, The Destroyer and Phantom Lady, are very popular today, despite the fact that they're no longer in publication.

Events: Such as upcoming movies create a temporary increase in value. The success of the Black Panther movie, led Fantastic Four #53, which marked the character's first appearance, to soar in value. Every time a comic book movie makes hundreds of millions of dollars, a comic-book owner's collection gets a little more valuable.

Top Five highest priced examples:

1-Action Comics #1 - $3.2M

The CGC 9.0 graded version of this book is one of the five highest known graded versions, with only one higher rated version rumored to exist. This iconic comic is well noted for debuting America's beloved superhero-Superman. The comic also sets the stage for Superman's home planet of Krypton. This level of prices for this book is not unprecedented, another CGC 9.0 graded copy was sold by Nicholas Cage for $2.16M. CGC 8.5 sold for $1.5M and CGC 8 for $1M, with even a CGC 6.5 version commanding $650,000.

2-Amazing Fantasy #15 - $1.1M

This is a near perfect CGC 9.8 graded specimen of a comic that marked the first ever appearance of Spider-Man back when he had webs underneath his armpits.

3-Detective Comics #27 - $1.075M

This is the highest ever graded CGC 8.0 unrestored copy of an issue where Batman makes his debut appearance. This comic also introduced Commissioner Gordon and Batman's alter-ego, Bruce Wayne. A CGC 7.5 graded version was sold for $657,000.

4-'All Star Comics' #8 $936,233

This CGC 9.4 graded copy marks the first appearance of Wonder Woman in the eighth issue of "All Star Comics" from 1940. The comic book has skyrocketed in value, possibly because of the insanely popular "Wonder Woman" film. A 9.0 copy sold for $411,000. 'Sensation Comics' # 1, the second appearance of Wonder Woman that continues her origin story and also includes the first appearance of Wildcat and Mister Terrific with a near pristine 9.6 grade sold for $399,000.

5-'Batman' No. 1 $850,000

A near-mint condition, CGC 9.2-graded copy of Batman's first comic book from 1940, this iconic comic marks the first appearance of the Joker and Catwoman.

Books

Printed

The collection and display of the written word has long been a symbol of prosperity and prestige. From the time of the Great Library of Alexandria, great individuals and institutions throughout history have assembled rare writings. There is a finite supply of "old" or "antiquarian" or "rare" books, as they are no longer being made, produced, and printed. Books are everywhere around the globe, and books can be moved easily to any place on the planet, making them a portable store of value. There will always be people who like to collect books that are important to them.

With a rapidly growing world population, there are new emerging countries with a better educated population and more affluent population, and thus new markets for antiquarian books.

The antiquarian book market largely consists of first editions of important works, although there are other types of collectible books as well. As with other collectible markets, tastes change over time. Some works retain their desirability while the demand for others peaks and then recedes. Many particularly important books have shown a dependably steady increase in retail value over time, but, as with any market, previous "performance" is no guarantee of future results. How much a book is worth is primarily a matter of context, as determining the value of books is not an exact science. Two different copies of the same scarce first edition are two different objects, a copy with one chip might be roughly equivalent to another copy with two

short tears. To look at a very high profile example, one Shakespeare First Folio sold at auction for $6.1 million in 2001, and another copy sold for $2 million in 2010. The reason for the vast difference is very simple: it was not the same book, just the same edition of the same title. A good way to examine how much rare books appreciate in value over time is to look at the prices paid for the exact same copy of a collectible book, and auctions are one of the best barometers for assessing the appreciation of the types of books in the collection.

Historical performance: One of the oldest and most venerable areas in the collectible space, rare books return 7-8% on the annual basis over long term, with 2019 returns in the 2% range.

Value drivers:

Core: Scarcity, Rarity, Provenance, Condition, Historical importance

Unique: Events

Scarcity: Is not only determined by the size of the first printing, but also by how many copies survive relative to demand. If the book is not one many people care about, or at least two people are willing to compete for, it will have little value. Conversely, there might be many copies of a first edition, but if a great number of people of means are willing to compete for them, then that book can have substantial market value. For example, the first edition of Herman Melville's Moby Dick did not sell very well and it languished in literary obscurity for several generations before it was widely accepted as a classic in the early 20th Century. 272 copies of the first edition were destroyed in a warehouse fire, so relatively few of the originally printed copies survive, and the book became scarce.

Rarity: Is governed by edition of the book, as well as the inscriptions that can be found within it. Edition is paramount to determining rarity. For most titles, the first printing of the first edition of the book is generally the most desirable, often by so wide a margin that nothing but the first printing

has any value as a collectible. To spot a first edition book look for terms like "first published" and "first printed" dates. Phrases such as "new edition" and "this edition" are meaningless. Later editions can also be highly sought after, especially if they contain additional illustrations or amendments. A first edition of William Camden's Britannia can only fetch $1,000, but a later edition with maps can be worth up to ten times that amount. The third edition of Isaac Newton's "Philosophiae Naturalis Principia Mathematica," for example, is the most collectible version, because that's the edition that includes Newton's initial comments on calculus.

Inscription adds to the value, as a book is not truly rare and unique unless there are distinctive markings to it. Inscriptions are important drivers of price, and can make a massive difference in the book's value. The range of prices for the same book can vary from $1,000 to $250,000 depending on the inscriptions.

There are four different tiers of inscriptions:

- **autographed by the author:** an author's signature adds value to a book.
- **inscribed to somebody**: signed to a regular person with a simple message.
- **inscribed to somebody associated with the book:** like the editor of the book, a research assistant or perhaps an illustrator.
- **dedication copy:** the top of the signed book pyramid is called a dedication copy, meaning it's signed on the dedication page and inscribed to the person for whom the author dedicated the book.

In addition, clear focus or a theme connecting a group of books makes the entire collection worth more, so specializing can be another way to make the investment really pay off. The 18th century Traité Des Arbres Fruitiers, a treatise on fruit trees, fetched $4.5 million in 2006, making it one of the most expensive books ever sold. This five-volume set shows the importance of creating themed collections, and the value a specialist collector will place on specific volumes.

Provenance: Is the history of the book ownership and plays a role in this market in the same way it does in other art and collectibles markets. In the book world, there are not so many problems with forgeries, as it is very hard to fake a printed book, although not completely impossible. Association distinguishes the most exceptional copies, such as ones presented to or owned by someone whose life or work has bearing on the author and the author's work. A copy presented by the author to his parents, spouse, or mentor would be such a copy, and they will appreciate at a much higher rate than just regular signed copies. Signature of an important previous owner can add to the book price.

Condition: The idea of collecting a rare book is that it has to be in the same condition as it would have initially been purchased. Most collectors desire copies of books that are as close to the original condition of the book when it was first offered for sale as possible. They often pay considerable premiums for copies that are considered in "fine" condition, particularly if such copies are difficult to obtain, and if the condition of the book has not been restored or repaired. A book in terrible condition even if it's a rare first edition, may not be worth very much at all.

However, a book that has yellowed pages and what is known as 'foxing' can actually increase in value. Foxing refers to brown spots on the page; an unavoidable ravage of age that affects most books at some point, even those that are meticulously cared for. Enthusiastic collectors see these natural flaws as confirmation of the age and integrity of the book, and will sometimes pay more than if the copy is pristine and paper-white. Books need to be kept away from direct sunlight and at an appropriate temperature and humidity, ideally on a shelf side by side with other books. The biggest damage to condition comes from reading, thus unread copies are ideal, guaranteeing there are no alterations, folded pages or notes to ruin the pristine state.

Physical factors that affect the price of rare books include not only the condition of the pages but also that of the dust jackets. Dust jackets are fairly rare these days and even books that were once sold with dust jackets to protect them tend

to have lost them over the years or thrown away by the initial purchaser, or even by the cashier as they were sold. Finding a first edition with a dust jacket intact can make a large difference to the price. For example, a first edition of Dashiell Hammett's Maltese Falcon can fetch $1,500 at auction, but a copy with the dust jacket can increase that amount to up to $75,000.

Historical importance: Popular science works like Charles Darwin *Origin of Species* transcend mere rare book collecting and are never out of favor. Twenty years ago a copy of *Origin of Species* could be bought for about $50,000; the cost today is more than $350,000. *Harry Potter and the Philosopher's Stone* came out in 1997, and within two years prices started going up due to the fact that the whole world, both adults and children, seem to love Harry Potter and the interest just keeps on going without showing any signs of slowing down. A copy of a Harry Potter book bought in the 90s for $5,000, today can be sold at auction for $60,000.

Events: One thing that can definitely bring increased interest to a book, is when there is a movie made based on it or whose adaptations are about to hit cinema screens. The caveat here is that the movie has to be good, otherwise the market softens drastically upon release. Books that are heading towards an important anniversary will gain increased attention and publicity in the run up to the special date. For example, 2022 will be the 100th anniversary of Ulysses and there is likely to be many exhibitions, media coverage and research leading up to the date, generating great deal of interest and demand for the work.

Top Five highest priced examples:

1-Bay Psalm Book - $14M

In 1640, 20 years after the Pilgrims landed on Plymouth Rock, the *Bay Psalm Book* emerged from printers in Cambridge, Massachusetts. There are 11 copies still intact today, mostly in the possession of libraries and universities.

2-Birds of America, James Audubon — $11.5M

Between 1827 and 1838, naturalist John James Audubon published a series of exquisite prints depicting hundreds of different North American bird species. Together, the 435 illustrations form the complete first edition of *Birds of America*. There are only 119 known complete copies in the world of this enormous four volume set. Two other copies of the book sold in recent years: one for $8.8 million in 2000 and another for $7.9 million in 2012.

3-Daniel Bomberg's 16th century Babylonian Talmud - $9.3M

Famous and finely preserved edition of the Talmud, a multi-volume series printed in Venice and one of the most significant books in the history of Jewish printing. Only 14 complete sets are known to be in existence.

4-The Canterbury Tales, Geoffrey Chaucer — $7.5M

A first edition of the 15th century bawd-fest sold for $7.5 million one of only a dozen known copies of the 1477 first edition, and the last to be held privately.

5-First Folio, William Shakespeare — $6M

First Folio is so rare because it is the first authoritative collection of his plays, compiled by his friends and business partners who helped run his theatre company and contains 36 plays, originally with many typographical errors. Intact copies are now among the most highly prized finds among book collectors, with only an estimated 228 out of an original 750 printed between 1622 and 1623 left in existence.

5.1-The Gutenberg Bible — $5.39M

Only 48 of the books, the first to be printed with movable type, exist in the world. The book was originally printed in folio form or as loose leaf pages that the owner would then get bound to their preference.

Manuscripts

Before the inventions of printing, in China by woodblock, and in Europe by movable type in a printing press, all written documents had to be both produced and reproduced by hand. Historically, manuscripts were produced in form of scrolls or books written on vellum and other parchment, papyrus, or other materials. In Russia, birch bark documents from the 11th century have survived, and in India, the palm leaf with a distinctive long rectangular shape, was used from ancient times until the 19th century. However rare a printed book is, it's still one of several copies available. But if you buy manuscripts, every item is completely unique. Manuscripts have been regularly sold since about the 12th century, and since then they've been a solid and steady market presence.

Most surviving pre-modern manuscripts use the codex format (as in a modern book), which had replaced the scroll by Late Antiquity. Some of the most common genres were bibles, books of hours, liturgical texts, religious commentaries, philosophy and law and government texts, with the book of hours the one best known today. A book of hours was used for owners to recite prayers privately eight different times, or hours, of the day. Each book of hours contains a similar collection of texts, prayers, and psalms, and books of hours made for wealthier patrons can be extremely extravagant with full-page miniatures, which is what makes them so valuable.

Though there are fluctuations, values have recently been increasing. There has been in the past five to ten years a significant uptick in interest in manuscripts, not just illuminated medieval manuscripts, books of hours, major literary manuscripts or archives, but also far less canonical items of 'social history', from manuscript commonplace and recipe books to diaries and scrapbooks, and even notes scrawled in the margin of printed works. The overriding-factor here is a "uniqueness" that outpaces the impact of-digitization on the rest of the market.

Historical returns: To be conservative, we can estimate the returns on rare manuscripts to be similar to those of books at around 7% annualized, as

there is no clear index to measure the true returns for the space. However, it is advisable to keep an upward bias with regard to these due to an even higher degree of rarity.

Value drivers:

Core: Scarcity, Rarity, Provenance, Condition, Historical importance

Unique: Age

Scarcity: Making a manuscript is an extremely time consuming process requiring dedication, and expertise of specially trained scribes, as well as artists who illuminated the works in many cases. Given the very long production times, manual process, small number of qualified makers and a limited range of subject matter, there are not that many manuscripts that still exist. Additionally, a large number of examples have been lost due to age, poor storage and even destruction for religious causes.

Rarity: Within the manuscript universe, some types of books stand out due to either outstanding artistic value from miniatures (as in the best books of hours), rarity of the subject matter or quality of material such as parchment, papyrus or vellum.

Provenance: Record of ownership of the book by famous individuals, families or association with specific events or places all contribute to the value. Oftentimes famous readers made notes in the margins, and if these can be conclusively attributed, it increases the value of the book.

Condition: In cases of older documents, some maintenance and restoration may be required to ensure that the book does not get damaged and retains its shape and content. While it is hard to expect manuscripts from the Middle Ages to be found in pristine form, partially due to age, and partially due to books being in heavy use during their lifetimes, the more preserved the specimen is the better.

Historical importance: Groundbreaking works by famous authors of antiquity and middle ages, first books to mention certain places, people, or events, and those that were commissioned for unique purposes by historical figures are all characteristics that enhance value.

Age: As most early books were produced on materials that do not preserve well, it is extremely rare to find a truly old example. Apart from the rarity, older books are more valued because of providing a unique insight into a certain time period.

Top Five highest priced examples:

1-Book of Mormon - $35M

Handwritten printer's manuscript of the Book of Mormon, dating back to 1830. This volume was used to print the earliest copies of the Book of Mormon and was bought by The Church of Jesus Christ of Latter-Day Saints.

2-The Codex Leicester, Leonardo da Vinci — $30.8M

The most famous of da Vinci's scientific journals, the 72-page notebook is filled with the great thinker's handwritten musings and theories on everything from fossils to the movement of water to what makes the moon glow. The manuscript was first purchased in 1717 by Thomas Coke, who later became the Earl of Leicester, and then, in 1980, bought from the Leicester estate by art collector Armand Hammer (whose name the manuscript bore for the fourteen years he owned it), and sold at auction to Bill Gates in 1994.

3-Northumberland Bestiary - $24M

The bestiary served as a sort of religious animal encyclopedia. It was made in 13th century England, by unknown monks.

4-Magna Carta - $21M

The *Magna Carta*, also known as Magna Carta Libertatum, is the thirteenth-century charter drafted by the Archbishop of Canterbury and agreed to by King John of England that laid the foundation for the future of the law as we know it, is one of the most famous texts in history. Today, only 17 copies predating 1300 survive.

5-St Cuthbert Gospel -$14.7M

The St Cuthbert Gospel or Stonyhurst Gospel is a pocket gospel book written in Latin from the 8th century. What makes this book unique is that it's one of the first examples of bookbinding in the world.

Maps

Maps are a symbol of our thirst for knowledge and desire to explore. Their shifting lines chart the course of human history: geography, politics, religion, and culture as well as being beautiful and highly prized works of art. Claudius Ptolemy wrote *Geography* in 150 AD, and is thought to be the first person to actually describe the latitude and longitude of locations, detailing over 8,000 places across the world. Using math and geometry, Ptolemy described locations in such great detail that they were used for hundreds of years afterwards, with cartographers creating the Ptolemaic map in 1300 AD. In 1569 Flemish cartographer Gerardus Mercator created the Nova et Aucta Orbis Terrae Descriptio ad Usum Navigatium Emendate, now known as the "Mercator map projection", that revolutionized navigation by creating a cylindrical projection of Earth designed purely for nautical travel. The model, which became the standard for sea-based navigation, outlined the shape and size of landmasses, making it easier to chart a course.

Everyone in the world has a map of their own, because everyone is from somewhere, or has a place in the world that holds a special place in their heart. There are countless reasons why people like maps. Childhood nostalgia of travelling with their family and using maps to trace their route, fascination with the age of exploration when explorers were sailing uncharted waters and discovering new lands and societies, interest in progress and evolution of a specific city or country over time, affection for the region they are from, a reminder of where they have been, or where they live now.

In an overwhelmingly digital world, maps can feel like outdated relics from an all-too-distant past. It is easy to forget how revolutionary it was, in a pre-Google age, to be able to chart the contours of the Earth. Antique maps teach us about the world – how it is and how it once was – and how perceptions of our planet have changed over the centuries. Just look to the Schedel world map of 1493, where a side panel depicts all the fantastical creatures that were believed to inhabit the farthest corners of the Earth; or to the countless maps from the 17th and 18th century that illustrate California as an island floating out to sea.

There was a time when the world of antique maps was considered to be old-fashioned and stale. Today, this picture has been transformed by the recognition of maps not just as important primary historical sources but also objects of great beauty. Increasing realization of their worth as primary historical documents and a unique way to capture a moment in history have increased the appreciation and value of antique maps as historical and collectible objects over recent decades.

While ancient cartographic material holds an undeniable draw, maps from the 20th century are the fastest growing niche. This is fueled by nostalgia, and an appreciation for a time that once was, by younger generations. The hottest trend in map collecting is 20th-century pictorial maps, which are bold, graphic maps that tell a story beyond the geography they represent. Pictorial maps use artistic and often cartoonish images on a geographical backdrop to educate schoolchildren, encourage tourism, sell products, sway political beliefs, or simply to amuse. Many pictorial maps are still affordable, but they continue to increase in demand and value.

For the investor, the financial prospects of rare map collecting are promising; while maps have been somewhat ignored in comparison to their artistic counterparts in the past, more recently the number of collectors has started to grow. With a limited supply of antique maps on the market, the potential for an increase in value is an obvious analysis. There have also been a significant number of people turning to invest in books and maps in an attempt to balance their investment portfolio in a backlash against the

recession and volatile stock market. In comparison to the art world, there are still many treasures to uncover and the material is relatively undervalued. It is still possible to obtain museum-quality and historically important works. For the price of a single mediocre impressionist painting, one can obtain a truly world class collection of atlases.

Historical performance: The growing demand for the limited supply of antiquarian maps is reflected in the rapid increase in value of the more sought-after pieces. The map market is dominated by collectors rather than speculators and remained virtually immune to the economic fluctuations and recessions that commonly affect art markets. Important antique maps are still remarkably undervalued considering their rarity, beauty and significance. While it is hard to estimate an accurate return for the asset class due to lack of published indices, given the recent auction trends and the dynamic mentioned above we can comfortably expect this asset to return around 10% on annualized basis.

Value drivers:

Core: Scarcity, Rarity, Provenance, Condition, Historical importance

Unique: Age, Maker, Size, Quality

Scarcity: As with other collectibles, creating a themed collection makes the value of the whole larger than the sum of the individual parts. The most valuable collections are those focused on a specific theme such as country, region, period, style, maker or even a quirk, such as maps depicting California or Korea as an island.

There are more collectors of maps of some regions than others, affecting the demand in the market and thus increasing the value of maps of those areas. For instance, world maps have a universal appeal. Among nations there are sizable numbers of collectors for maps of the United States, Great Britain, Germany, Australia, and Canada, and increasingly Japan and China. Within the United States, some of the larger states such as Texas, California, and

Florida have much interest, but the earliest maps of any state or region would be in demand. Some areas that have small populations but are vacation destinations such as Bermuda, Malta, and some of the islands of the West Indies are popular. Areas that are more remote or with smaller less affluent populations have less demand and are often very decorative and well-priced. Some regions such as North America have always been rich in enthusiastic investors, which has ensured that they always fetched premium prices. The economic strength of the area depicted on a map is naturally reflected in the number of potential collectors.

Many maps have a long publication history. For example, there were over 30 editions of Ortelius' monumental work, Theatrum Orbis Terrarum, from 1570 to 1612, and during that period, the individual copper plates from which the maps were printed were revised, repaired, or in some cases, replaced. Earlier versions are better quality and fewer in number and thus more valuable, unless a revision includes a significant discovery or had a shorter print life.

Rarity: Some maps were issued in small numbers and are relatively rare. If other conditions that enhance value are present, the map is further enhanced by rarity, but rarity alone does not create value. Rare maps depict names, places or events for the first time. The first printed map of the Holy Land; the earliest obtainable authentic map with the place name America on it. Map collectors are often drawn to the real rarities such as Abel Buell's A New and Correct Map of the United States of North America from 1784, the first map to have been printed in the newly independent United States, and one of only eight known copies. A category of more modern maps, 19th and 20th century, caricature, propaganda and advertising pieces, seen as giving fundamental historical insights into their time are now hugely collected, but there are not that many of them on the market due to poor paper quality and large number destroyed, making them surprisingly rare.

Provenance: Monarchs and politicians from the Renaissance period had a great thirst for knowledge of the world. As new discoveries were being made

in the New World and in Asia, they wanted to explore new possibilities for trade. The British Library Collection holds what was for centuries the largest atlas ever published, the Klencke Atlas, made specifically for Charles II that is 1.75 meters high and 1.90 meters wide when open, and is said to require six people to carry it. Sometimes maps drawn by explorers themselves come to market, such as the manuscript chart of Livingstone's Zambezi expedition (1858-1864) sold by Christie's in 2010. Drawn by the expedition's surveyor, Francis Skead, to record the journey and the mouths of the river, it provides a direct connection between primary surveillance and the opening up of the interior of Africa.

Condition: Is a crucial factor in assessing the current and likely future value of any piece. The condition of the map will have a bearing on the value - if you have two prints of the same map and one shows signs of mold and has insect holes, it will be worth less than the other in a better state. However, if the damaged map is relatively rare, it will still hold considerable value.

Ideally an old map should be in as close condition to the original as possible. If the original owner put the map aside and rarely consulted it and preserved it well the map can be in "as new" condition but such circumstances are rare. Older paper usually is of high quality and deteriorates only slightly with age, but since about 1820, cheaper paper has been used and this can deteriorate much more quickly.

Top defects to watch out for:

1. Stains. These may be from water, coffee, tea, or wax as these are all things that can fall on the map in the course of its use.

2. Tears. These occur through use. Maps were often folded and are weakest at the folds, where tears normally appear.

3. Margins. It is desirable to have a margin on each side of at least a quarter inch if for no other reason than to enable framing to occur.

4. Creases. Those resulting from mishandling affect value to the extent that they interfere with the appearance of the map.

5. Backing. Maps have often been dry mounted or glued to another surface. This can often reduce the value a great deal, as the glue or backing can contain substances that make the map susceptible to wear, discoloration or other deterioration. Sometimes folded maps have deteriorated to such an extent that they are professionally rebacked with tissue or rice paper. This usually enhances value compared to a map that needs restoration.

When they were produced, some maps were fully colored at the time to enhance appearance and readability, some were partly colored, some were colored in outline, and many not colored at all. Generally, three or four colors (green, pink, orange and yellow) distinguished political subdivisions, black was used for names, red color for cathedrals or other buildings and to distinguish large cities, and blue stood for water. When maps were colored at or close to the time of production, it is referred to as contemporary color as in contemporary to the printing of the map. Often older maps issued without color have color added in whole or in part. Any color added long after the map was issued is referred to as modern color which is less desirable. Many uncolored maps are much more attractive with skillfully applied modern color, but collectors prefer maps only originally issued in color.

There's also a big difference between maps that were separately published in the first place and sheet maps that have been cut out of atlases. So many atlases have been cut up for their maps that whole atlases are now rare and more valuable than the sum of the maps they contain.

Historical importance: Some maps, particularly those of explorers, are the earliest to depict an area or feature, the discovery of a part of the world, or the first correct mapping of an important geographical feature. Other maps might depict an important battle or similar event. Other examples may be imagined geography such as California as an island. Generally the closer such maps date to the event the more importance and thus value they have.

For example, Universalis Cosmographia (1507) by the German cartographer Martin Waldseemuller is the first map to recognize the Pacific Ocean and the separate continent of "America," named in honor of Amerigo Vespucci, who identified the Americas as a distinct landmass.

Age: Is more an enhancement of value than its determinant. For similar maps the older ones generally the more valuable, but age alone does not determine value as some very early maps of regions of relatively little interest have little value. Age and rarity are often synonymous as basically the older a map, the less likely it is to survive, but maps printed in the 20th century, can surprisingly often be rarer than pieces several hundred years older, the result of printing on less durable paper.

Maker: Cartographers attempt the near impossible, rendering a three-dimensional sphere on a flat surface. Historically, the best map-makers had to possess a mathematician's mind, an artist's hand, and the shrewd eye of a businessman. Those with these qualities established themselves as successful cartographic publishers, and set the benchmarks for accuracy and reliability by which maps can be judged to be important.

The Dutch were among the most successful traders and explorers in the 16th and 17th centuries, and the atlases printed and produced in the coastal region of north-western Europe during that period are among the most spectacular of books. Perhaps the most influential of map makers is the Flemish geographer, Gerard Mercator (1512- 1594), who is famous for developing a map projection in which mathematical calculations translated the 3D world onto a 2D surface.

Other famous Dutch cartographers were Willem Janszoon Blaeu (1571 – 1638) who worked for the Dutch East India Company and had access to the updated records of ongoing exploration, and Abraham Ortelius (1527 – 1598), creator of the first modern atlas, the Theatrum Orbis Terrarum (Theatre of the World), first published in 1570. Where two cartographers or publishers are known to have worked together, or took-over publication from one another, they will be listed together, e.g., Mercator/ Hondius.

Size: Generally the larger the map the more opportunity for detail and decoration. Such maps also display well so they are usually more valuable than smaller maps of the same area or event. Some maps are very large and difficult to display, thus reducing their value.

Quality: Some early maps were enhanced with large cartouches, sea monsters, ships and other decorative additions. Such maps display well and thus have greater value.

Subject matter: The geographic region directly affects the value due to market demand. Specific countries, regions or areas command more interest than others. Maps of the world are of global interest and therefore are generally the most expensive maps from a given source. The market in North America is also larger than in South America and therefore demand is higher for maps depicting North America or its constituent parts. Certain geographical regions are more 'interesting' due to historical events or current popularity, i.e., The East Indies, or the wine regions of France. Maps of more remote or less affluent regions tend to be less expensive.

Top Five highest priced examples:

1-Waldseemüller America map - $10M

The map, whose full name is Universalis cosmographia secundum Ptholomaei traditionem et Americi Vespucii aliorumque lustrationes ("The Universal Cosmography according to the Tradition of Ptolemy and the Discoveries of Amerigo Vespucci and others"), is a printed wall map of the world created by German cartographer Martin Waldseemüller in 1507. This is the only surviving copy of this map, which is the first to use the name "America" to describe the New World.

2-Ptolemy's Cosmographia (atlas) - $3.99M

1477 first illustrated edition with 26 copperplate maps of Ptolemy's Cosmographia, translated by humanist Giacomo d'Angelo da Scarperia

published in Bologna by Dominicus de Lapis with the erroneous colophon date of 23 June 1462.

3-Battista Agnese atlas of the world (atlas) - $2.77M

This portolan atlas is attributed to Battista Agnese (1514–1564), one of the most important Italian Renaissance cartographers. Of Genoese origin, Agnese was active in Venice from 1536 until his death. He produced approximately 100 manuscript atlases, of which more than 70 still exist, either with his signature or attributed to his studio. Considered works of art for their high quality and beauty, the atlases are mostly portolan, or nautical, atlases printed on vellum for high-ranking officials or wealthy merchants rather than for use at sea.

4-Abel Buell USA Map - $2.1M

This map produced by Abel Buell in 1784 was the first one of the U.S., made just a year after the Treaty of Paris acknowledged the independence of the US from Britain. It's one of the rarest maps in the world, as only seven known copies exist, this being only the third sold in 120 years.

5-Kunyu Wanguo Quantu- $1M

A 1602 12x5 foot rice paper map showing China at the center of the world produced by Italian missionary Matteo Ricci, created at the behest of Emperor Wanli.

Photographs

Louis Daguerre took the earliest confirmed photograph of a person in 1838 using a technique he developed which would become known to history as "daguerreotype process". He captured a view of a Paris street where one man having his boots polished stood sufficiently still for the several-minutes-long exposure to be visible. The existence of Daguerre's process was publicly announced, without details, on 7 January 1839, and the news created an international sensation. France soon agreed to pay Daguerre a pension in exchange for the right to present his invention to the world as the gift of France, which occurred when complete working instructions were unveiled on 19 August 1839. In October 1839, an American photographer Robert Cornelius is credited with taking the earliest intentional photographic self-portrait of a human made in America.

The first flexible photographic roll film was marketed by George Eastman, founder of Kodak in 1885, but this original "film" was actually a coating on a paper base. Films remained the dominant form of photography until the early 21st century when advances in digital photography drew consumers to digital formats. Although modern photography is dominated by digital users, film continues to be used by enthusiasts and professional photographers. The distinctive "look" of film based photographs compared to digital images is likely due to a combination of factors, including differences in sensitivity, resolution, and continuity of tone.

Hailed as the most democratic of art forms, photographs as a collectible art form only began in the late 1970s or early 1980s. Collectors wanted

ownership and to be involved in the arts, and photographs were a great starting point. Those starting off with photography often went on to build their collections by expanding into other categories like painting and sculpture, making this a type of gateway to collecting art forms. They're hugely accessible, and as the subject matter can relate back to everyday life, a little less conceptual. Photographers are increasingly seen in the same light as painters and sculptors, recognized for their contribution to art history's narrative. We are used to constantly digesting and generating images on our smartphones, making people more comfortable with the medium of photograph, which is easier to understand than a painting.

Historical performance: For lack of a more reliable index, and given that photographs are a form of art, we can expect the returns for this asset class to be in line with the general art indices, which leads us to assume an annualized return of around 5%.

Value metrics:

Core: Scarcity, Rarity, Provenance, Condition, Historical importance

Unique: Maker, Subject

Scarcity: Photography has until now had an ambivalent status in the art collecting world, and for good reason. Collectors value scarcity, and with film or digital pictures it is possible to make an unlimited amount of copies. Photographers have responded by limiting their reproductions to just a few signed limited edition images with just five or ten prints being standard and the negatives kept by the photographer. All the prints in the edition are produced at the same time, so buyers know that there will never be more produced.

Rarity: Limited edition prints, especially the artist or printer's proof versions are deemed rare and so are likely to hold more value. Rare prints are usually single photos or very limited editions that capture an image that is memorable and transcends time and cultures. Emotionally charged moments, iconic portraits, and unusual nature scenes make rarity.

Provenance: The most important thing to ensure authenticity is to have a signature or the artist's stamp on the photograph, qualifying it as an original. Photographer stamps showing the date of production are also important as an image printed as close to the creation of the negative as possible is more valuable. If the subject also signed the photograph, that will additionally increase the value.

Condition: Photographs are most valuable when they are in pristine condition, which given their age is not that difficult given that the owner stores and cares for them properly. Photos should be without creases and handling marks and be kept in good condition behind museum-quality glass, avoiding direct sunlight and water damage.

Historical importance: Some photos capture a unique moment in time and commemorate for posterity the events and people involved. Pictures of historical events involving famous people, capturing the moment of victory or defeat in sports or just candid portraits of well-known individuals, especially those who are camera shy all contribute to this metric. If a famous personality was photographed at a meaningful date, this will make a large difference to the value of the piece.

Maker: Recognized and famous photographers will command higher premiums. If their work has been converted into a book, displayed in an art gallery or a museum and received glowing critic's reviews the value will be multiples higher than the work of an unknown artist.

Subject matter: The importance of the subject, historical or otherwise, plays a role in determining the value of the piece. There are various popular themes, such as nature shots, portraits, gatherings and conceptual pieces, and an exceptional example of each of these will be highly valued.

Top Five highest priced examples:

1- Phantom — Peter Lik (2014) $6.5M

On December 9, 2014, fine art photographer Peter Lik shattered all existing records with the sale of this Phantom black and white image.

2-Rhein II — Andreas Gursky (1999) $4.3M

German photographer Andreas Gursky is known for his large-format architecture and landscape photographs, often taken from above. The C-print mounted to plexiglass was digitally altered by Gursky, who wanting to construct a desolate landscape, removed distracting elements including a factory building, walkers, and cyclists.

3-Spiritual America — Richard Prince (1981) $3.97M

It is one of the most controversial photos in history depicting the 10-year old and naked Brooke Shields. Her childish body is in great contrast with her seductive and mature facial expression.

4-Untitled #96 — Cindy Sherman (1981) $3.9M

Sherman is known for her provocative self-portraits. Sherman used the centerfolds of men's erotic magazines as inspiration for this work. She appears as the complete opposite of a model who we would find in those pictures. Many people claim that her facial expression and body language shows vulnerability.

5-For Her Majesty — Gilbert & George (1973) $3.7M

Gilbert & George are partners in life and work, but the pair is adamant that they are "two people, but one artist." These photographic provocateurs created this installation as a Gelatin Silver print, commemorating drunk evenings of the duo.

Handbags

In 1983, Hermès chief executive Jean-Louis Dumas was seated next to an English actress, Jane Birkin, on a flight from Paris to London. Jane was known for carrying a wicker basket wherever she went and when she tried to fit her famous basket in the overhead compartment, the lid came off, spilling the contents everywhere. Jane complained to her seatmate that it was impossible to find a weekend bag she liked, and the Hermes boss took up the challenge, creating a black supple leather bag for her in 1984. Although Birkins are one of the most exclusive and sought-after bags today, it wasn't until the '90s that the Birkin became one of the ultimate status symbols.

The Birkin bag may be distinguished from the similar Hermès Kelly handbag by the number of its handles: the single-handle handbag is the Kelly; one with two handles is the Birkin. Birkin and Kelly bags generated between €1.7 billion and €2.1 billion of revenue for the brand in 2019. The total number of Birkin bags Hermès produces each year is a well-guarded secret, but it's estimated that there may be around 200,000 total in circulation. Scarcity in the bag market is a large component of value, and Hermès, which keeps its supply below demand and often creates limited-edition pieces, is dominant. Hermès says the lengthy process required to produce the bags, made of premium animal skins that take time to harvest before being hand-sewn by rigorously trained artisans in France, prevents it from meeting demand.

The barrier to getting a Birkin is extremely high with the waiting list implemented by Hermes for a Birkin bag being sometimes as long as six

years, and each buyer only allowed to buy a maximum of two bags per year. To be moved closer to the top of the list, one needs to show that they are a serious and wealthy fan by making large and frequent non-purse purchases such as scarves, shoes and wallets. This has contributed to driving the resale value of Birkin bags upwards, with bags regularly selling on the secondary market for much more than their original price, and they can be repaired for life.

As a status symbol for the elite and ultra-rich, the main factor affecting the secondary market for Birkins is desire. Beyond the media attention, the exclusivity of the bag along with the difficulty in purchasing one brand new from Hermes means demand far outweighs supply on the secondary and investment market for Birkin bags. Unlike the stock market and the regular luxury market, which includes high-end but still relatively accessible goods from brands such as Burberry or Gucci, the ultra-luxury market fluctuates little, even in difficult economic times. There is a difference between luxury and ultra-luxury. While the first suffers during worse economic times, the second is impervious to economic factors that can affect other industries such as high-street retail and stock markets. Along with privately owned watchmakers Rolex and Patek Philippe, Birkin is one of the few brands whose goods are more expensive to buy used than new. For most luxury labels, a used handbag sells at a 35% discount to store prices, but Hermès shoppers can expect to pay a 50% to 100% premium to store prices for unusual colors. In 2019, global sales of luxury handbags at the five leading auction houses were around $30 million. When Hermes reopened some stores in mid-April 2020 after months of widespread closures amid the region's coronavirus lockdown, the brand brought in a whopping $2.7 million in just one day at its flagship store in China alone.

Historical performance: Hermes Birkin handbags have only experienced various levels of positive fluctuation since their introduction 35 years ago. The Birkin bag outpaced the S&P 500 in the last 35 years, with an annual return of 14.2%, compared to the S&P average of 8.7% a year.

Value metrics:

Core: Scarcity, Rarity, Provenance, Condition

Scarcity: Production of the Birkin and Kelly bags is strictly rationed, with approximately 70,000 units made every year. The waiting list for the bag is about six years. It takes about 48 hours of work by highly trained artisans to manually make each bag, as the stitch used cannot be replicated by a machine; it takes two needles simultaneously passing through the same seam to produce a Birkin correctly. Additional scarcity is introduced by limited amount of exotic skins available, and if precious metals and jewels are part of the bag. Birkins are distributed to Hermès boutiques on unpredictable schedules and in limited quantities, which creates artificial scarcity and exclusivity.

Rarity: The key contributors to rarity are color and skin type used. Some of the top models, like Himalaya Birkin (the designation 'Himalaya' does not apply to the origin of the bag, but rather to the color, said to resemble snow-capped Himalayas) are made in extremely limited numbers, it is believed that only one or two of these bags made from dyed crocodile skin are produced each year by the Hermès atelier. The process of dyeing a crocodile hide is time-consuming and exponentially more difficult as the shades lighten; to create the immaculate white of the snow you have to remove all of its natural pigment.

Provenance: Proof that the bag is original includes receipts, packaging, lifetime repair warranty, and any other accompanying documents to verify authenticity. Each Hermes handbag has the Hermes logo embossed in gold or silver print to match the corresponding hardware. The date code, known as "blind stamp", indicates the date of manufacture and can also be used in authenticating a bag.

Hermes does not issue an authenticity card, and if the bag comes with an orange plastic credit card that say "Hermes" it is most definitely a fake. The only papers that come with a Hermès handbags are CITES (Convention on International Trade in Endangered Species) certificates which accompany exotic skin bags made from Lizard, Alligator or Crocodile skins.

Condition: The bag should be in new and ideally unused condition, although minimal use is still acceptable and does not greatly detract from the value. Additionally all the original items included with the bag must be present (keys, lock, clochette, dust bag and leather card).

Top Five highest priced examples:

1-Hermès Birkin Bag by Ginza Tanaka: $1.9M

Created by Japanese designer Ginza Tanaka, this bling-y piece combines platinum, 2,000 diamonds, and a pear-shaped eight-karat stone that can also be removed and worn as a brooch. The bag's diamond sling can also be worn as a bracelet or necklace.

2-2012 Birkin Sac Bijou: $1.9M

Created by Pierre Hardy, creative director of fine jewelry at Hermès, the Birkin Sac Bijou is made entirely of rose gold and studded with 2,712 diamonds, with only three models made.

3-Hermès Himalaya-$379,261

White Niloticus crocodile Hermès Himalaya encrusted with more than 240 diamonds (10.23 carats) on its 18-karat-gold hardware.

4-Hermes Himalaya - $300,168

An unused 12-inch matte Himalayan crocodile handbag, with white-gold hardware set with 245 F-color diamonds weighing close to 10 carats.

5-Blood red braise shiny porosus crocodile: $298,000

Designed in Porosus crocodile skin, 18-karat white gold, and diamond-studded hardware

Miscellaneous

There is a key distinction to be drawn between a collectible curiosity with a few interesting high end samples and a robust deep market capable of accommodating ongoing demand. There are many fascinating collectible asset classes that, due to their limited volume, low price point for investment grade specimens, highly idiosyncratic features, or difficulty in applying value metrics and estimating their worth, do not qualify for investment as a separate standalone asset class. There are also some bizarre examples, like a Luxembourg-based company creating a new collectible asset class from tins of sardines that improve with time like good wines, as the fish bones disappear and the flesh of the fish is candied.

Instead of completely eliminating all items from these asset classes, it makes more sense to create an opportunistic portfolio that contains the cream of the crop items from these non-core asset classes. This allows for a unique way to take advantage of some extremely rare, desirable and highly valuable assets which create value and add to diversification benefits, while optimizing research, analysis and due diligence efforts to focus on areas with highest impact on the total portfolio.

Below we explore some asset classes that for reasons outlined above do not pass the screen to qualify as a core asset class, but nonetheless have great potential for their top level investment grade items to be included in the Opportunistic portfolio containing a medley of diverse treasures.

Gems

In ancient times gemstones, together with gold and silver, were used as forms of money because of their universal value. They were and still are a concentrated form of wealth that comes close to a true currency, because they're rare, transferable, durable, and portable. The world demand for fine gemstones far exceeds the supply, and gemstone prices mainly move upward over time. Gemstones are a product of nature that take hundreds of millions of years to form; it is not a created-on-demand product but a rare, precious, durable and incredibly beautiful one. There is such a limited supply that their value cannot be swayed by government interference or price manipulation, because there is not a hidden stockpile or mine.

Top specimens of nearly every gem type are collectible, with the most popular gemstone for investors being the diamond. In India, diamonds were thought to be created when bolts of lightning struck rocks. Plato wrote that these stones were alive, containing celestial spirits. By the 15th century, Venice had perfected the diamond-cutting process, further mesmerizing royalty and the aristocracy. Only 0.1% of all mined diamonds are colored. Green, orange, pink, blue, and yellow are extraordinary finds, but pure red diamonds are almost completely unheard of.

Other gemstones like the ruby and the emerald are also considered excellent investments. Romans believed that emeralds could restore their vision and Egyptians maintained these green stones would ease childbirth and ward off evil spirits. Transparent emeralds are extremely rare. In fact, flaws (called inclusions) are often overlooked and celebrated like a type of fingerprint.

Rubies have long been linked to fortune and healing. Ancient Hindus believed that by offering rubies as a tribute to Krishna, they would be reincarnated as rulers. Ivan the Terrible believed that powdered ruby could improve the heart and memory. Burmese warriors wore these stones under their skin for protection. Pigeon's blood red is the ideal color, and considered far more valuable than a diamond of a similar size.

When buying gemstones for investment purposes, it is critical to buy top grade gems. Fine gemstones are distinguished by vivid, intense color, outstanding clarity, and excellent cut. There are two processes through which gems take a substantial jump in price; between rough and cut and between loose gems and finished jewelry (to be covered in the next section). These involve more effort, but they're some of the best ways to increase gem values. Rough gems, cut gems, and finished jewelry all hold investment potential.

Investment grade has no clear meaning when applied to gemstones. Like the terms "precious" and "semiprecious" stones, it's too broad and has too many exceptions. Diamonds that can safely be considered "investment grade" are Fancy Vivid pink or blue diamonds larger than three carats, preferably emerald- or round-cut; white diamonds over five carats that are D flawless or internally flawless; and vivid yellow diamonds over 10 carats.

Fine unheated Burmese rubies over five carats, the rarest of all colored gems, draw prices as high as $300,000 to $400,000 a carat at auction. Vivid red, known in the trade as "pigeon's blood" is the most valuable color. Rubies tend to have inclusions, so color is more important than perfect clarity. Blue sapphire over five carats is the second most popular colored stone for investment. The rarest sapphires are from Kashmir, but no new material has been mined there in more than 100 years. Next most valuable is Burma sapphire, followed by Ceylon and Madagascar. Fine untreated Colombian emeralds, over 10 carats, are also quite valuable, followed by the top Brazilian emeralds.

Historical performance: The colored gem market exhibits steady, but somewhat subdued performance averaging around 6% annual returns on long term basis, with last year's returns flat to slightly negative.

Value metrics:

Core: Scarcity, Rarity, Provenance, Condition, Historical importance

Unique: Quality, Region

Scarcity: This is primarily defined by gem type and site of origin, which is the key for colored stones. As there are originally limited quantities of gems at any given locale, and even fewer left today, the supply of high quality stones is quite limited.

Rarity: A gemstone chosen for buying should be fairly rare such as emerald, ruby, diamond or sapphire. Many semi-precious gemstones like amethyst, garnets and opals are pretty, but not generally investment worthy. There are also other less known gems which are very rare, such as taaffeite, benitoite, tanzanite, poudretteite, jadeite, red beryl, black opal, and grandidierite which hold some value due to their extreme rarity but are not advisable as part of an investment portfolio.

Provenance: Distinguishing natural from synthetic gems is critical as it could mean the difference between valuing a gemstone at thousands of dollars per carat or just a couple of dollars. Natural gems are those formed in the Earth, while synthetic ones are duplicates of natural gems grown in the lab and while they look almost indistinguishable to the naked eye they lack scarcity and rarity that a natural gem possesses. Independent lab certification from a reputed gem lab is required to make sure the stone is what it appears to be.

Condition: A high-quality small stone, without imperfections or inclusions will retain more value than a larger stone of mediocre quality. Gems are rated by GIA (Gemological Institute of America), a non-profit institute dedicated to research and education in the field of gemology and the jewelry arts and based in Carlsbad, California. The GIA Laboratory provides a variety of gem grading and identification reports for diamonds and colored stones, and generally include color, clarity, cut and carat weight as well as comments about any treatments detected and an opinion of country of origin for colored stones.

Historical importance: Many gems have been associated with famous people and rulers throughout history, and have often graced various crowns and other symbols of power.

Quality: The overall quality of the gem can be judged by reviewing its color, clarity, and cut, as well as an overall impression of the piece.

Region: Certain areas are known for producing the best gems of its kind in the world, and as a result the region from which the stone came matters. The value of gems is magnified when they come from specific sites known to produce the best quality. Burmese pigeon blood rubies, cornflower-blue Kashmir sapphires and deep green Colombian emeralds are examples of such stones.

Top Five highest priced examples:

The below examples represent the most valuable gems that exist on the planet today. As another way to look at values, here are the most expensive stones on per carat basis:

Tanzanite—$1,200 per carat
Black Opal—$9,500 per carat
Red Beryl—$10,000 per carat
Musgravite—$35,000 per carat
Alexandrite—$70,000 per carat
Emerald—$305,000 per carat
Ruby—$1.18 million per carat
Pink Diamond—$1.19 million per carat
Jadeite—$3 million per carat
Blue Diamond—$3.93 million per carat

1-Pink Diamond: Pink Star- $71.2M

This 59.60ct oval Internally Flawless Fancy Vivid Pink diamond was mined by DeBeers in South Africa in 1999 and is the largest Vivid Pink diamond on record. It was originally cut from a 132.5 carat rough diamond, and it took 20 months of cutting for the stone to take its current shape. It is the largest Internally Flawless Fancy Vivid Pink diamond that the Gemological Institute of America (GIA) has ever graded and it has received the highest color and clarity grades from the GIA.

2-Blue Diamond: Oppenheimer – $57.5M

At 14.62ct, the Oppenheimer Blue is the largest Vivid Blue to ever be sold at auction. This emerald cut diamond was named in honor of its previous owner, Sir Philip Oppenheimer, whose family once controlled the legendary DeBeers company.

3-Blue Moon of Josephine – $48.4M

This 12.03 ct diamond with a rare crystal blue color discovered in 2014 in South Africa was bought by fugitive Hong Kong billionaire Joseph Lau Luen-hung for his seven-year-old daughter Josephine, after whom he named the stone.

4-The Graff Pink - $46.2M

A nearly 25-carat very rare pink diamond, believed to be one of the greatest pink stones ever discovered.

5-Orange Diamond: The Orange – $35.5M

Believed to be the world's largest and most expensive orange diamond at 14.82ct, this pear shaped Fancy Vivid Orange diamond is exceptionally rare, as most orange diamonds also display a secondary color.

Jewelry

The notion that jewelry retains its value is ingrained in traditions and cultures around the world. Tribal people sometimes use beads as currency, and jewelry may be offered as a wedding dowry. The implication is that jewelry endures and retains its value over the long term. Jewelry as a valuable asset is a tradition that has been handed down in different cultures throughout history.

Jewelry is portable which makes it an easy asset to carry across borders and store at home. It can easily be carried away if one has to leave in a hurry.

Gold rings, necklaces and diamonds have often been smuggled by refugees forced to flee a country and wanting to take their wealth with them. Precious jewelry retains its value across the globe and is easy to quickly convert to cash.

The value of jewelry can be influenced by underlying movements in gold and gemstone markets, but quality jewelry is usually worth considerably more than the sum of its component materials. Buying rare and signed one-of-a-kind jewelry is similar to buying fine art, but pieces don't have to be signed to be collectible and solid investments. Jewelry pieces that prove to be a good investment, are normally authentic vintage or antique pieces in excellent condition and representative of the period they were designed.

Historical performance: As high end jewelry's value is mostly derived from the value of the impressive stones around which the object is formed, its returns are in line with gems, but slightly higher due to a great deal of value added craftsmanship, being in the neighborhood of 8% annualized.

Value metrics:

Core: Scarcity, Rarity, Provenance, Condition, Historical importance

Unique: Brand, Quality, Size

Scarcity: As there is a natural limit to the amount of objects that a skilled craftsman can produce and an artist design, there is a natural cap on the amount of pieces that are released to the market each year. For a given brand this is compounded by the importance of location, as the location where a jeweler made a piece can also affect its value. For instance, vintage Cartier pieces made in France are worth more than Cartier pieces made in New York.

Rarity: As always, uniqueness plays a role in how valuable something is. The rarer a piece of jewelry is, the more likely it is to appreciate in value assuming fine craftsmanship and high quality materials. For example, natural pearls are undergoing resurgence in popularity, as until the 1920s,

when affordable cultured pearls came in, it could take decades to assemble a string of matching natural pearls, and the intrinsic worth of such pearls is now being recognized.

Provenance: A famous piece of jewelry, or one that was crafted by a master, or a respected designer is more likely to retain its value, and even appreciate. On top of that, a piece of jewelry owned by someone famous is likely to be more valuable. If a piece belonged to noteworthy members of society, such as Hollywood legends, blue-blood elites and royal families, that can add several zeros to the final asking prices.

Condition: The overall appearance of the piece, degree of preservation, all the original materials and stones being intact are all important in determining the value of the piece.

Historical importance: Objects gifted by or to important historical figures or made to commemorate certain events carry additional historical significance and command higher prices.

Brand: Jewelry from the collections of the world's top designers retains its value, as they are known for using high-quality stones and precious metals in each piece. They produce distinctive jewelry for celebrities and royalty, and limited edition collections and their pieces appreciate with each passing year because they are unique and of proven exceptional quality.

Jewelry from Art Deco and later periods incorporating platinum and diamonds signed by Bovin, Boucheron, Cartier, Tiffany, Bulgari, Van Cleef or Arpels is particularly sought after because their pieces were of exceptional quality. Cartier's 'Tutti Frutti' bracelet which boasts an explosion of emeralds, rubies, sapphires and diamonds and can take an extravagant amount of hours to craft, sold in 2002 for around $400,000, and for almost a million dollars in 2016.

Quality: A high quality stone is always much more valuable than one with low quality. If stones that form the piece of jewelry are of high caliber, it will

make the entire object more valuable. If there are many smaller stones in the piece, it will be valued more based on its artistic and aesthetic virtues. However, if the piece includes a significant stone, the value of the stone becomes the key determinant of value for the entire piece.

Top Five highest priced examples:

1-The Hope Diamond - $250 M

Perhaps the most famous jewel in the world is a 45.52 carat blue stone known as the Hope Diamond with unusual blue coloring coming from impurities caused by trace amounts of boron atoms. In 1666, it was bought by a French gem merchant named Jean-Baptiste Tavernier and named the Tavernier Blue. Not too long after, it was cut and renamed the French Blue, under which name it was sold in 1668 by Tavernier to King Louis XIV. In 1792, the French Blue was stolen from the royal family and cut again and the largest section of what remained of the diamond was named Hope upon its appearance in a London banking family's gem collection in 1839. The Hope diamond is surrounded by sixteen white diamonds and has been attached to a diamond necklace.

2-A Heritage in Bloom - $200M

This masterpiece creation of Wallace Chan, is made of precious stones of 383.4 carats, weighs half a pound and took nearly 47,000 hours for the craftsmen to make. The craftsman used six hundred pink diamonds, one hundred and fourteen icy-green jadeites, seventy-two white-mutton jades and nineteen divine-colorless diamonds to make this beautiful piece.

3-Peacock Brooch — $100M

The Peacock Brooch was first released in 2013 at the TEFAF Art Fair in the Netherlands. The brooch, shaped like a peacock with fanned feathers, contains a total of 120.81 carats and over 1,300 stones in white, yellow, blue, and orange diamonds. A very rare, dark blue pear-shaped diamond sits at the center, and alone totals 20.02 carats.

4-L'Incomparable Diamond Necklace – $55M

Set on a bed of 18k gold are 407.48 carats of diamonds that make up the L'Incomparable Diamond necklaces. At its center is the largest Internally Flawless yellow diamond known, which is about the size of an egg. The large diamond at the center of the necklace was discovered randomly in a pile of mining rubble roughly 30 years ago.

5-The Hutton-Mdivani Jadeite Necklace – $27.4M

This famous piece of jade jewelry made of 27 graduated jadeite beads, with a clasp of 18k yellow gold, rubies, and diamonds, has a notable history in royalty. Its previous owner, American socialite and heiress Barbara Hutton, was gifted the necklace by her father as a wedding gift for her marriage to Georgian Prince Alexis Mdivani in 1933. The necklace itself is an exceptional piece of jewelry due to the fact that such high quality jade usually cannot yield beads more than 10mm in diameter due to the scarcity of jadeite boulders. With each bead of the necklace measuring over 15mm in diameter and all beads carved from the same boulder, the Hutton-Mdivani Jadeite necklace is a true rarity, hence its price.

Cigars

The word cigar originated from "sikar", the Mayan-Indian word for smoking, which became cigarro in Spanish, although the word itself, and variations on it, did not come into general use until the mid-18th century. Cigars, more or less in the form that we know them today, were first made in Spain in the early 18th century, using Cuban tobacco. At that time, no cigars were exported from Cuba.

The cigar arrived in North America in 1762, when Israel Putnam, later an American general in the American War of Independence (1774-1778), returned from Cuba, where he had served in the British army with a selection of Havana cigars and large amounts of Cuban tobacco seed. Cigar factories were later set

up in the Connecticut area, processing the tobacco grown from the Cuban stock. Cigar smoking did not really boom in the United States until around the time of the Civil War in the 1860s, with individual brands emerging by the late 19th century, and cigars becoming a status symbol. During the same period, cigar smoking had become so popular among gentlemen in Britain and France that European trains introduced smoking cars to accommodate them, and hotels and clubs boasted smoking rooms. The after-dinner cigar, accompanied by glasses of port or brandy, also became a tradition.

There are few other hobbies in which collectors continuously destroy their prized possessions for the sheer pleasure of it. But lately that perspective has been shifting toward that of the wine aficionados who curate their cellars based not only on the pleasure principle but also on their ever-increasing values. Often associated with celebrations and prestige, viewing cigars as an investment is an increasing trend among cigar smokers, collectors, and investors worldwide. A good box of cigars, if stored correctly and of the correct vitola (measurement), brand and series will soar in value as the tobacco ages and other cigars of the same vitola become scarce. Cigars from a good vintage continually mature, evolve and improve, much like a fine wine.

There is an increase of hand-made Cuban cigars being bought across the globe, particularly in countries like China, which helped Habanos S.A reach approximately $500 million in sales during 2017. The market for collectible cigars is young, and largely supported by those investing in wine and similar commodities. Since the late 1990s auction houses such as Bonhams in the United States and Christie's and C. Gars in London started selling cigars, often at the end of a wine and spirits auction.

Although non-Cuban brands from the Dominican Republic and the US have proliferated in production and popularity, it's the Cuban variety that collectors desire most, such as limited editions of Dunhill, Davidoff, Cohiba, Partagas, Montecristo, sought-after Cuban brands, with established reputations for quality. They are the best of the best in terms of blending, construction and appearance. These brands, if stored properly and unused,

have a good chance of rising in value due to their consumable nature. Most exclusive and rare are Limited Edition Cigars and Regional Editions Cigars. The Limited Editions (Edicion Limitada), are made with unique or unusual sizes, tobacco aged for at least two years, and are only produced in the same year that they are crafted. With Regional Editions, the cigars are sold exclusively in a regional market and are on sale for two years, until Habanos S.A decides whether to stock them in regular production.

The rarest category of collectible Cuban cigars was produced before February 3, 1962, the date President John F. Kennedy signed Proclamation 3447, which banned all U.S. trade with Cuba. Pre-embargo Havanas are the only Cuban cigars that Americans can legally possess, provided there is documentation, such as a tax stamp or a sales receipt, proving that the cigars were purchased before the embargo. These cigars command premium prices if they have been stored correctly, not only because they can be legally bought and sold in the United States but also because many of them have mellowed and matured, like a fine vintage port. The best cigars, like rare wines, increase in value for two reasons. They grow rarer as collectors smoke their specimens and, if stored correctly, taste improves over time

In many ways, the embargo was the best thing to happen for cigar collecting, because it resulted in Cuban cigar makers and tobacco growers migrating to the Dominican Republic, Honduras, and Nicaragua, which are now the three most prolific cigar-producing countries outside of Cuba.

Historical performance: The demand for high end cigars has exploded worldwide, leading to a rather robust annual return of around 12% for top of the line items.

Value metrics:

Core: Scarcity, Rarity, Provenance, Condition

Unique: Age, Brand, Size, Rating, Shape, Quality

Scarcity: With cigars, this is defined by a combination of factors, including size, wrapper, manufacturing type, country of origin and time made. There is natural scarcity due to the fact that there is a limited amount of high quality tobacco available, as well as a labor intensive and time consuming production process. As cigars need to age to reach peak performance, this is another very natural element contributing to scarcity as there is a very finite number of cigars from a given year in the past and that number can never be increased.

Rarity: For super premium lines, production is restricted to a few thousand, or even hundreds. Habanos, the Cuban state tobacco company, releases three limited-edition cigars a year, and there is only one run of these cigars produced, all tobacco used having been aged for a minimum of two years prior to the cigar being rolled. Select distributors work with Habanos to produce a set amount of a cigar that will be exclusively available in their region, and these regional editions are highly sought after among collectors and aficionados. There are some cigars that are just so rare that even veteran collectors and aficionados may never have seen or smoked them.

Provenance: Means records proving that the cigar was sourced from a reliable vendor, all seals are intact and condition of cigars and boxes is pristine. It also has to have documentation that it was stored in a humidor that keeps cigars by maintaining them in conditions similar to those in which their tobacco grew, fermented and rolled; temperature around 65 degrees Fahrenheit (17 Celsius) and 65% relative humidity with no direct sunlight are ideal.

Condition: Cigar condition is key, as a damaged cigar loses most of its value. Optimal conditions will ensure that the cigars are not exposed to too much (or too little) humidity, will keep the oils in the leaves, and will ward off mold. Keeping cigars in the right conditions will also stop them from harboring the 'tobacco beetle' (lasioderma serricorne), which would render the cigars worthless. Soft spots, uneven construction, and mold can be red flags. The cellophane wrappers on older cigars should have a soft, oily brown patina.

Age: Like wine, cigars have a series of peaks in which their flavors ebb and flow, and there is no real way to tell if a cigar has aged well without

sampling it. That means collectors should expect some "luck of the draw" when purchasing extremely old cigars, even if they have been well humidified and have a fine bouquet. Some Cuban cigars can be aged forty years or more, mellowing as time passes depending on brand, blend, and storage conditions, but there is a point of no return when the cigar may become totally bland. On average, all cigars are best smoked at ten to twenty years of age. The limited edition cigars allowed to age under optimum conditions are considered the most desirable. Cigars can be stored indefinitely in a humidor, as long as the correct conditions are maintained.

Brand: It is important to purchase only the best known and highly reputable brands. The best cigars to purchase as investments are Habanos limited editions (with signature dark wrappers), and those from the larger brands such as Cohiba, Montecristo, Romeo y Julietas, Partagas, Dunhill, Hoyo de Monterey, H. Upmann and Davidoff. In 2019 Habanos S.A., the Cuban cigar monopoly, has simplified the way it classifies cigars into two main categories: Global Brands and Portfolio Brands. The Global category consists of six of the country's best-known brands: Cohiba, H. Upmann, Hoyo de Monterrey, Montecristo, Partagás and Romeo y Julieta. Those brands are sold in every market where Cuban cigars are available, and in all La Casa del Habano shops around the world. The Portfolio category is made up of 21 brands, divided into three sub-categories: high-value brands, volume brands, and an umbrella category called "other".

Size: There is no correlation between the size of a cigar and its strength, but larger sizes are in greater demand than smaller sizes, although there are exceptions. Many large-format cigars, especially double corona and Churchill sizes, are in extremely limited supply, primarily due to shortage in large wrapper tobacco. With less top-quality wrapper leaf available to serious cigar manufacturers, many are finding it harder and harder to produce larger-sized cigars, which usually are their flagship sizes. It may take as long as three years for new wrapper tobacco to find its way to a cigar; one year of growing, six months of processing and an additional 18 months of aging. In a good year, only 10 percent to 15 percent of a plantation's harvest may be of sufficient quality to be classified as wrapper.

Although the metric system has been compulsory in Cuba since 1858, cigars are usually measured in inches according to their length and ring gauge. The length is simply measured in inches such as a Corona, which is usually 5.25" long, and the ring gauge, the cigar's diameter, is measured by 64ths of an inch rather than a decimal. Most cigars can be categorized among the 12 common sizes from smallest to largest: Petit Corona (4.5×42) Gordito (4.5×60) Robusto (5×50) Corona (5.25×44) Toro (6×50) Gordo (6×60) Panatela (6×34) Lonsdale (6.5×42) Churchill (7×48) Lancero (7.5×38) Double Corona (7.5×50) Gran Corona (9.25×47).

Rating: Scoring well in Cigar Insider and Cigar Aficionado ratings can help increase the value of the cigar. Cigar Aficionado's scores on a 100-point scale with scores of 90 points or higher considered as investment grade. Scoring is based on Flavor 45%, Complexity 10%, Balance 5%, Burn 10%, Draw 10% and Overall Impressions 20%.

Shape (vitola): Shape will affect the fullness of the flavor, the heat of the smoke, and the length of the burn of the cigar in question. It is generally accepted that parejos, will burn longer than most figurados, though this is largely dependent upon the strength of the individual smoker's draw. Cigars are limited in shape to Parejo and Figurado. Parejo, which means "flush" or "straight" in Spanish, is the classic cigar shape, straight with one rounded capped end called "the head" and a flat open end known as "the foot". Anything that isn't a Parejo is simply referred to as a Figurado. There isn't a single type of Figurado cigar, but the main ones are Torpedo, Belicoso, Pirámide, and Perfecto.

Quality: The quality of a cigar is primarily a function of the tobacco used, especially a wrapper and the method in which it was produced. The outer leaf surrounding a cigar is significant, as a poor wrapper can ruin the appearance of a cigar and throw off the balance of its tobacco blend, making it smoke harshly or unevenly. Being the only directly visible tobacco leaf, the wrapper is often the focus of attention from enthusiasts. To be considered a truly alluring wrapper, the leaf should be thin and delicate while featuring as

few visible veins as possible. The result should feature a smooth texture with a glistening sheen of rich oils.

Darker-wrapper leaf is generally more attractive and achieves higher prices than lighter-wrapper leaf. Cuba, and practically every other premium cigar maker, meticulously color-sorts its hand-rolled cigars to ensure that those in each box have matched wrappers in the same shade of brown. Significant variations in color and size can be an obvious sign of counterfeits.

There are seven basic color distinctions among wrappers ranging from light green to completely dark: Candela, Claro, Colorado claro, Colorado, Colorado Maduro, Maduro, Oscuro.

Hand rolled cigars are much better quality than machine rolled cigars. They are comprised only of tobacco where the filler, binder, and wrapper tobacco leaves have been grown, aged, cured, and fermented according to their intended use, without additives. Hand rolled cigars are also more likely to have properly spaced filler tobacco that allows the right amount of air flow through the cigar; machines may roll filler too tight or too loose.

Top Five highest priced examples:

1-Gurkha Royal Courtesan Cigar – $1M per box ($25,000/cigar)

Each one of 40 hand-rolled cigars is infused with the delectable Remy Martin Black Pearl Louis XIII, which sells for $165k a bottle. To ensure perfect production quality, only selected hand rollers are permitted to lever the cigars. In addition, all the artisans are blindfolded to heighten their senses so that their movements are natural with minimal distractions. The Royal Courtesan cigar is filled with rare Himalayan tobacco that has been watered only with Fiji water. Each piece is wrapped in gold leaf and the band is embellished with diamonds totaling up to five carats.

2-Gurkha Black Dragon – $115,000 per box ($1,150 per cigar)

The Gurkha Black Dragon cigar packs a robust punch as it is made from fine tobacco leaves that are rolled in Honduras. Each leathery and peaty cigar measures 8.5 inches by 52 ring gauge. The cigars are placed in limited edition handcrafted camel bone boxes with 100 pieces in one box.

3-Gurkha His Majesty's Reserve – $15,000 per box ($750 per cigar)

This brand is made with 18-year-old tobaccos and it boasts rich chocolate undertones. To add to the taste, each roll is enhanced with the premium and rare Louis XIII Cognac. The Gurkha company makes less than 100 boxes of 20 of this amazing product each year and the enterprise's president decides to whom they should be allotted.

4-Mayan Sicars – $507,000 per Box ($634 per cigar)

The ancient Mayans smoked tobacco and this is proved by the discovery of 800 pre-Columbian cigars in Guatemala in 2012. The cigars were dated back to 600 years ago, but they are still fit to be smoked even today.

5-Cohiba Behike – $18,000 per box ($450/cigar)

Famed Cuban cigar manufacturer Cohiba released this brand in 2006 to celebrate its 40th anniversary. It was named Behike to honor a noted chieftain of the Taino Indians. The cigars are made with select tobacco and only 100 humidors were made, each hosting 40 rolls. Because they proved to be very popular, Cohiba released less expensive versions of this product later. Expert roller Norma Fernandez Sastre made all the 4,000 cigars of this product line. They are grown and blended at El Laguito Cohiba factory and are sized at 52 inches and have a length of 7.5 inches.

Gaming cards

Most collectibles gain some of their value from nostalgia, and there are a few collectibles that not only have that emotional and nostalgic appeal, but also stand the test of time. With the rise of non-sports card collecting, both vintage "Magic: The Gathering" collectible trading cards and vintage "Pokemon" collectible trading cards are some of the hottest high-dollar items on the market today continuing to set new records at auction after auction. Much like comic book collecting, trading card collecting has grown up. PSA and BGS, the premier grading firms in the baseball card space, grade and authenticate popular collectible trading cards such as "Magic: The Gathering" and "Pokemon" cards.

Magic the Gathering:

In the early '90s a scientist named Richard Garfield approached game publisher Wizards of the Coast with an idea for a board game called Robo Rally. They turned him down, because his prospective design was too expensive for the company's then-meager production capabilities, but they asked if he could come up with something lighter and faster to play. Garfield returned with the concept for a collectible card game in which players would tear open randomly-sorted booster packs in hopes of unwrapping powerful cards to add to a store-bought starter deck. "Magic The Gathering" made its debut in the July of 1993, and by the end of the summer Wizards had already sold out of their initial 2.6 million card print run.

"Magic: The Gathering" is a trading/collectible card game with each player working to assemble a deck composed of cards that will result in best odds of winning a match. It can be played in various rule formats, which fall into two categories: constructed and limited. Each game of Magic represents a battle between wizards known as "planeswalkers" who cast spells, use artifacts, and summon creatures as depicted on individual cards in order to

defeat their opponents. Although the original concept of the game drew heavily from the motifs of traditional fantasy role-playing games such as Dungeons & Dragons, the gameplay bears little similarity to pencil-and-paper adventure games, while simultaneously having substantially more cards and more complex rules than many other card games.

There are online communities hundreds of thousands strong dedicated to speculation and MTG card trading. Over 20 million people in 70 countries play Magic today, and there are several pro tours with millions in prizes. Magic can be played by two or more players, either in person with printed cards or on a computer, smartphone or tablet with virtual cards through the Internet-based software Magic: The Gathering Online or other video games such as Magic: The Gathering Arena. Netflix has partnered with Hasbro to produce a show set in the Magic universe, that could very well lead to prequels, sequels and spinoffs in the footsteps of fantasy epics like Lord of the Rings, Game of Thrones, and Harry Potter.

Magic has remained consistently popular over the last quarter century and one of the key things that keeps its value stable is a social contract it has with their customers, called the "Reserved List." In 1996, Wizards guaranteed that a handful of cards from the game's earliest sets would never be printed again in "a functionally identical form". This helps to preserve the value of rare cards, which become even more rare over time as they're lost, damaged, or enter permanent collections. While "Magic The Gathering" is the most popular tabletop game in the world, there are only 13,000 copies of some of the Reserved List cards in circulation. That ensures an environment where a huge swath of the player base will never get the chance to play with, say, a Black Lotus or a Time Walk.

Most desired are cards from the vintage 1993 and 1994 printing of Magic, i.e. Alpha or Beta, the Magic community's nickname for the game's first two print runs, from Arabian Nights, Antiquities, or Legends, the game's first three expansions. The cream of the crop are those that are a part of the Power Nine, a set of extremely rare cards with powerful effects, giving any

player who has them a huge advantage over their opponent. These are Black Lotus, Time Walk, Ancestral Recall, Timetwister, Mox Emerald, Mox Jet, Mox Pearl, Mox Ruby and Mox Sapphire.

Historical performance: Given the dedicated, loyal, and growing global following, it is no wonder that the returns for the top end of this unique useable asset have been some of the highest in the collectible space at around 15% annualized return. This estimate applies both to MTG and Pokemon cards.

Value metrics:

Core: Scarcity, Rarity, Condition

Scarcity: "Magic: The Gathering" cards, raw or graded, have a strong secondary market driven by four types of buyers: avid collectors, players, investors, and speculators. Graded cards appeal more to investors than players, and hence are more resilient to things that have a major impact on most MTG cards: decline in the popularity of the game, specific cards banned from playing, or new sets that come out. The Reserved List, guaranteeing that cards from the game's earliest sets would never be printed again, ensures the scarcity aspect of top cards.

Rarity: Iconic cards that are no longer being printed and that were originally printed with a low run are key. The 10-20 top iconic cards in the game are the rarest, but the golden standard is Alpha, the first and most limited print run. Alpha cards are easily distinguishable from Beta cards as unlike all succeeding sets, cards from Alpha have steeply rounded corners. There were about 1,100 copies of each Alpha Rare printed, and there's estimated to be about 500 of each left in existence. A rather unique part of knowing which cards will increase in value is knowing how well they play in the game. During the prestigious Magic Grand Prix tournament, which happens four times a year, the top players in the world show off the best decks in the game for a Twitch audience and game-winning cards in those decks immediately spike in value.

Condition: The most in demand cards are the graded examples with very high grades. Unlike sports cards, a PSA 7 card is not considered in particularly good shape because the cards are only 30 years old and many of them have been preserved well; the value is in the PSA/BGS 9 to 10 graded cards. Grading companies give a sense of security for less knowledgeable investors who want to avoid counterfeits, and provide value to the truly dedicated collectors who want to have the most flawless piece of anything they collect.

Top Five highest priced examples:

1-Black Lotus - $166,100

The "Holy Grail" of Magic: The Gathering, this particular card transcends the game in such a way that its use will be read about on gaming site news. This is THE Magic card that everybody dreams of owning, and only 1,100 were ever released. The BGS 9.5 rated Limited Edition Alpha Black Lotus was last sold for $166,100 in March 2019, nearly doubling in price from $87,000 July 2018 sale. The illustration on Black Lotus is a black lotus flower over a foliage backdrop, painted by Christopher Rush. Card allows the user to add three mana of any color to the mana pool.

2-Ancestral Recall - $20,000

The card was originally called "Ancestral Memories". It was originally going to be a common, but Richard Garfield was persuaded to make it a rare instead. The ability to draw three cards with no drawback allowed many decks to become dangerously fast. Eventually, Ancestral Recall was banned in all formats but Vintage, where it is restricted.

3-Mox Sapphire - $13,500

The word "Mox" was derived from the English slang word "Moxie" associated with energy and vigor. This version adds blue mana to the pool.

4-Mox Jet - $9,000

This version adds black mana to the pool.

5-Underground Sea - $8,000

Counts as both swamp and islands and is affected by spells that affect either. Can be used to add either B or U to mana pool.

Pokémon:

As a teenager, Pokemon creator Satoshi Tajiri was so fond of collecting insects that classmates called him "Mr. Bug". His Pokemon video game, originally released for the Nintendo Game Boy in 1996, has become an enduring multimedia success, selling billions in games, merchandise, and phone apps. In 2019, the game was downloaded over a billion times. Pokémon creature-adorned playing cards have been a favorite of collectors since their release in 1996, and today the media franchise has over $100 billion in revenue and the game is played in over 70 countries.

The goal of collecting and pitting monsters against one another has been particularly appealing for trading card collectors, who have created an entire secondary market for the low-tech version of the game. First editions, misprints, and other characteristics all affect value. For many Millennials, the original 1999 Pokemon card games remain a staple of their childhood, providing what seems like a lost art in a nostalgic feeling. It signaled the end of the tangible toy age and the beginning of the virtual age, as no other item became as popular or as connective as Pokemon in years following.

In 2017 a complete set of 103 first-edition Pokemon cards printed in English from 1999 has sold for just under $100,000. First-edition Pokemon cards can be identified by a small black circular stamp to the bottom left of the Pokemon image, denoting they were part of the original release in 1999, and each card was graded GEM-MT 10 or Gem Mint condition by authentication body Professional Sports Authenticator (PSA), meaning the

set was virtually perfect. In 2019, the same set went for $107,010 and in June 2020 for $125,000 via Rally Rd, the premier fractional collectible platform. There have only been 3 complete sets in GM condition ever offered in public auction.

Value metrics:

Core: Scarcity, Rarity, Condition

Scarcity: Pokémon cards given or won in tournaments are prized collector's items, and very few are routinely available for sale.

Rarity: As with most collectible items, the rarest cards are usually those which are first or special edition, e.g. one off cards given out or won at Pokemon competitions or events. The language of a card can also play an important role, as some cards had very few copies issued in a specific one. An English Charizard, for example, was only available through a 'Trade Please' campaign where Pokémon fans and collectors had to send in two Pokémon cards, receiving a trainer card and a Charizard in return.

Condition: Cards in complete mint condition enjoy dramatically increased values. PSA and BGS, the major players in the baseball cards world, are relied on to provide grading in the game cards market as well. Same grading scales apply as for all other trading cards.

Top Five highest priced examples:

1-Pickachu Illustrator - $234,000

The Holy Grail of Pokémon cards, this PSA 9 near mint example featuring artwork by Pikachu's creator Atsuko Nishida depicting Pikachu holding what appear to be drawing tools was sold in July 2020. 39 Pokémon Illustrator cards were awarded to the winners of the Coro Coro Comic Illustration Contest in January 1998, with only 10 believed to still be in existence. The last sale of this card was for $224,500 in 2013.

2-Kangaskhan Parent/Child Promo Cards - $133,000

Awarded as prizes at a 1998 parent and child tournament, and then instantly retired.

3-No. 1 Trainer Promo Card - $90,000

Made for a two-day competition in 1997 to celebrate the success of Pokemon franchise, one of 7 that exist in the world and graded PSA 10 Gem Mint.

4-Tropical Mega Battle No. 2 Trainer Card - $60,000

A top prize in a series of 7 tournaments.

5-No. 3 Trainer Promo Card - $32,500

Awarded to the third highest-ranking player in the annual World Championship.

5.1 Pre-Release Raichu

With an estimated 8 to 10 copies in existence, Pre-Release Raichu was supposedly never meant to be discovered. The name stems from the "Prerelease" stamp found at the bottom right corner near Raichu's foot. Wizards of the Coast, the original distributor of Pokémon cards, denied the existence of this card until a staff member unveiled an image of it in 2006. It's impossible to estimate the value of this card if one ever makes it to market.

Weapons

Guns

The first device identified as a gun, a bamboo tube that used gunpowder to fire a spear, appeared in China around 1000 AD. One theory of how

gunpowder came to Europe is that it made its way along the Silk Road through the Middle East; another is that it was brought to Europe during the Mongol invasion in the first half of the 13th century. Around the late 14th century in Europe, smaller and portable hand-held cannons were developed, creating in effect the first smooth-bore personal firearm. During the early modern age, these hand-held cannons evolved into the match lock, wheel lock, dog lock, and flintlock rifle, respectively, then the breech loader and finally the automatic weapon. The first assault rifle was introduced during World War II by the Germans, known as the StG44. It was the first firearm that bridged the gap between long range rifles, machine guns, and short range sub-machine guns. Since the mid-20th century guns that fire beams of energy rather than solid projectiles have been developed, and also guns that can be fired by means other than the use of gunpowder.

Any one of the millions of firearms, in working condition, that were used between the Civil War and World War I, during World War II and Korea, are safe investments. Interest in Vietnam-era firearms indicate that they will become the next future collectible, especially as awareness is taught through the sale of reproductions. After that, it's only a matter of time before more modern rifles, pistols and shotguns join the collector's market in a significant way. The worst guns to collect for investment are modern rifles, i.e. AR- and AK-platform guns, as well as their receivers, parts, accessories, and so on. These won't reliably appreciate, both in spite of and because of the fact that Americans tend to buy huge quantities of certain guns based on current events.

Historical performance: On average, most collectible firearms increase in value by 3% to 5% per year based on historical auction prices, there is, however, no recognized index to track the performance of this class.

Value metrics:

Core: Scarcity, Rarity, Provenance, Condition, Historical importance

Unique: Brand, Events

Scarcity: Smaller bores (caliber) guns appreciate more quickly than larger bores (especially for shotguns) because fewer are produced, which makes them less common, with vintage small caliber guns selling for twice or three times the price of its larger caliber counterpart. The measurement of the bore in shotguns is expressed in terms of gauge, the smaller the gauge number the larger the bore.

Rarity: Guns manufactured by famous gunsmiths are rare and in high demand. A cohesive collection can be a better investment than a handful of different individual guns, as it is often worth more as a set than the sum of their individual values.

Provenance: Guns that retain original sales receipts, boxes, paperwork and accoutrements, bring more money in the future. Guns with a documented history of interesting previous owners are also valuable, like a 38-caliber Colt Police Positive revolver from the 1920s owned by Al Capone with a paper trail attesting its origins, that sold for $109,000. Other famous examples include Bonnie and Clyde's gun at $504,000, Smith & Wesson that killed Jesse James at $350,000, Wyatt Earp's Colt .45-caliber Revolver from OK Corral at $225,000, and Hitler's Golden Walther PP at $114,000.

Condition: Taking care of a firearm is critical for seeing a return on investment, as a gun is only an investment if it's properly cared for. It's best not to shoot the gun or manipulate its action beyond ensuring its safety; pristine condition (never been shot) is ideal. NRA Condition Standards classify antique guns into six categories from excellent (all original parts, over 80 percent of its original finish with sharp lettering, numerals, and design on metal and unmarred wood) to fine, very good, good, fair, or poor. A separate Percentage System rates the percent of original finish that remains on the gun from 0 to 100 percent, and is an input into the overall grade estimate. Firearm collection should be stored in a room kept at a consistent 70 degrees Fahrenheit, so that the wood stocks don't expand and cause permanent cracks, and at around 50% humidity to avoid metal corrosion or cracking.

Historical importance: First model from a famous maker, a unique piece from a master gun smith, or an illustrious history all contribute to the historical importance of a weapon.

Brand: Brand loyalty drives pricing. Sometimes even a less desirable gun model can net you a profit if the right brand name is stamped on the barrel. Some of the famous brands are classics like Colt, Winchester, Smith & Wesson, Remington, Beretta and Browning. Among modern examples Ruger, SIG Sauer, Heckler and Koch, FN Herstal, and Glock are considered best in class.

Events: Demand is high on anniversaries. Some increases respond to market trends, like anniversaries. The Civil War centennial (1965), 150 year anniversary (2015) and Revolutionary War bicentennial (1976) all caused spikes in interest in the respective weapons, followed by flat or declining interest.

Top Five highest priced examples:

1-Singing Bird Pistols: $5.8M

The 1820 singing bird pistols have stolen the heart of many collectors with their ingenious masterwork and mechanism. They are limited in number since only four were created, and can only be seen at the top museums of the world. They are made of gold with decorations of pearls and diamonds.

2-Cabot Guns Meteorite Pistols: $4.5M

The Big Bang Pistol Set consists of a pair of left and right pistols that are constructed almost entirely of 4.5 billion year old meteorite. Unknown to western civilization until the early 1800's, pieces were used by the ancient Nama people in the construction of tools and weapons. In 2015 Cabot Guns' master craftsman shaped a 77-pound piece of material into two unique weapons. The exteriors have unique Widmanstatten patterns that are found in octahedrite iron meteorites.

3-George Washington's Saddle Pistols: $1.9M

This set of saddle pistols was originally given to Washington by his French ally Marquis de Lafayette and was used by Washington all through the Revolutionary War. The pistols feature beautiful gold inlays and detailed rococo carvings that make the pistols just as much a work of art as they are weapons. After Washington's death these pistols eventually fell into the possession of President Andrew Jackson who cherished them for most of his life before gifting them back to Washington's family.

4-Nicolas –Noel Boutet Pistol: $1.8M

After the Restoration of the monarchy, this pistol was made by Boutet in France in 1825. It falls in the category of the most beautiful guns that display unique and exuberant decorative features.

5-Simon Bolivar's Flintlock Pistols: $1.69M

This pair of flintlock dueling pistols belonged to Venezuelan military leader Simon Jose Antonio de la Santisima Trinidad Bolivar y Palacios Ponte y Blanco. During South America's revolution against the Spanish empire, Bolivar played a key role in liberating Columbia, Venezuela, Panama, Ecuador, and Peru. He also helped establish the first union of independent nations in Latin America and became the president of this union. His impact on the modern world was huge and many monuments dedicated to his achievements can be found throughout South America.

Swords

The sword is rich in history and was the weapon of choice in Europe, African continent and Asia for centuries, long before it was popular in America. Sword manufacturing dates back to 3700 BC, when copper mining began in ancient Egypt and Anatola (Turkey). The vast number of swords, types and styles manufactured by ancient civilizations through the 19th century makes it impossible to identify all permutations. Overall price

for European swords is more reasonable than Japanese and Chinese pieces and there is a far greater variety in type and design.

There are two parts to a sword – the blade and the hilt. The blade is made with a single or double-edge and used to cut, thrust or both and has six parts: Edge, Tip, Back, Flat, Fuller, Ricasso.

The hilt is the upper handle part, consisting of the guard, grip, and pommel.

Other design features were also added over the years to signify military rank, social class, and the sword or fighter's country of origin. Most notable were a scabbard (protective sheath for blade made from wood, leather, steel or brass); sword belt (used to carry a sword, over-the-shoulder kind known as a baldric); and tassel (decorative woven material wrapped around the hand to prevent a weapon from being dropped).

The most popular swords with today's collectors are:

1. Falchion: heavy, short, single-edged blade used from the 13th to 15th Century in Europe.

2. Longsword: two-edged blade, measuring 44 to 50 inches, produced in Germany and Switzerland for thrusting, cutting and close contact battles during the 15th and 16th Century.

3. Greatsword: large, two-handed sword used for close contact fighting in the 16th and 17th Century with a blade length of 50 to 72 inches and weight between 6 to 10lbs.

4. Broadsword: general term used for a double-edged military sword, from the 17th to 19th century measuring from 30 to 45 inches.

5. Rapier: In the 16th and 17th Century, this was a lightweight, double-edged blade with a thick cross section used to fence, thrust and duel. From the 19th Century, it became known as a Gentleman's sword or walking sword and was used to signify military rank or an officer's class.

6. Cutlass: standard sword, made in various styles, used generally in naval conflicts.

Historical performance: Value of high end swords grows at an average of 5% each year, with rarest examples gaining as much as 20%.

Value metrics:

Core: Scarcity, Rarity, Provenance, Condition, Historical importance

Unique: Age

Scarcity: Almost all European Swords were destroyed or cast into the sea at the demise of its master, explicitly destroying almost all high end supply, thus obviously creating natural scarcity. As these instruments are made of metal, they are also susceptible to ravages of time, and many remaining pieces have succumbed to rust and other naturally occurring processes.

Rarity: Not only is the amount of items quite limited, but even of those some are much harder to locate than others. There are some countries, time periods, and materials that combined make a sword rare, as well as unusual shapes, decorations, etc. In case of swords, rarity should be judged against a specific segment to which it belongs.

Provenance: Can be tested by examining various parameters like size, materials, and consistency. Metals used to produce blades were different from materials in use today as modern forgers lack the skills and craftsmanship of past sword makers. Sometimes a sword comes with distinguishing hallmarks, a signature or maker's mark which helps identify where it was manufactured and by whom. The blade and hilt of a sword should be consistent with its model, period and country of origin, if the sword features and appearance do not match with the time period it may have been renovated.

Condition: The blade should not be bent and the hilt should be tightly fastened to the blade; if it feels loose, it could signify that the blade or hilt

have been replaced. If the blade has been cleaned, it may be damaged; this will decrease the value. If it doesn't have a matching scabbard, the value will decrease.

Historical importance: If a sword was owned and used by an important historical figure, and the connection is clear and provable, that increases the value dramatically. For example, the last sword used by Napoleon sold at an auction in France in 2007 for $6.5 million, one of the highest prices paid for any sword on the market.

Age: All else being equal older blades are more in demand, as a function of their rarity and scarcity, provided they are in good condition.

Top Five highest priced examples:

1-18th Century Baoteng Saber - $7.7M

The weapon with inscriptions and decorations alluding to the Chinese Emperor Qianlong is an S-shaped saber with a fitted white-jade handle stylized with ornate leaves and floret. The steel blade is decorated with inlaid gold, silver, and copper, with one side revealing a poetic two-character name: Bao Teng, or 'Soaring Precious'. The work was made in the Palace Workshops of the Imperial Household Department, and is representative of the mid-Qing Dynasty. A production of 90 sabers was created over 47 years, and the weapon's worth is due to both its aesthetic and historical value.

2-Napoleon Bonaparte's Gold-Encrusted Saber - $6.5M

This gold-encrusted sword was used by Bonaparte at the Battle of Marengo in 1800, when he ousted the Austrian army from Italy. It was passed down from generation to generation of the Bonaparte family, and was deemed an historical monument and therefore unable to leave the country. The curved saber was forged by Nicolas Noel Boutet and is decorated in gold and has an ebony and gold handle.

3-15th Century Nasrid Period Ear-Dagger - $6M

This double-edged straight blade gets its name from the design of the hilt pommel, consisting of two flattened discs that resemble ears. They were widely used in Spain during the 15th and 16 centuries, and were introduced to Europe through Italy. The decoration around the blade comprises the figure of a man with a crossbow, hunting numerous animals (including a lion).

4-Shah Jahan's Personal Dagger - $3.3M

Shah Jahan ruled from 1627-1657, and the dagger is an understated, elegant blade with gold inscriptions and decorations. The inscription on the dagger is the most detailed of any of Shah Jahan's personal objects, containing his name, title, and the place and date of the dagger's manufacture.

5-"The Gem of the Orient" Knife - $2.1M

A lavish knife, designed and crafted in 1966 by one of the world's greatest knife makers Buster Warenski for a Japanese customer. The filigree handle is encrusted with 153 emeralds totaling 10 carats, nine diamonds (5-carats), and 28 ounces of gold for the rest of the handle and blade.

Wooden decoys

The history of decoys in North America dates back at least 2000 years, but decoys were used even further back in other parts of the world like early Egypt. The oldest decoys in North America housed in the Smithsonian Museum were found in an Arizona cave and were dated with native pottery pieces found alongside. When the colonists first arrived in North America, they found that the natives were using mud, bulrushes, fowl carcasses, and other materials to create imitations of ducks and other fowl. These imitations attracted live birds, which the hunters would then kill or capture. The word "decoy" came from a Dutch word referring to the cages Old World hunters built to attract and tame wild birds. By the mid-19th century, most decoys in the New World were made out of wood rather than

mud, and commercial and sport hunters alike used them to help lure their prey.

In the late 1800s and early 1900s, duck was considered a delicacy, even more so than today. Hunters would sell waterfowl for $1 or $2 a bird, shooting 100 or more in a day, and making a full-time living from the demand for them. Without wooden duck decoys for the birds to flock to this wouldn't have been possible. From the mid-19th century through the early-20th century, the use of painted, wooden, hollow or solid shorebird, goose, and duck decoys came into fashion among bird hunters. While no longer used today due to advances in decoy materials and technology, these wooden duck decoys are highly collectible, with entire auction houses dedicated to the buying and selling of these magnificent works of folk art.

Commercial hunters often owned hundreds of decoys, which they would set out in large numbers to attract as many birds as possible. As sport hunting became more prominent among the wealthy, some carvers began making fewer decoys but of higher quality for this new clientele. Sport hunters wanted decoys that were beautiful, not just useful. Eventually, some carvers began making decoys for purely decorative reasons. Decoys varied in style from region to region, as the environment and species of a given area dictated their design. The main tenets of construction have remained the same throughout the years: each decoy is made from two pieces of wood, one piece for the body and one for the head.

The market first started with small, niche groups of enthusiasts throughout the United States in the 1950s and '60s who began collecting antique duck decoys. When Hal Sorenson of Burlington, Iowa, published a magazine called "The Decoy Collector's Guide" in 1963, people all over the country started to realize that there were others out there who collected these duck decoys. Booming prices were largely due to a shift in the collector population from sport hunters to people worth millions of dollars going after decoys. The first million dollar price was achieved when two decoys (Canada goose and a preening pintail drake) by A. Elmer Crowell of East

Harwich, MA, were sold for $1.13 million each in a private sale, in September 2007. The record-setting decoys were sold in a larger collection of 31 decoys for $7.5 million in total.

Historical performance: This is a surprisingly active market both for the small very high end set and the rest of the investment grade universe. Based on historical auction data, the best examples average about 10% annualized return.

Value metrics:

Core: Scarcity, Rarity, Provenance, Condition

Unique: Maker

Scarcity: The reason decoys are so valuable is because 90% of them were repainted or had their heads broken off, so the ones that are left in good condition are the best ones and go for high prices. Decoys of some species, like wood ducks and teal, are rarer than others, as are decoys carved in unusual poses like sleeping, swimming, or feeding. In 1920 Congress had passed the North American Wildlife Act and North American Migratory Bird Act, which limited hunting and banned commercial hunting of most species altogether, and the demand for decoys all but disappeared. Decoys became even scarcer in the 1950s and 1960s when mass-produced plastic decoys became available and many hunters discarded or burned their wooden decoys. Larger pieces were not made frequently, and as a result tend to go for higher prices.

Rarity: There are different species of decoys such as shorebirds, duck, geese, and more, and some are much rarer, with most collectors preferring antique duck and goose decoys. Shorebirds are also quite rare because this type of hunting was outlawed in 1928, and fewer items were made and remain, so they tend to go for higher prices. Areas have specific decoy types, with different species for each of the regions such as New England, Long Island, New Jersey, and North Carolina.

Provenance: Decoys that are documented are more desirable, as a large portion of the value of the piece comes from the ability to trace it to the original maker and ensure it is authentic.

Condition: Both state of the paint and of the wood itself need to be as near to perfect as when it was originally made, but original condition with minimum repair and repainting is preferred. Those never actually used for hunting, of course, tend to be in better condition and, thus, most valuable, given all other factors are equal.

Maker: Artisans known for exquisite craftsmanship and with a stellar reputation have built up brand value and will command higher prices. The most famous practitioner was Elmer Crowell (1862-1951), a master carver and painter.

Top Five highest priced examples:

1-Canada goose and a preening pintail drake by Elmer Crowell - $1.13M

2-Red-breasted merganser hen by Lothrop Holmes - $856,000

3-Feeding dust-jacket style black bellied plover by Elmer Crowell- $830,000

4-Preening pintail drake by Elmer Crowell-$801,500

5-Unattributed eider drake decoy - $767,000

Autographs

People have been collecting autographs for thousands of years. Aristotle was the first known collector of signed manuscripts and maps. The autograph market has been overlooked because it doesn't afford the investor the status of a classic car, or the immortality of owning one the world's rarest stamps.

There isn't enough material available to promote the market like rare coins, sports cards, or comic books, so most new collectors are brought into the field by existing collectors, and prices rise due to true collector interest, and not just actions of speculators.

Autographs are a booming area for collectors, thanks to increasing demand for unique examples, and many rare autographs can still be found at the more affordable end of the collectibles spectrum. The value of a signature can vary greatly depending on what the signature is on, the size of the item, condition, and of course if it is dedicated to anyone. Generally speaking signed photos are best, the larger the better, as autographed photos can command more than four times the price of a straight signature. Forbes magazine publisher and investor Malcolm Forbes was one of the most prolific collectors in the hobby. When he died in 1990, Forbes' collection of over 4,000 autographs from US presidents was estimated to be worth in the region of $40M-$50M, though later auctions suggest that this was an underestimation.

More and more of the world's largest economies are turning towards collectibles, and as they do so, they are becoming more open to western culture. There are currently estimated to be around three million autograph collectors worldwide, with the figure increasing every year, especially in Brazil, Russia, India, and China. Generally these new collectors are interested in international figures, but they're also starting to repatriate national items that have been sold abroad from celebrities, movie stars, athletes, musicians and scientists.

Historical performance: The PFC40 Autograph Index tracks the values of 40 of the world's most sought-after autographs since 2000. A basket of rare autographs delivered annual compound growth of 10% over the past 20 years, beating most traditional investments. Even the worst performing name in the index (Jimi Hendrix) delivered 5% annual compound growth, with none showing a loss in value over those 20 years.

Value drivers:

Core: Scarcity, Rarity, Provenance, Condition, Historical importance

Scarcity: Autographs are unique and not easily replaced. When the right combination of quality and uniqueness is present in an autograph, it is nearly a guarantee that it will increase in value. Autographs are finite as we all pass away and at that point we stop signing our names, so there is only a limited supply of every person's autograph available. Some icons like Steve McQueen and Marlon Brando rarely signed their names, while others like Bette Davis and Marilyn Monroe signed a lot of fan mail and as a result are a lot more plentiful and consequently a lot less scarce and valuable.

Rarity: Is defined not only by how frequently an autograph appears in the market, but also by the form the autograph takes. Letters written entirely in the hand of Napoleon, for example, are extremely rare while those just bearing his signature are much more common. Known rarities include anything written by William Henry Harrison as president because he died only a month after taking office, as well as handwritten letters penned during the presidencies of Andrew Johnson, Herbert Hoover, Franklin Roosevelt, JFK and LBJ. There are a few artists whose letters are genuinely rare, like Seurat and van Gogh, and nearly every one of the old masters are extremely difficult to find. Every ten or fifteen years a document signed by Raphael or even Michelangelo might appear, but anything signed by Durer, Leonardo, Rembrandt, etc., is almost unheard of as are examples from composers like Monteverdi, Handel, Bach, or Mussorgsky. Neil Armstrong stopped signing autographs in 1994, making the first man on the Moon's signature extremely rare even before his passing in August 2012.

Provenance: Can add some value to a letter if it can be proven, ideally verified by a reputable dealer with a certificate of authenticity (COA), which, of course, is only as good as the dealer's reputation. There are several well-known associations that most good dealers will belong to, the three main ones being UACC, AFTAL and PADA. These only accept established dealers, and have some very strict membership rules, and all members of any

of these three associations are clearly listed on the relevant association websites. Real provenance for autographs can only mean a good and provable link from one source to another, such as the item concerned having been through the hands of several known and knowledgeable dealers or auction houses. Another reason an expert is needed is to detect autographs made by autopen, a device used by many famous figures to sign their autographs for them which automatically reproduces an autograph, and could produce up to 3,000 signatures in one day, as these autopen signature have little or no value compared to a real one.

Establishing provenance for older documents is very difficult as there are limited avenues to ascertain if the item under consideration is authentic, i.e., written and/or signed by the person whose autograph is under review. When determining authenticity, it is a good idea to start with examining paper and ink, to verify that both are from the correct historical period. A second most common issue that raises questions regarding authenticity are the changes in the appearance of a person's handwriting. This can change dues to physical issues, different styles used in different periods of life or just a whim. Napoleon used several different signatures during his career, but to discourage forgeries always incorporated an elaborate design as part of the signature that would make it more difficult to copy.

Condition: Is probably the least significant issue when buying or pricing autographs. It is detrimental when a common autograph is in poor condition and favorable when a rare autograph is in excellent condition. Some general condition concerns for autographs might be: folding, tearing, browning, foxing, lightness of the ink, staining or missing pieces of paper. Autographs are perhaps the easiest collectible asset to care for, as most autographed items can be stored in a simple portfolio without need for a costly climate-controlled storage facility or an expensive garage.

Historical importance: The piece in the autograph puzzle that exerts the greatest influence in defining value is content. A letter that describes an event in history or that has a close association to the author's fame may be

described as having high content. Most collectors search for letters in which the writer describes an event that is closely associated with the author's fame. Consequently, letters by Napoleon about preparing for battle, Mozart on composing an opera, Einstein discussing relativity, or Hemingway on writing, bullfighting, or fishing are highly sought after. Letters written between famous individuals are generally very desirable, but may involve a bit of work to uncover additional, associated identities. A letter written by Francis Crick, the discoverer of the DNA in March 1953 to his 12-year-old son, Michael, describing the "beautiful" structure, was sold at auction in New York for $6M.

Top Five highest priced examples:

1-George Washington - $9.8M

His signature on his personal copy of the Constitution, Bill of Rights, and the First Congress is the highest valued autograph ever sold. The book now sits in the Washington presidential library in the White House.

2-William Shakespeare - $5M

Though Shakespeare wrote about 38 plays and hundreds of sonnets, he didn't leave too many signatures behind. There are only six known surviving documents that bear the Bard's signature.

3-Abraham Lincoln - $3.7M

In 1863, Abraham Lincoln signed the Emancipation Proclamation, releasing millions of people being kept as slaves. Lincoln originally signed 48 copies. Of those, only 26 surviving copies are known to exist today.

4-Babe Ruth - $388,375

As a star athlete, Babe Ruth signed many autographs, and most valuable autographed items are those that have been kept in pristine condition, such as a baseball that Ruth signed when it was brand new.

5-Jimi Hendrix -$200,000

Guitar legend Jimi Hendrix's signed 1965 record contract turned out to be worth much more as a collector's item than it may have been to Hendrix. In the contract, Hendrix agrees to sell the rights to his songs for a mere 1 percent royalty fee.

Vinyl

A phonograph is an analog sound storage medium in the form of a flat disc with an inscribed, modulated spiral groove. The phonograph disc record was the primary medium used for music reproduction throughout the 20th century. It had co-existed with the phonograph cylinder from the late 1880s and had effectively superseded it by around 1912. At first, the discs were commonly made from shellac; starting in the 1940s polyvinyl chloride became common. Records retained the largest market share even when new formats such as the compact cassette were mass-marketed. By the 1980s, digital media, in the form of the compact disc, had gained a larger market share, and the record left the mainstream in 1991. Since the 1990s, records continue to be manufactured and sold on a smaller scale, and during the 1990s and early 2000s were especially used by DJs and listened to by a growing niche market of audiophiles. By the mid-2000s, records made of any material began to be called vinyl records, or simply vinyl.

The last few years have seen a meaningful rise in vinyl sales; 26% of American album sales come from vinyl, with sales now reaching a 25-year high, offering serious potential for those looking for quirky or unique alternative investments. Record Store Day, an event that began in just 2007 is being credited with being a key reason behind the LP revival. Over 250 labels release special limited edition records specifically for the day, providing even more opportunity to get your hands on a rare record. Limited editions of new releases specially pressed for Record Store Day become instantly collectible.

In 1985, you could buy an album on a cassette, CD, or record. Today, when a record label releases a new or archived album on vinyl, they do so to treat the record as a collector's item. The artwork, liner notes, and even the color of the record itself is paid careful attention. Music fans rarely play their records, streaming the album instead and treating the oversized physical edition as a work of art. This is similar to early vinyl collectors, who sought after hard-to-find records, never played them, and kept them as a token of their hours spent digging through crates. Whether they're playing them on turntables or keeping them in the package, vinyl enthusiasts are nonetheless reviving a once-dying industry. Revival of vinyl is powered by the rediscovery of a unique listening experience and visceral engagement with the music. Perhaps most surprising is that these young vinyl enthusiasts are not as interested in current chart hits as they are in investing in old records and limited edition sets. Vinyl's resurgence is an unexpected side-effect of the trend that at one point seemed set to kill it off — music's transition into a digital world of streaming and MP3s. People have grown nostalgic for the aesthetic, tactile pleasures of records, the look of the sleeve, the feel of the disc.

Historical performance: There has been slow but steady growth in this asset class yielding around 7% annually.

Value metrics:

Core: Scarcity, Rarity, Provenance, Condition

Unique: Age, Brand, Artist, Events

Scarcity: Records that sold well and are common are going to be less valuable than records that sold poorly or are hard to find. However, even records that sold well when new can become scarce in time, as many have been thrown away or damaged through heavy play or abuse. The most valuable record by a particular artist may not be their best-known title, but rather one that was disregarded by the public and critics when originally

released, making it relatively scarce today. A good example of this would be Music from the Elder by Kiss, released in 1981 after a string of best-selling albums. It had a different sound from their previous releases and offered no hit songs or songs that regularly received airplay, quickly going out of print and making the remaining copies rather scarce.

While natural scarcity can be a major factor in a vinyl record's value, intentional scarcity can affect it even more. Producing only a limited number of a given title, and by making it publicly known that production will be limited to a small number of copies, the record companies have a greater likelihood of having a particular title sell out quickly, rather than sitting on a shelf for a period of months or years. One other factor that can significantly affect a vinyl record's scarcity and value is the availability of reissues. Starting in the 1980s, record companies reduced the prices of slow-selling records, keeping them in print but offering them for sale at a lower price point. Reissues can often affect a vinyl record's value dramatically, and sometimes, the price of original pressings can drop as much as 90% when a formerly rare album again becomes available as a newly-released record.

Rarity: There are multiple features that make a record rare. Promotional copies are usually pressed before stock copies in relatively small quantities, making them collector's items. While the labels on most records are colored, many promotional issues have white labels, which has led to the term "white label promo" being used among collectors. Some promotional copies may be issued only as a promotional item and these "promo-only" releases are especially sought after by collectors, though the interest in them will be directly related to the interest in the artist.

Acetates that are individually cut on a lathe by a recording engineer command a high value in the marketplace as they are both rare and unusual. First pressings distinguished by their labels and that may contain different versions of one or more songs, which will differ from those used on stock pressings are rather unusual and limited in production to just a handful of copies, and are highly regarded and sought out by collectors. Since collectors

tend to favor original pressings, for a given title, the most desirable label variation would be whichever one was in use on the day the record was originally released for sale to the public.

Format is a significant factor that can affect a vinyl record's rarity and value. Until 1957, records were sold only in mono. Between 1957 and 1968, records were usually sold in both mono and stereo, and between 1972 and 1976, a few records were available in four channel quadraphonic sound intended for a niche market, and never sold in large quantities. Quadraphonic copies are almost always worth more money than the same album in stereo.

While most records are pressed from black vinyl, sometimes other colors are used, and on rare occasions, a special process is used to create a picture disc, which has a photograph or other graphics actually embedded in the record's playing surface. With few exceptions, colored vinyl and picture disc pressings are limited editions, and are usually far harder to find than their black vinyl counterparts. Records pressed in foreign countries may have different titles, or different covers from the more common versions or be pressed on colored vinyl. Many albums from Japan from the late 1950s through the early 1970s were pressed on dark red vinyl and issued with a paper sash, or "obi," that wrapped around the cover and provided information for the buyer in Japanese. These pressings are highly regarded by collectors for both their unusual appearance and their sound quality.

The square sleeves are an integral part of the experience and have boosted the careers of many visual artists including Andy Warhol, Roger Dean, Burt Goldblatt and Peter Saville. Their designs gave the music a visual language which turned records into some of the most recognizable works of art the world has come to know. Picture sleeves bearing the title of the song, the name of the artist and perhaps a graphic or photograph were available only with the original issues of the records and were discontinued once sales of the record began to pick up. This is one of the factors that pretty much has no exceptions; a record with a picture sleeve is always more valuable than the same record without one.

Provenance: One factor that can influence vinyl records value is having the autograph of the artist on it. While autographed albums and singles aren't particularly common, they usually do command a premium over regular copies of the record that are not signed. Autographed records that are personalized tend to sell for less money than those that simply have the artist's signature on it. When it comes to musical groups and autographs, albums that are autographed by the entire group will sell for substantially higher prices than those with the signatures of some, but not all, members. Autographed records with clearly documented provenance, such as a photograph of the artist signing the record, tend to bring the highest prices of all.

Condition: When it comes to evaluating a vinyl record's value, nothing is as important as condition. Most mass produced records sold over the past 60 years or so have been poorly cared for by their owners. They may have been played on low-quality equipment, stored outside of their covers, and handled by their playing surfaces, rather than their edges. Many covers were poorly stored, leading to ring wear or splits in the covers. Furthermore, owners often wrote their names or other information on the record's cover or label.

Collectors will often pay a huge premium for sealed, unopened examples of records they are seeking. A copy of an album that is still in original, unopened shrink wrap will sell for a lot more money than one that is in opened condition, even if the opened copy has not been played. Sealed copies of older albums by the Beatles, for example, might sell for as much as ten times the price of an opened one. As many as half of all record buyers never play their records, and one in ten don't even own a record player.

For the best chance of making a profit, records should be graded 'M' or 'NM' quality using Goldmine Magazine standard as the most widely used, recognized and understood by the greatest number of record collectors and dealers worldwide. Their Vinyl Grading Systems goes from Mint (M) to Poor (P), with the top grades of Mint (M) and Near Mint (NM) comprising

the investment grade universe. Most of the time, LPs are sold with two grades, one for the record and one for the cover. If an album is graded VG for the cover and VG+ for the record, the two values are added together and divided by two to get a rough estimate of the value of a "mixed grade" LP.

Age: While age can have an effect on a vinyl record's value, it's one of the less important factors. Releases from early in the career of a famous artist may have more value than those from later in their careers, particularly if they didn't become famous right away. Also the older an album is, the harder it is to find a copy that has never been opened or played, so in this sense age matters given that other key metrics are in line.

Brand: Respected record labels are a good guide for quality, and a record produced by a famous label, like RCA, UK Decca, Mercury Living Presence, Deutsche Grammophon, Phillips and Columbia will command a higher premium in the market than one from a small, unproven or unknown one.

Artist: Style, fame, authority and image are big factors in determining the value of a record. Artists in the rock, blues, jazz, classical and soul categories tend to be more collectible than those in the easy listening or country. Exceptions to that exist; that can come in the form of artists who were never particularly popular, but who were influential in the industry. As a rule, popular artists will have records with higher values than obscure ones. For bands the classical favorites are The Beatles, Rolling Stones, Pink Floyd, The Who and Queen; for individual artists Elvis Presley, David Bowie, Bob Dylan, and Jimi Hendrix are notable examples.

Events: Early prints of records by recently deceased artists will multiply in value almost instantly following the news of their death, particularly as new prints are likely to flood the market, making the originals even more in demand. Other events include release anniversaries, group milestones and special concerts.

Top Five highest priced examples:

1. Wu-Tang Clan: Once Upon a Time in Shaolin - $2M

This is the only copy ever produced. The record comes with a contract which stipulates that the buyer may not attempt to sell or make money from the record for 100 years, although the owner may release the album for free should they wish to.

2. The Beatles: White Album - $790,000

Ringo Starr was known to own the very first copy of the band's self-titled double album from 1968, since the records were printed with serial numbers in sequence and Starr's copy bears the number '0000001'.

3. Elvis Presley: 'My Happiness' - $300,000

The test pressing of Elvis Presley's first ever recording.

4. The Beatles: Sgt. Pepper's Lonely Hearts Club Band - $290,000

Signed by all four Beatles original 1967 pressing of *Sgt. Pepper.*

5. John Lennon & Yoko Ono: Double Fantasy - $150,000

Signed by Lennon himself just hours before his death on December 8th, 1980, the last record Lennon ever signed.

Asset class metrics

The five core metrics are applicable to all asset classes, although in some cases not all of them are necessary or relevant to determining the value of an item. Some of these findings are rather intuitive, but it is always helpful to confirm intuition with analysis. Key takeaways from the table below are that provenance is not really a factor in comics, stamps, memorabilia or trading cards; condition is not that important in the consumable segment, and historical importance is only applicable in about 50% of the cases. Incorporating this insight into your mental model of each asset class allows you to quickly form an initial opinion of an investment based on the minimum required number of factors, thus greatly improving decision making efficiency.

Table 1:

Core portfolio:

Asset	Scarcity	Rarity	Provenance	Condition	Historical importance
Paintings	x	x	x	x	x
Sculpture	x	x	x	x	x
Books	x	x	x	x	x
Manuscripts	x	x	x	x	x
Maps	x	x	x	x	x
Photographs	x	x	x	x	x
Cars	x	x	x	x	x
Motorcycles	x	x	x	x	x
Watches	x	x	x	x	x
Handbags	x	x	x	x	
Wine	x	x	x		
Whisky	x	x	x		
Cognac	x	x	x		
Champagne	x	x	x		
Comics	x	x		x	
Memorabilia	x	x		x	
Trading cards	x	x		x	
Stamps	x	x		x	
Coins	x	x	x	x	x
Banknotes	x	x	x	x	x

Opportunistic portfolio:

For the opportunistic portfolio, provenance and historical importance are not that crucial for graded collectibles, just as in core portfolio, and historical importance does not matter much for consumable or decorative items.

Table 2:

Asset	Scarcity	Rarity	Provenance	Condition	Historical importance
Gems	x	x	x	x	x
Jewelry	x	x	x	x	x
Guns	x	x	x	x	x
Swords	x	x	x	x	x
Autographs	x	x	x	x	x
Wooden decoys	x	x	x	x	
Cigars	x	x	x	x	
Vinyl	x	x	x	x	
Game cards	x	x		x	

As we have learned in the asset class review in previous sections, on top of the five core metrics universally applicable to every collectible type, there are some that are specific to only one or a few asset classes. It is important to understand how similar variables may affect different collectibles and which parameters to pay attention to for an accurate first impression. Below tables help summarize the parameters that go into estimating value for both core and opportunity portfolios.

Unique metrics:

Core portfolio:

Table 3:

Metrics	Paintings	Sculpture	Books	Manuscripts	Maps	Photographs	Cars	Motorcycles	Watches	Handbags	Wine	Whisky	Cognac	Champagne	Comics	Memorabilia	Trading cards	Stamps	Coins	Banknotes	Vinyl	Count
Artist	x	x	x	x	x	x															x	7
Quality	x	x			x																	3
Subject matter	x	x	x	x	x	x																6
Size	x	x			x																	3
Year							x	x														2
Make							x	x														2
Model							x	x	x													3
Engine							x	x														2
Transmission							x	x														2
Paint color							x	x														2
Interior							x															1
Brand							x	x	x	x	x	x	x	x	x	x	x				x	12
Complications									x	x												2
Material									x	x												2
Region					x						x							x	x	x		5
Vintage											x			x								3
Age			x	x	x						x	x	x	x	x	x	x		x	x	x	13
Rating											x	x	x	x								5
Batch												x										2
Events			x													x		x			x	5
Errors																		x	x	x		3
Grade																x	x	x	x	x	x	6
Count	4	4	6	3	6	2	8	7	4	3	5	5	3	4	4	4	4	4	4	3	4	

The above is meant to serve as a useful reference guide for quick review of the salient points to note when evaluating an investment in a specific asset

class. We can also gather some insights as to which parameters affect multiple classes and begin to develop an intuitive feel for what to look for when analyzing investment opportunities of each type. For example brand and age affect the majority of the items, grade most of portable collectibles, and rating most consumables.

Opportunity portfolio:

Table 4:

Metrics	Cigars	Vinyl	Gems	Jewelry	Guns	Gaming cards	Swords	Wooden decoys	Autographs	Count
Brand	X	X		X	X					4
Quality	X		X	X						3
Maker		X						X	X	3
Age	X						X			2
Rating	X	X								2
Events		X			X					2
Region				X						1
Size	X									1
Shape	X									1
Usability						X				1
Count	6	4	2	2	2	1	1	1	1	

For the opportunity portfolio it's a bit tougher to draw conclusions, as the variables that affect the values are even more unique and idiosyncratic. Some common themes which can be gleaned from above are brand, maker, quality and age have a measurable effect on value.

As grades and ratings are indispensable to valuation of a large number of asset classes, in order to do a quick gut check, it helps to know what the leading and reputable rating agencies and forums are, and what values to

look for. Using the below for reference, it is quite easy to gain a rather accurate first insight into whether a proposed asset is worth reviewing further: if the grade is in the investable range then it likely warrants further study, if not, the odds are it is not a good candidate for investment. There are, of course, some exceptions to the rule, especially in the trading cards and comics space, where extremely rare and old cards can still be very valuable despite a lower grade. You can get your free copy of the reference table at http://www.michaelfoxrabinovitz.com/ and use it as a guide, as well as a worksheet to capture reasons for your own evaluation of a particular opportunity, so you can begin to build a database of the characteristics of assets you selected, as well as review and refine your reasoning over time.

Rating agencies	Memorabilia	Trading cards	Comics	Stamps	Coins	Banknotes
PSA (Professional Sports Authenticator)	x	x				
BGS (Beckett Grading Service)	x	x				
SGC (Sportscard Guaranty Corporation)	x	x				
CSG (Certified Sports Guaranty)	x	x				
MEARS ((Memorabilia Evaluation And Research Services)	x					
JSA (James Spence Authentication)	x					
CGC (Certified Guaranty Company)			x			
CBCS (Comic Book Certification Service)			x			
PGX (Professional Grading Experts)			x			
PSE(Professional Stamp Experts)				x		
ASG (Authenticated Stamps Guaranty)				x		
PCGS (Professional Coin Grading Service)					x	x
NGC (Numismatic Guarantee Corporation)					x	x
PMG (Paper Money Guarantee)						x

Grade ranges	Memorabilia	Trading cards	Comics	Stamps	Coins	Banknotes
PSA (Professional Sports Authenticator)	1-10	1-10				
BGS (Beckett Grading Service)	1-10	1-10				
SGC (Sportscard Guaranty Corporation)	1-10	1-10				
CSG (Certified Sports Guaranty)	1-10	1-10				
MEARS ((Memorabilia Evaluation And Research Services)	A1-A10					
JSA (James Spence Authentication)	COA					
CGC (Certified Guaranty Company)			1-10			
CBCS (Comic Book Certification Service)			1-10			
PGX (Professional Grading Experts)			1-10			
PSE(Professional Stamp Experts)				5-100		
ASG (Authenticated Stamps Guaranty)				1-100		
PCGS (Professional Coin Grading Service)					1-70	1-70
NGC (Numismatic Guarantee Corporation)					1-70	1-70
PMG (Paper Money Guarantee)						1-70

213

Desired grades	Memorabilia	Trading cards	Comics	Stamps	Coins	Banknotes
PSA (Professional Sports Authenticator)	8-10	8-10				
BGS (Beckett Grading Service)	8-10	8-10				
SGC (Sportscard Guaranty Corporation)	8-10	8-10				
CSG (Certified Sports Guaranty)	8-10	8-10				
MEARS ((Memorabilia Evaluation And Research Services)	A8-A10					
JSA (James Spence Authentication)	COA with WPP					
CGC (Certified Guaranty Company)			8-10			
CBCS (Comic Book Certification Service)			8-10			
PGX (Professional Grading Experts)			8-10			
PSE(Professional Stamp Experts)				90-100		
ASG (Authenticated Stamps Guaranty)				90-100		
PCGS (Professional Coin Grading Service)					60-70	60-70
NGC (Numismatic Guarantee Corporation)					60-70	60-70
PMG (Paper Money Guarantee)						60-70

Rating agencies	Whisky	Cognac	Wine	Champagne	Cigars	Vinyl
Whisky Advocate	x					
Wine Enthusiast		x				
Spirit Journal		x				
Beverage Taasting Institute		x				
Wine Advocate			x	x		
Wine Spectator			x	x		
Cigar Insider					x	
Cigar Aficionado					x	
Goldmine Magazine						x

Grade ranges	Whisky	Cognac	Wine	Champagne	Cigars	Vinyl
Whisky Advocate	10-100					
Wine Enthusiast		10-100				
Spirit Journal		10-100				
Beverage Taasting Institute		10-100				
Wine Advocate			10-100	10-100		
Wine Spectator			10-100	10-100		
Cigar Insider					10-100	
Cigar Aficionado					10-100	
Goldmine Magazine						P to M

Desired grades	Whisky	Cognac	Wine	Champagne	Cigars	Vinyl
Whisky Advocate	90-100					
Wine Enthusiast		90-100	90-100	90-100		
Spirit Journal		90-100				
Beverage Taasting Institute		90-100				
Wine Advocate			95-100	95-100		
Wine Spectator			95-100	95-100		
Cigar Insider					90-100	
Cigar Aficionado					90-100	
Goldmine Magazine						NM, M

Emerging collectibles

The collectible universe is always continuing to expand, and this trend has been accelerating in recent years. As new technologies, ideas, and, most importantly, mindsets, emerge and evolve, the definition of what is a desirable and valuable asset expands in predictable as well as surprising new directions. The asset classes described below are quite new, but have already become widely known, talked about, and accepted by both investment and collecting communities as viable and sustainable. The volume and diversity of options in each is continuing to evolve, and they are well on their way to being included on par with the other mainstream collectibles in the universe.

Some of the classical five core metrics can be applied to items in this space as well, as the creators are cognizant of the economic advantages scarcity and rarity can confer, but the issues of provenance, condition, or historical importance (with possible exception of "first of its kind" objects) are completely non-existent.

Crypto collectibles

Crypto collectibles are unique digital assets in the form of non-fungible tokens (NFTs) that can be digital utilities or wearables within video games and virtual worlds, or standalone collectible crypto art pieces, decorations, and digital objects, stored on distributed ledgers. Like Bitcoin, they are limited in quantity by design, but unlike Bitcoin, each piece is unique and customizable. They are

built on top of blockchain technology on the Ethereum Request for Comments (ERC) platform using ERC-721 protocol. Some of these NFTs have surprisingly high prices due to their scarcity levels (1 of 1 crypto art pieces), or high importance to game mechanics (unique digital trading game cards).

Digital collectibles have risen in value at a far faster rate than just about everything in the analogue art world, largely due to being pegged to cryptocurrencies, and thus being a major beneficiary of the explosion in virtual wealth. They can be bought and sold for nominal fees and there's no need to enter the intimidating world of galleries and auction houses to acquire them. Although the buyer doesn't get to own a physical object, consumer research increasingly reveals that modern collectors, especially millennials, are less hung up about possession.

Some examples of valuable crypto collectibles are:

Decentraland land parcel: Decentraland is a VR world founded by Ari Meilich and Esteban Ordano in 2017 where players (netizens) are incentivized to purchase land parcels that can be customized in accordance with the owner's aesthetic preferences or sold to another player who is looking to get a place in a fancy virtual neighborhood. All in-game assets including virtual LAND are ERC 721 NFTs (Non-Fungible Tokens) and the in-game currency is a native ERC 20 cryptocurrency, MANA. In late 2018, one player was so desperate to move to a "better location" that he paid over 1,000 ETH worth $215,000 in order to purchase a land piece in-game.

CryptoKitty: CryptoKitties was one of the pioneers of crypto collectible space and the first blockchain-based game that was popular enough to significantly impact the performance of the entire Ethereum network. These virtual felines have a combination of collectability and tradability that has attracted more than 235,000 registered users spending more than 37,000 Ether, or about $52 million in transactions, according to the company. In May 2020, the digital collectibles migrated away from the Ethereum network and moved over to its own custom-built blockchain, Flow, which

launched in 2019, as "breeding" CryptoKitties on Ethereum had also become prohibitively expensive for potential users, at around $1 per cat.

The game is extremely straightforward: breed, trade and sell digital cats. Players can purchase digital felines with certain attributes like eye color, body size or pedigree and "breed" their digital pets with those of other players on the network, at an agreed-upon rate, to generate more cats. There's no guarantee to how the algorithmically produced kittens will appear and a limited number of highly desirable early-generation kitties command the highest sales prices and "stud fees." One of them named Dragon (also known as CryptoKitty #896775), with a set of very rare trait combinations sold for 600 ETH or over $170,000 at time of the sale. Dragon broke the record of Founder Cat #18, which sold for 253 ETH ($110,000 at the time of sale) and CryptoKitty #4 sold for $107,000 on the same day in December 2017.

Official Formula 1 virtual car: F1 Delta Time is a blockchain game licensed by Formula 1 and developed by Animoca Brands consisting of a collectible component as well as a racing gameplay component. The company has completed three auctions of unique and official Formula 1® NFTs: the landmark "1-1-1" car auction closed on 28 May 2019, for a record price of 415.9 ETH or $120,000, for a 1 of 1 digital representation of an original Formula 1; the "Monaco Edition 2019" car auction completed on 22 June 2019, for 108 ether (worth $30,000 at the time of sale); and the "France Edition 2019" closed on 15 July 2019, for 96.6 ether (worth $25,000 at the time of sale).

Gods Unchained: Gods Unchained is a competitive trading card game on Ethereum blockchain where players try to win by defeating their opponent and reducing their health to zero. The game has five card types, namely Common, Rare, Epic, Legendary and Mythic, the rarest of collectible cards. With about 6.8 million cards in existence, there's only one count of each Mythic card printed. The first landmark sale of a card was for 138 ETH ($62,000 at the time of sale), and shortly after another powerful Mythic card sold for 210 ETH ($31,000 at the time of sale).

Virtual assets

65% of U.S. households own a gaming device, and the average gamer is a 35 year old with money to spend and a strong conviction that video games provide more value for their money than other entertainment choices. Growing revenues demonstrate the increasing willingness of gamers to spend real money on their virtual characters and rare items in online worlds. These decisions can be seen as "life-affirming", as people feel better and have a higher self-esteem as a result of it. Revolutionary changes in how gamers engage and experience games are happening, driving innovation and growing the importance and values of in-game assets.

In the world of record breaking virtual asset sales, one game stands above them all: Entropia Universe (Project Entropia) created and operated by a Swedish company MindArk, part of the next generation of gaming known as MMORPG (massive multi-player online role playing gaming), that allows players to interact in a world of three-dimensional virtual environments.

Mainstream games operate a 'closed loop' system, where items can only be bought from the developer and players cannot then sell or trade them with each other, but many niche games operate a freer in-game economy where items can be bought and traded among players, with rarest items fetching sky high prices. Unlike many other MMORPG, Project Entropia actively supports sales of virtual products with actual cash value within its real economy system. The economy offers the user a secure and safe way to make purchases, sales and exchange real life currency into PED (Project Entropia Dollars) and back again into real money, at a fixed exchange rate of 10 PED to 1 US Dollar.

Virtual real estate is a difficult item to categorize. On one hand it is a unique virtual item in game, while on the other its economics much more closely resemble those of actual shares or even real estate investment. Following are some record setting examples of the value these unique investments can generate.

Example 1: Treasure Island

In December 2004, a treasure island that exists only as computer bytes within an online role-playing game was sold to a 22-year-old Australian player David Storey, known in game as "Deathifier", for $26,500. The owner has complete mining and hunting taxation rights and can also allocate parcels of land to sell to other players. The purchase price was fully recouped in the first year, by purchasing "creature DNA" and scattering different species across the island, including some rare and unique animals. Now the project generates $36,000 of annual pure profit for Storey and his investors for doing very little, other than offering players a chance to kill virtual animals.

Example 2: Space Resort "Club Neverdie"

In October 2005, a virtual space resort was sold for a price of $100,000. The auction began taking bids on the 21st of October and just three days later the buyout price was met by Jon Jacobs, known as "NEVERDIE" in game. This was the largest amount ever spent in the massive multiplayer online gaming space, surpassing previously world record-breaking sale of the virtual Treasure Island by a factor of four. Operating profitably from day one, the resort recouped the $100,000 in its first 8 months of existence, all from taxes generated by players mining and hunting on the property. The property was listed in the Guinness World Records book in 2008 as the most valuable virtual item. In November of 2010 the asset has been broken up into smaller portions and sold off to new investors for $635,000, giving its original owner an ROI of 535% in just five years.

Example 3: Crystal Palace

In 2009 Erik Novak, known in game as "Buzz 'Erik' Lightyear," purchased Crystal Palace Space Station located in space near Planet Calypso in Entropia Universe for $330,000. In December 2018 the estate was sold to the public via an in-game share offering for $500,000. In the years he operated the property, the owner earned $50,000 every year, for an

estimated $400,000 over 8 years, more than covering his original investment. A healthy $170,000 (51% on top of the original purchase price) bonus at the time of sale was icing on the cake.

The new owners of shares in virtual property have enjoyed similar profits as Buzz. The shares yield about 12% annually, and the price has doubled from the initial offer price of $10 to around $20 within a month of trading, making for a spectacular annualized return for initial investors and providing a steady ongoing coupon with additional possible capital appreciation portion to be realized upon sale.

While paling by comparison with the sky high values in Entropia, where not only virtual real estate, but other virtual items like armor, weapons and equipment routinely sell for thousands of dollars, other games have also seen some high ticket items. Following are some of the most interesting examples in the space:

- In Second Life the city of Amsterdam built and modeled after the real-life version, fetched $50,000 in an eBay auction.
- In Dota 2, an Ethereal Flames Pink War Dog sold for $38,000. This item is a very rare combination of the most sought-after courier type, effect, and color, with only four others known to exist.
- In Age of Wulin, a game that was hugely anticipated in China, a guy who picked up an one-of-a-kind sword for $16,000 was able to effortlessly cruise through the game.
- In Diablo 3 an Echoing Fury Mace sold for $14,000 (or roughly 40 billion in in-game gold). The guy who had this item originally sold it for $250, and it was bought and sold a few more times, until somebody finally realized how valuable this item was.
- In World of Warcraft a level 70 Elf (the max level at the time) named Zeuzo wearing some of the best and rarest items in game was sold for $9,500. Ironically, the character was deleted shortly after for violating Blizzard's terms of service regarding the sale of characters.

- Virtual baseball cards: Like real-world baseball cards, virtual players can be sold and traded on the marketplace created and maintained by Lucid Sight in partnership with MLB, with the official blessing of Major League Baseball playing an important role in the attractiveness of these digital assets. Unlike collectible trading cards, there is no risk of damaging the item, and thus the "condition" premium completely goes away. They can't be counterfeited, the company can't issue more of them, and there's no need to have experts verify the authenticity of these items. Some of the most notable sales included that of former Washington Nationals outfielder Bryce Harper whose bobblehead fetched $7,300, and one of Clayton Kershaw, LA Dodger star, which fetched $3,500.

- Action sequences tokenization: NBA Player Association, and blockchain company Dapper Labs announced the launch of NBA Top Shot, which allows fans to own action moments from the league's history. Instead of a physical card, fans own a clip of video that's been converted into a unique digital token and inscribed on a blockchain. Presumably, a clip of playoff winning jump shot will be more valuable than one of a regular season free throws, much like a Michael Jordan rookie card fetches far more than the card of an NBA bench-warmer.

- Digital clothing: Gamers have been spending money on digital fashion for years. The San Francisco company's "Kim Kardashian Hollywood" game, which allows users to dress as an avatar in clothing from Robert Cavalli, Balmain, and Karl Lagerfeld, has generated more than $240 million in sales since its launch in 2014.

As can be seen from a rather eclectic list above, the diversity of options in virtual collectibles is large and growing, with the future volume and directions limited only by technological advances and creator imaginations.

Digital art

General

The January 1987 issue of OMNI magazine featured predictions from fourteen "great minds" about what they believe the future held. Bill Gates made the following prediction as he imagined the typical household of the future. "You're sitting at home. You have a variety of image libraries that contain all the world's best art. You also have very cheap, flat panel-display devices throughout your house that provide resolution so good that viewing a projection will be like looking at an original oil painting. It will be that realistic." In saying this, Gates, perhaps unknowingly, prophesized the future of the digital art market.

The market for digital artworks (anything that uses digital technology as part of the creative or presentation process) is flourishing, thanks in large part to younger collectors. Although prices have been rising, one attraction of digital art is that it is still generally cheaper than traditional paintings, sculpture and other collectibles found in galleries and at auctions, both at the lower end of the market and at the higher end, where prices for digital art mostly top out below $1 million.

A big problem with producing and selling digital art is how easily it can be duplicated and pirated. Once something is copied and replicated for free, the value drops and the prospect of a resale market disappears. Blockchain helps solve this for digital artists by introducing the idea of "digital scarcity"; issuing a limited number of copies and tying them back to unique blocks proving ownership. It is also used to create ledgers where digital-art transactions are recorded and art is stored, allowing the buyer to verify the number of images in existence and trace the ownership of a piece all the way back to its creator. In order to make their art collectible, artists produce a set number of editions for each work, and the more limited the edition is, the higher the price. Limited edition artwork that has uniqueness and clear

provenance guaranteed by blockchain retains its value and can be easily resold in secondary markets.

There are people out there using new technological media that is just as revolutionary as Picasso's style. Even digital art that seems strange can become quite expensive as tastes change and true digital scarcity becomes a reality. All of which means forward-thinking art investors will invest in new media and technologies in order to get the best returns. As an example, artist Kevin Abosch brought blockchain technology and photography together to create a piece of digital art titled Forever Rose. The artwork was based on Abosch's photo and sold for $1 million, with the cost split among the 10 buyers evenly, with each buyer paying $100,000 in cryptocurrencies and receiving 1/10 of the ROSE token.

Investors considering a purchase should be clear what equipment they need to present the artwork, as some pieces can simply be viewed on a computer, but others might require a projector or a virtual-reality viewer (VR art will be described more fully in the next section). Prospective buyers should understand how the artwork can be protected from technological obsolescence, as years from now, replacements or servicing may not be readily available for equipment that breaks down and software needed to view images may go out of date. An artwork might be cutting-edge technology at the moment, but technology has a tendency to rapidly become obsolete.

Virtual reality art

Virtual reality (VR) is the term used to describe a three-dimensional, computer-generated space where a user can explore and interact with his environment, become part of a virtual world, and manipulate objects or perform a series of actions. It is a brand new technology, and one that is currently more familiar to gamers than art collectors. VR works of art are starting to be exhibited in major shows and museums, including New York's Museum of Modern Art and the Whitney Museum of American Art. It is a

rather unique paradigm where frontiers between art and technology converge and evolve into a new asset class with unique features and challenges.

By way of example, the main piece exhibited in Faurschou Foundation in Venice, La Apparizione, is an artwork presented in an empty three-by-three-meter room. Viewers step inside, slip on a VR headset and are transported into outer space, where they can circle a levitating, golden Jesus, his glowing body convulsing sporadically, shooting off showers of golden embers.

Comparisons with other types of art do not always prove useful. Lemmerz, the creator of the work, is primarily a sculptor, and it is unclear how can a VR "La Apparizione", an experience, be compared to his 2013 bronze sculpture of Jesus, which is an object. It is impossible to hang "La Apparizione" on a wall like a painting, but five editions are for sale by its creator Christian Lemmerz, each costing around $100,000.

The art world establishment is yet to fully embrace digital art. Neither Christie's nor Sotheby's have sold a VR work, but both have expressed cautious interest in the medium and in March 2017, Sotheby's became the first major auction house to exhibit virtual reality art at its New York headquarters. The technology-focused exhibition "Bunker" featured the aforementioned "La Apparizione" and a VR work by Sarah Rothberg called "Memory/Place: My House". With strong and growing collector interest in the medium, it is only a matter of time before VR starts appearing at major auctions.

By deliberately restricting supply, galleries create a market for virtual reality art that is based on scarcity, as with paintings and sculptures. But unlike other art, virtual reality pieces are infinitely replicable, as in their most basic form, they are simply digital files that can be experienced by anyone with a VR headset. While an artist can easily limit the editions of a sculpture, it is much harder to curb the spread of a digital file. Collecting such material involves letting go of some of the preconceptions we have about unique art objects and their attendant value so a collector of VR art might need to get comfortable with the idea that they own a work that is also freely available

to others. Collecting may start to look more like patronage: an investment in artistic and technological experimentation for its own sake, with partial or collective ownership of works to lay claim to the asset.

Valuing virtual art poses a new challenge for buyers and sellers alike. Galleries normally look to artists' previous work when setting prices, but with only a small number of VR artworks on the market, there are only a few precedents to refer to. VR artwork may be tweaked or improved by the artist over time, as software and hardware capabilities improve. These changes and updates are made available to initial collectors, so that someone who acquires a piece early is able to enjoy the same experience made available to future collectors of the same artwork.

With VR artworks there are unique issues of obsolescence as the work itself is intrinsically tied to the tech that its built upon, a problem we already touched upon in the general digital art section. These artworks require a different type of care and stewardship than conventional ones, with a mandatory check-up every year to ensure that rather than being faced with an obsolescence five years down the road, and dealing with obscure technical issues from years past, the owner can just attend to the smaller more incremental issues as they crop up on a year-to-year basis.

Generative art

Generative art refers to works that in whole or in part have been created with the use of an autonomous system that is non-human and can independently determine features of an artwork that would otherwise require decisions made directly by the artist. It draws inspiration from modern art that makes heavy use of orderly geometric patterns and is programmed using a computer that intentionally introduces randomness as part of its creation process, becoming a collaboration between the computer and the artist. The artist controls both the randomness and the order in the art, with the outcome being different each time the generation script is run.

Controlled randomness may sound contradictory, but artists have always sought ways to introduce randomness into their work to stimulate their creativity. Thinking about the process of coding generative art as being similar to painting or sketching is actually the right way to approach it logically. By incorporating chance into a piece of code art, you get a different, completely unique piece of art each time you run your script, load your page, or respond to some user interaction. Unlike analog art, where complexity and scale require exponentially more effort and time, computers excel at repeating processes near endlessly without exhaustion. The ease with which computers can generate complex images contributes greatly to the aesthetic of generative art.

AI Art

In October 2018, Christie's became the first auction house to bring a piece of AI (artificial intelligence) art to auction. The work was titled Portrait of Edmond Belamy and it was created by the French artist collective "Obvious" and sold at auction for $432,500, shattering the initial $10,000 estimate. It was created by a computer program that generates new images based on patterns in a body of existing work, whose features the AI "learns".

The painting was one of a group of portraits of the fictional Belamy family created by an AI trained by the Paris-based collective. Its members Hugo Caselles-Dupré, Pierre Fautrel, and Gauthier Vernier explored the field of art with artificial intelligence using a set of algorithms called GAN (generative adversarial networks). Like other machine-learning methods, GANs use a sample set, in this case art images, to deduce patterns, and then use that knowledge to create new pieces. A typical Renaissance portrait, for example, might be composed as a bust or three-quarter view of a subject. The computer may have no idea what a bust is, but if it sees enough of them, it might learn the pattern and try to replicate it in an image.

Future collectible assets

This section will attempt to look into a home-made crystal ball and forecast some of the possible "items" that people will consider to be desirable, valuable, and collectible in the future. These are not predictions or forecasts, but rather pure conjectures based on the current state of the collectible market, trends in the art, technology and investment industries, general economic, social and cultural considerations and above all, the author's imagination.

Genetic art

Genetic art involves modification of genes to express unique qualities in living organisms or humans. Although this kind of art has existed for some time (Edward Steichen exhibited hybrid delphiniums bred for a specific color at the Museum of Modern Art in 1936), only in the last few years has it gained much attention. Contemporary biotechnologies offer new, unprecedented opportunities to genetically manipulate living creatures and design them according to human ideas. Some artists are already turning the laboratory into the studio. Tissue cultures, synthesis of artificially generated DNA sequences or biorobotics are all tools that can be used to create groundbreaking works. Artists who work with live organisms deal with a different kind of time than regular painters or writers, a much slower kind of time, that of plant and animal generations.

Joe Davis is one of the seminal figures in this field, and his work laid the foundations for a new artistic discipline, one of the first to blur the lines

between art and modern biology. In the late 1980s, Davis collaborated with molecular biologist Dana Boyd to insert for the first time a non-biological DNA message. The work, *Microvenus,* encoded a binary representation of the Germanic rune for the female goddess of earth and life into a coding sequence of the bacterial strain E. coli. He also worked on a project titled *Malus ecclesia,* that involved encoding the top 50,000 pages of the English Wikipedia page into bacteria to be transferred into apple trees as a biblical reference to the apple tree as the tree of knowledge in the Garden of Eden.

The next frontier in the evolution of this field, and one that is still mostly in the realm of imagination is called transgenic art. It is envisioned to be a new art form based on the use of genetic engineering techniques to transfer synthetic genes to an organism or to transfer natural genetic material from one species into another, to create unique living beings. The nature of this new art is defined not only by the birth and growth of a new plant or animal but also by the relationship between artist, public, and transgenic organism. Organisms created in the context of transgenic art can be taken home by the public to be grown in the backyard or raised as human companions. Ethical and responsible interspecies creation will yield the generation of beautiful chimeras and fantastic new living systems, such as plantimals (plants with animal genetic material, or animals with plant genetic material) and animans (animals with human genetic material, or humans with animal genetic material).

Experience transfers

When discussing experience transfers as a collectible asset, it is important to keep in mind that the technology to implement this is not yet available and thus the definition of this futuristic asset class, as well as its possible features and applications is pure conjecture. A number of books and movies have explored the theme from various angles, so the concept is familiar to today's readers and moviegoers, but it is still in embryonic stages of scientific research. Let us stipulate that in 50 or even a 100 years the problem will be

successfully solved, and the technology to share memories and experiences in fully immersive fashion has been commercialized and is widely accessible.

This will allow for a creation of a wide range of experiences, ranging from mundane to extreme, with the most exciting and unique ones being rare and highly sought after. The unique life experiences will vary on many parameters including location, duration, intensity, complexity and interactivity, with the highest prized ones having the highest score across all the metrics.

There is a tremendous potential for creativity in this field, such as generating custom multi-sensory experience sets or combinations that are impossible to achieve in the real world or enhancing certain aspects of an already intense situation to allow the user to experience a situation or episode from a new or unexpected angle.

Emotion collections

This futuristic asset class is distinct from experience transfer, in that it is more focused and foregoes the context in order to capture just the pure raw set of emotions experienced in various contexts. These will vary by type, duration, intensity, and senses involved and will allow the owner to experience a unique emotional state independent of the actual experience or events causing it. The ability to synthesize, enhance, combine and direct emotional scenarios represents the very essence of the art world, taking the very thing that draws us to art and making it itself the object of wonder.

Sensory collections

Similar to emotion collections, this is a set of unique sensations, with the core focus being on smell and taste. Humans detect smells by inhaling air that contains odor molecules, which then bind to receptors inside the nose, relaying messages to the brain. Most scents are composed of many odorants;

a whiff of chocolate, for example, is made up of hundreds of different odor molecules. There are 1 trillion scents that the human nose and brain are capable of distinguishing from each other, but we experience complex smells via combinations of seven primary odorant groupings: camphoric, musky, rose, peppermint, ethereal, pungent and putrid. Using these seven building blocks as a palette and overlaying secondary smells and unique primary combinations and proportions, a sensory artist can create a masterpiece of smell (olfactory) art. Smell is one of our primary senses, and rare combinations or unique instances found or created by experienced curators will be highly prized.

Smell has been scientifically proven to be strongly linked with memory and the brain learns to recognize scents by recalling what was going on in the vicinity the first time it smelled them. For example, during an experience with roses, the brain tags the odorant signature with other sensory information received at the same time: what the flower looks like, how the petals felt on the skin. Thus, creatively manipulating the building blocks of smell allows for creation of smell profiles that not only please, but also evoke very concrete associations and experiences, making for a very nuanced and unique product. Our sense of smell is integral in appreciating and savoring food as well.

Like the mechanics of smell, we experience complex flavors via combinations of five basic taste-receptor types (sweet, salty, bitter, sour, and umami). Special foods are tied into our very earliest memories and can evoke a range of sensations that extend greatly beyond simple pleasure of a well formed or unique bite on the tongue. Using these five as a tool kit, a range of flavors can be designed by a taste artist and be tailored to specific occasions, places, and events, or create more general taste profile sequences or combinations that may have universal appeal.

Body augmentations

Human augmentation is generally used to refer to technologies that enhance human productivity or capability, or that somehow add to the human body. Modern advancements in many areas of technology and biology have led to a greater variety of implants and other technologies that could be classed as human augmentation. We are still in the very beginning stages of discovering the possibilities of this technology, but with time more intricate and powerful devices will appear that allow us to have a single or even multiple superpowers such as magnetism, extreme sight, faster regeneration, super hearing, augmented taste, smell, memory and multiple other permutations of features. A uniquely augmented subject can be considered a work of art by itself, similar in some sense to genetic art. Fast forwarding to the time when all modifications will be done on a genetic level, the vintage augmentation tech, much like the first examples of Apple computers or Atari video consoles, will be highly sought after.

Future transport

Classic cars and motorbikes have been a staple of the transport collectible space for over a century. As we look to the future we can imagine other modes of transport arising, evolving, and eventually being considered vintage. These can be early models of purely autonomous vehicles, drones, jetpacks, or whatever new yet unknown mode of transportation comes to be. Much like we value classic cars and motorbikes today, these future classics will be evaluated using similar criteria and will almost certainly be one of the most important verticals of future collectibles.

Androids

A staple of many sci-fi movies and shows, androids, or humanoid robots are the fantasy tech of the future. Assuming that fantasy becomes reality, and

androids as human helpers and companions evolve, the early models will be rare technological curiosities, relics of the time before everything changed. Perhaps, as they become a part of the population, they will no longer be treated as high-tech property, but equal members of society. The human collectors will prize these rare and historically important items, but this new generation of advanced beings may have a great deal of interest in their history and the demand for early models will soar driven by their curiosity (assuming they view collecting and investing as desirable activities).

People tokenization

We have already seen the trend in digital collectibles where game winning actions have been tokenized and became valuable and unique assets. This can be extrapolated to the time when it will be possible to fully digitize a famous person, such as an athlete or an actor, including all his past and ongoing actions, talents and features and own the rights to use the unique digital version in various VR settings. This will be a revolutionary development in digital collectible space allowing separation of physical and virtual personas, and with a built in rarity, this has potential to become a very large and vibrant market.

Dormant asset tokenization and liquidity

There are dormant assets, such as countless murals, frescoes and buildings of high Renaissance or pre-Renaissance years that are priceless (or more accurately not yet priced), but as yet unmonetized including works by Old Masters like Michelangelo, Raphael and Leonardo. This tremendous amount of dormant art around the world is dormant precisely because it cannot be bought or sold, or monetized in any other form beyond the meager visitor fees that barely cover their maintenance costs.

The difficult part is assigning value to these assets, but once this puzzle is solved, dormant art assets can be monetized via tokenization and sold to

individual investors. Owning a piece of the Louvre, the Eiffel Tower, the Mona Lisa, or Statue of David will be a thrilling experience for anyone, and due to the built-in rarity and brand name these are sure to become some of the most prized collectibles. There are currently multiple ways to estimate the value of specific buildings, locations, or pieces with some of the key ones being market value, investment value, public interest value and value in use among others. Once a universally accepted valuation method is developed and generally agreed upon, this asset class will explode.

The above thought experiment is meant to show the amazing range of possible future asset classes that will make the collectible investing space that much more vibrant, deep and profitable for centuries to come. Most exciting of course are the possibilities not written about here, and that still lie beyond our collective imaginations. The "undiscovered country" of the future contains many surprises and wonders, and while it is thrilling to speculate about what may be, the only thing we can know with certainty is that we stand at the very beginning of an explosion of collectible choices and verticals.

Fractional ownership framework

Uses and benefits

In 1602, when the Dutch East India Company issued the first shares of stocks tradeable on the Amsterdam Stock Exchange, these capital market visionaries could not have imagined the business model they pioneered would be used centuries later by collectors to become fractional owners of a wide range of the most valuable objects in the world and allow them to freely trade these fractional interests like stocks. Fractional ownership allows investors to enjoy products without the hassles or risks of full ownership. Most individuals do not have sufficient funds to build a high-quality portfolio of collectibles on their own, because each piece can be quite costly. Partial ownership is a way to allocate to an otherwise unaffordable set of options by purchasing only the ownership stake desired. This gives the buyer a way to participate in the upside without needing to commit to the full price of ownership, while still fully benefitting from capital appreciation of the asset and eventual sale proceeds. Evidence suggests that fractional investors have a medium to long-term investment time horizon, providing a clear indication that fractional investment platforms are not attracting investors looking for a quick buck.

With fractional ownership, investors can diversify their portfolio to include investments which were previously too expensive and out of reach of the vast majority of investment public. At the same time, those wishing to sell high-valued assets have a much easier task, where instead of searching for one investor willing to purchase the asset, they can now access a much larger

pool of investors by significantly decreasing the minimum investment amount thanks to, once again, fractional ownership framework. When illiquid assets become more liquid, and accessible to a much larger audience, illiquidity discounts of approximately 20–30% are removed, greater value is captured from the underlying asset, and investors, in turn, get better returns. Instead of waiting weeks or months for an individual buyer to purchase a high-ticket item, once converted to a share it can be offered on the secondary market for investors to purchase. The benefits that accrue to each share's owner are many, among the chief ones being value transfer from the artwork, portfolio diversification, potential appreciation and faster liquidity since shares are infinitely easier to buy, sell, and store than paintings or other collectibles.

Artwork has distinguishing characteristics that make each piece "nonfungible". You can't swap out one Monet for another; each is unique, and a reproduction is not the same as the real thing, but stock certificates are fully fungible. Each one is the same as all others. Until recently, the only viable way to sell a painting valued at $10 million was to go through an auction house like Sotheby's or Christies, who would charge a premium of up to 25% for selling the painting. With the evolution of securitization and tokenization techniques in art, the industry is poised for a similar monumental transformation to the one that real estate markets went through 40 years ago. Real estate is today a widely accepted investment class, accessible to a large community, and is commonly included in portfolios for diversification purposes, and art, along with collectibles, is headed in the same direction. The ability to sell a $100 million painting in $100 increments can unlock millions of dollars in currently illiquid assets. Fractional ownership lowers the barriers of entry for new investors and helps them to increase portfolio diversification and construct a portfolio they want.

A key mindset that fractional owners need to adopt, is reconciling themselves to the fundamental paradox of partial ownership. They'll never be able to drive their cars, read their comic books, taste their wine, or hang

their paintings on their wall. But the benefits of the paradigm far outweigh the minor unhappiness, as with the model of co-ownership, investors can have access to a large number of higher-value pieces, increasing their chances of getting a positive return on their investment and deriving a great deal of utility from the size and stability of their profits..

Tokenization vs securitization

In modern finance, the generally accepted way to create fractional ownership of an underlying asset or pool of assets is via a process of securitization. While there are many nuances and legal and operational intricacies involved in the process, it can be summarized in the following simple steps:

1. Owner of the assets collects the assets in a pool and transfers the pool to a legal entity called a special purpose vehicle (SPV).
2. The SPV structures the assets within the pool into several tranches, according to different risk levels and characteristics and issues securities backed by the underlying assets.
3. After issuing the securities, the SPV sells the securities to investors, while transferring the proceeds to the owner afterwards.

Securitization is thus the process of converting assets with low liquidity into more liquid security instruments, from their basic form into tradable stocks that are backed by a pool of standardized assets of a single type. Tokenization is the next generation of securitization, and involves converting an asset into digital tokens on the blockchain system that link to this single underlying asset and derive their value from it. It is the process of digitally storing the property rights to a thing of value (asset) on a distributed ledger, so that ownership can be transferred via the blockchain's protocol.

For structured finance professionals, tokenization might seem like securitization, but the biggest difference between tokenization and securitization, is

programmable business logic that is introduced into the tokenized asset, reducing the need for manual settlements.

As premium art and collectibles increase in value as a whole, fractional ownership offers a unique opportunity to benefit from this value appreciation. If a $10MM painting was fractionalized into 10,000 units, 1,000 investors will be able to each own a share that can be traded, and its ownership and authenticity validated via smart contract. Digital scarcity, the same concept that allows us to treat Bitcoin as currency, enables us to treat digital art as if it were physical art. This is opening up new marketplaces where digital artists can sell their work.

Fractional ownership platforms can be separated into two broad categories: those for collectibles for which value judgments are relatively straightforward; and those for fine art, for which perceptions of value are constantly in flux. There are tens of thousands investors participating on platforms below with total assets invested in tens of millions of dollars. Below is a partial list of platforms by type and ownership format:

Art:

Securitization:

Masterworks: https://www.masterworks.io/

Artopolie: https://www.artopolie.com/

Arthena: https://arthena.com/

Feral Horses: https://www.feralhorses.co.uk/

Tokens:

Acquicent: https://acquicent.com/

Artsquare: https://www.artsquare.io/

Look Lateral: https://www.looklateral.com/

TheArtToken: https://www.thearttoken.com/

Wunder: https://wunder.art/

Maecenas: https://www.maecenas.co/

Malevich: https://malevich.io/

Monart: https://www.monart.art/

Superrare: https://superrare.co/

Dada: https://dada.nyc/artgallery

Digital Objects: https://digitalobjects.art/

Collectibles

Securitization:

Rally Rd: https://www.rallyrd.com/

Otis: https://withotis.com/

Collectable: https://www.collectable.com

Mythic Markets: https://mythicmarkets.com/

Vinovest: https://www.vinovest.co/

Tokens:

Curioinvest: https://curioinvest.com/

Bitcar: https://bitcar.io/

Democratization of rare asset ownership

Benefits for sellers

Collectors

For current owners, additional demand and ability to sell their assets via or to the fractional ownership platforms creates a large new source of liquidity, and thus de-risks the original investment from the liquidity perspective. The platforms also allow for easier and more seamless experience of using collectible assets as collateral, as the risk of the loan is effectively spread across fractional owners, and the fact that the asset is already trading on a fractional secondary market alleviates some concerns about price discovery and liquidity.

Ability to sell only a part of the asset, while keeping the majority share, as well as physical possession (with appropriate insurance and storage guidelines in place) allows the owner to retain the aesthetic premium of possessing the asset while monetizing some of the asset for other purchases.

There are also multiple solid benefits in terms of financial planning, including tax optimization, estate transfer, and ability to meet future projected cash flow needs in an optimal fashion. The ability to quickly value and, if needed, monetize existing illiquid assets is a valuable tool to have in every one of these instances and speeds up and simplifies a number of previously time consuming tasks associated with these processes.

Museums

Museum collections are not static, and there is a large portion of works that is rarely, if ever, displayed and just remains stored in the vaults. While museums are generally reluctant to sell works (a process called deaccessioning), they will part with lesser pieces or items received as part of a bulk donation that do not fit with the curator's vision or museum mandate. Monetizing some of the less popular work, which may still be valuable and highly demanded in the market, allows the museum an easy way to raise funding for new acquisitions and other operational needs.

One of the big problems for museums when they are looking to obtain a highly desired item in the market, is that these tend to go quickly, and often it is not possible to get all the required committee approvals in time. Museums thus frequently purchase works from dealers shortly after auctions at substantial markups. The ability to quickly raise funds by using current holdings as collateral, selling minority stakes in some works, and realizing liquidity via storage sales as noted above gives museums a fighting chance and the war chest required to obtain the true masterpieces before they are taken off market by private collectors.

Dealers

Dealers' core business involves acquiring or taking items on consignment and disposing of them for a profit. While the acquisition process may be somewhat efficient, where dealers have connections to artists and other galleries that allow them to source works they believe are valuable and in high demand, disposing of these assets is another matter entirely, a slow and time intensive process. Utilizing fractional ownership avenues makes the process quick, efficient, transparent and profitable, allowing galleries to bring in more new works, turn over their capital faster, and get exposure to a new type of buyer who is ready to invest in quality assets in large volumes. A second opportunity is to use their existing collection as collateral, and to use the leverage to increase the number of desired pieces acquired. Not only

does this allow the dealer to grow his footprint and profitability, it also de-risks the process by providing a built-in base of future customers for the new pieces, provided the standards of quality are maintained for all acquisitions.

Foundations

Foundations frequently have indefinite time horizons and a set of causes that are supported on an ongoing basis. This means that not only do they have to ensure that their capital base grows every year in order to continue to use the income, but they also need to manage cash flow for existing and especially new projects and directions as they arise. Enhancing its cash flow generation capabilities via using assets as collateral or selling minority ownership stakes into the fractional market, allows a foundation to fulfill its core mission, and expand its reach into supporting a wider range of important causes.

Estates

One of the big challenges for estates is an undeniable fact that what the prior owner has considered a treasure and has spent a lifetime collecting, the heirs do not necessarily view as such. Access to a large pool of interested buyers provided by the fractional ownership model is a perfect solution to address speed of disposition, large volume sales, and cost efficiency compared to the auction houses, which goes to the fiduciary duty of the executor to extract the highest possible value for the beneficiaries.

In cases of a single large asset with multiple heirs, where some want to monetize, and some want to hold on to the asset, the fractional framework allows, like in the case of individual collectors to sell a minority share of the asset while retaining the majority and physical ownership, thus making conflict resolution in difficult inheritance circumstances easier.

Benefits for buyers

Individual investors

For millions of individuals around the globe buying tiny fractions of luxury collectibles is a way to participate in an economy previously exclusively reserved for the very wealthy. All share a unifying premise: luxury goods won't just hold value, they will appreciate over time. The core benefit is access to a wide range of assets that have solid portfolio diversification characteristics, serve as inflation hedges and allow for better financial planning. This group is not particularly concerned with aesthetic or historical component of the asset, making it easier for them to dispassionately evaluate the investment purely on its potential for profit.

HNW investors

Most HNW and UHNW investors already have a good level of exposure to the asset class, and thus have a high degree of familiarity with the features and benefits it brings. For this population, the key benefit is the ability to obtain greater diversification within their current sub-asset classes, as well as expand to new ones in a controlled and exploratory fashion before making a decision to go bigger.

Openness to viable new ideas and directions, ability to weather a temporary loss in value, and longer time horizons are the key characteristics of this group of investors. Ability to explore profitable opportunities with low initial commitment and the option to significantly increase the allocation later as comfort and knowledge grows make this a very attractive investment channel. As collectible assets are considered good inflation hedges, the fractional platforms can serve as a great avenue for acquiring alternative assets to balance the portfolio with them.

Family offices

The needs of this segment are akin to those of a foundation, with a very long term time horizon, multi-generational wealth transfer planning needs, and high tolerance for illiquid asset classes. The core use of fractional platforms in this case is to acquire desired assets at better prices than possible at auction or via private purchases due to much lower transaction costs, and increased breadth of collectibles that can be acquired within a short time frame. Most family offices already manage a curated portfolio of art and other collectible assets collected by owners primarily for its aesthetic and prestige value, so there is a great degree of familiarity with the nuances of valuation and identification of desirable assets.

Platforms function and features

There is a core philosophy that can be taken as the gospel of the fractional ownership paradigm: **Possession is overvalued, ownership is undervalued**. Creation of fractional ownership platforms transforms a simple but powerful idea above into a concrete real life solution. Its key mission is to open access to a very large data dense global market which up till now has only been available to very few.

The current state of the market for art and collectibles is such that virtually all the valuable assets are held by a very small number of parties, and are exchanged rarely, inefficiently and at great cost to both sides. The new paradigm is involving a much wider audience, making the process more liquid and transparent, and enabling old and new players to unlock, realize and benefit from the value of a wide range of assets that are becoming liquid. The composition of global wealth and consistent growth in the pool of potential buyers suggests there should be no shortage of available capital or interest to purchase high-end collectibles. Below provides a detailed look into market liquidity, efficiency and transparency issues addressed by creation of platforms, as well as existing and upcoming features which make this seismic shift in wealth management practical and easily accessible to all.

Core issues solved by platforms:

Lack of transparency

Currently only a relatively small portion of transactions in high end collectibles happen at auction, with the majority happening via private trades that rarely get reported or recorded. Even the ones that do happen via auction are not necessarily true reflections of demand or market price as public auction results can be manipulated, thereby distorting a work's fair market value.

A fully transparent process presented by the platform, where asset shares in a primary offering are offered to the market in a liquid and fully transparent fashion, enables investors to gauge demand by the speed with which available fixed number of shares are acquired and to track the number of independent bidders and average shares bought per transaction.

Once the asset has been initially sold on the platform, and is later made available for secondary trading, there is even more transparency, as it is possible not only to see the current market price, but also the amount of people offering and bidding the asset at each price point, allowing a clear view of the depth of the market, supply demand imbalances, and historical price performance.

Proof of authenticity

The first step in deciding whether to acquire an object, is to ensure that you are buying what you think you are buying. For most unique objects, art or collectible, the possibility of fraud is high, and grows exponentially higher with the increase in the object's value. Reputable platforms take authentication very seriously and certificates of authenticity issued by third parties, such as proven and recognized experts in a specific asset class, who are unaffiliated with the seller, are a key element in building investor trust

and comfort and is the cornerstone of confirming the object's valuation. Once this has been obtained, a separate insurance policy is taken out to insure against selection process errors and to help provide an additional layer of confidence and mitigate residual legal issues.

Provenance, of which authenticity is an integral part, also is tracked in a variety of ways not only to confirm the legal ownership chain during the entire lifetime of the object, and ensure all preservation and safety protocols have been followed, but also to justify enhanced value if special events or famous owners can be proven to be associated with the object.

Excessive transaction fees

Apart from illiquidity, the biggest problem with the high end collectible market is the exorbitant cost of buying and selling items via auctions. Buyers are charged a premium of up to 25% on top of the sales price, and sellers are charged a variety of fees (for photography, insurance, storage and marketing), as well as a commission of as much as 20%, depending on the selling price. This creates a very high barrier to profitability of the object, and enforces an unnaturally long holding period required to just break even.

Platform fee models are more collaborative in nature, and significantly lower than those of auctions or dealers, making this channel much more attractive to both buyers and sellers of rare objects by being the low cost option while retaining high standards of care. By drastically lowering the fee structure, fractional platforms have not only created liquidity, but also directly challenged the existing auction business model, perhaps forcing them to follow suit, at least partially, thus creating a possible positive effect for even those market participants who are still using auctions as primary means of object acquisition.

Illiquidity

This is the biggest problem cited by opponents of collectibles as an asset class, due to a very small pool of both buyers and sellers of rare objects, monetizing a valuable asset is a notoriously expensive, time consuming and elaborate process. In addition, most auction houses hold auctions for specific objects at specific times once or twice a year and dealers are somewhat limited by the idiosyncratic desires of their client lists.

Platforms provide a simple and clear solution to all the issues noted above. Fractionalization makes the object liquid, and this is perhaps the most important effect of the platforms. Making objects available for purchase and subsequent secondary sale to a very large and growing global audience on a continuous basis removes both the concern about depth of market on both sides, and the question about timing of transactions, as once accepted, the asset can be traded multiple times within a day.

Long holding periods

Related to the problem of illiquidity and excessive transaction fees, long holding periods have traditionally been dictated by high levels of both of these parameters. While a long term investment approach for assets that are typically considered inflation hedges is not necessarily a bad one, the issue here is that if monetization is required within a short time frame, the only outcomes are either a fire-sale at heavily discounted prices or, even worse, inability to sell at any price.

Platforms provide a much needed source of liquidity, both broad, as its investors are generally asset class agnostic, and deep, as the investor pool is large and global as noted earlier. As a result the problem and necessity of long holding periods goes away almost completely, as transactions can be affected with high frequency and at required volumes.

Expert knowledge required

Investment in exotic asset classes requires a great deal of subject matter expertise, as the myriad of nuances and potential for fraud make mistakes not only quite possible, but also extremely costly. Developing expert level understanding of key value metrics for each asset class is a multi-year process requiring serious dedication, time and passion. One of the benefits of the platforms is that they provide this very level of subject matter expertise required to properly select, evaluate and verify the assets placed on the platform. While a buyer still needs to be aware of key value metrics for each asset class, the platform provides comfort and aligns its interests with investors by providing objective expert evaluation of a particular asset's merits.

Key role of platforms:

Providing a secure and trusted investment channel: There are several aspects that go into making a platform suitable and desirable for use by informed investors. It has to ensure that it inspires trust, demonstrates credibility, shows alignment of interests with investors, and provides convenient execution, monitoring and reporting capabilities. Trust is built through confidence that the assets offered have passed extensive and independent provenance checks and value estimation by both internal experts and independent third parties. Credibility is earned via a track record of selecting objects that are not only authentic, but also rare and scarce enough to maximize the probability of value appreciation beyond base inflation. Alignment of interests is best demonstrated via having "skin in the game" or investing its own funds alongside the general public. Technical capabilities such as making the process of investing seamless, allowing easy options for reviewing and interpreting results and making understanding the portfolio composition easy all serve to build loyalty and enhance investor comfort.

Sourcing desirable high quality investment assets: The key to having a successful platform is the ability to allow investors to acquire high quality assets at reasonable prices from a range of sources in order to provide the diversity of options along with ensuring built-in price appreciation potential. Sourcing can be done directly from current owners by providing them with an incentive in the form of significantly lowered commission; primary dealers who have an incentive to churn their inventory; and, at times, opportunistically, at auctions if it has been determined that a particular piece is substantially enough mispriced.

Creating liquidity for securitized assets: Once assets have been sourced and vetted, they are made available to platform investors to acquire fractional ownership via share purchase. The initial offering is conducted at a pre-scheduled time at a pre-determined fixed price where all investors can submit purchase orders indicating the amount of shares they wish to acquire and these orders are filled in order of submission. A proper share locking and queuing system that ensures the integrity of the bidding process and includes all the relevant and necessary fallbacks is an indispensable prerequisite for a robust primary offering. Once the primary offering is done, a mandatory waiting period (90 days in cases of securitization), has passed and the asset is fully live on the platform, secondary offerings are conducted via trading windows with single market clearing price for all participants. The trading windows are currently typically scheduled on a quarterly basis, but as platforms evolve these will undoubtedly be transitioned into daily markets available 24 hours a day to accommodate global demand.

Providing exit options: There are two ways to create liquidity for an asset via fractional platforms: ongoing liquidity offered by the ability to sell shares on secondary market, and final liquidity, where the whole asset is sold to an interested buyer at a price approved by majority of current shareholders. The first avenue provides for planned trading and disposition of investments to rebalance the portfolio, lock in profit, limit the losses or free up cash for a more attractive new investment. The second avenue, where timing cannot be predicted, provides unexpected liquidity, and while it will always lock in a profit, it also contributes to some reinvestment risk as there may not be

assets currently offered that are of interest to replace the ones sold, creating potential cash drag issues.

Developing asset class addition methodology: There are many unique and niche asset classes in the world of collectibles, with the most important ones covered in Section 4. At the present time, only a portion of available asset classes are represented as investment options on major platforms, but there is a framework that exists to determine which additional asset classes and in what order can and should be made available on the platform. By eliminating the human factor in the determination process and making it based on hard data on preferences gathered from a wide community of investors, the platform gains clear insight that allows it to provide access to the exact combination of assets desired by its current and potential future user base.

Fee models

In order to fully appreciate the role of the platforms, it is important to learn how these entities make money, and why the way they structure their compensation serves as part of their marketing and trust building strategy. While the permutations of fees are numerous, items below highlight the most commonly used approaches.

Fee from original asset seller

This fee is actually an important marketing component and a key differentiator for platforms vs auctions. Making this a low number (4-5%), allows platforms to ensure they are able to source assets at a price attractive to the seller, while still generating a healthy margin. Making the fee strategically low enough, to be almost nominal compared to the 25-30% markup of auctions, lets top platforms, like Rally Road, attract and retain a large pool of individual collectors.

Upside from block share ownership

Investors' confidence in the fact the platform's interests are fully aligned with theirs is paramount to build comfort and confidence with the channel. A practice by top platforms, including Rally Road, of buying a block of shares in each new investment on par with other investors ensues a great deal of trust, as well as allows the firm to enjoy the upside of the assets they have carefully vetted and selected. While a minimum stake is often a regulatory requirement under a securitization approach, taking a larger one (if capital allows) demonstrates strong commitment and focus.

Commission on each transaction

Probably the most traditional of all methods of generating revenue, employed by the Feral Horses platform, for example, is taking a certain fixed fee for each transaction that takes place on the platform. Its benefit is in its simplicity and transparency, where the user knows exactly what the additional costs to them are. The downside is that it does not demonstrate any alignment of interests with users or encourage frequent trading to improve liquidity and price discovery.

Spread between asset bought and platform sale price

As methods of initial asset acquisitions vary, this type of fee applies when the platform initially acquires the object in the secondary market, and then makes it available to investors. Used by Masterworks, among others, the purchases are sourced through a variety of channels, including auctions, as auction buying can create additional comfort with a five year warranty from the auction company on authenticity, and title risk mitigated by publically recorded transaction. This fee is conceptually similar to the fee from original asset seller framework, with the key difference being that here the investors pay that fee.

Management fees for investment vehicles on yearly basis

This method practiced by among others, Masterworks, the category leader in art platforms, is borrowed directly from the financial markets, where it is utilized by most pooled investment vehicles. A small yearly fee charged for each asset on the platform until it is disposed of provides a regular and predictable stream of cash flows to the platform that can be used to cover operational expenses.

Custom services: future functionality

Asset gathering

The ability to identify and source high quality assets is the absolute key to platform ongoing operations and continuous success. Depending on the specific purpose for which assets are being acquired, slightly different approaches can be taken to ensure the right mix of assets is targeted and obtained from the right sources. The below discussion covers the three main asset gathering paths.

Sourcing specific items for custom portfolios: This is one of the core pillars of platform functionality. The ability to locate, secure, and curate top level assets on an ongoing basis is no trivial task, and requires a combination of expertise, connections, organization and financial strength. The key skill is to establish a broad portfolio of channels diversified across asset classes and seller types in order to ensure a steady supply of high quality items. The first steps of this are being taken by top platforms in their respective niches like Rally Road (collectibles), and Masterworks (art), but this is one area where continuous growth, improvement and optimization are an absolute must.

Managing bespoke asset portfolios: This is a solid way to diversify platform service offerings to cater to existing collectors who are interested in

outsourcing management, curation and sourcing for their portfolios to reputable third party providers, while retaining full ownership benefits. Sourcing assets for this group serves as a double positive for the platform, whereas it not only secures an additional stream of revenue, but also organically grows a direct and somewhat captive channel for future items to be offered on the platform.

Creating thematic portfolios: One interesting and very useful way to allow investors to instantly create a high quality diversified portfolio, is by putting together a thematic or multi-theme model portfolio that contains a number of chosen assets either within a particular sub-asset class or across a spectrum of classes. Issuing fractional shares in these entities will provide investors with instant diversification within or across asset classes and will present a more streamlined approach to portfolio building.

Trading functionality

Having a robust set of tools enabling fast, transparent and costless transfer of shares, as well as ongoing price discovery is a key feature set that allows investors to integrate these investments into their overall wealth management plan. The base functionality of providing more frequent trading windows, and continuous trading down the road, is an important feature, and is in the works on most major platforms, but there is a need for a broader set of tools such as:

Cross platform trading arrangements: Currently the fractional platform universe is fairly fractured, as we saw in Section 5, with many platforms competing to provide access to similar asset classes. Quality of access and the ability to source unique assets is without a doubt one of the key differentiators and competitive advantages of any platform. However, from a strategic perspective, once an investor has successfully participated in a primary offering and most of the loyalty and reputational benefits have accrued to the original platform, allowing greater investment flexibility by entering into agreements with other platforms lets investors transact in

secondary shares across multiple venues. This can be implemented between two or more platforms, and serve to create a much more vibrant market for investors.

Cross platform joint sourcing and securitization arrangements: Providing diverse options to its customer base on ongoing basis is essential for successful functioning of the platform. While the larger ones will have secured a solid pipeline of potential deals, it will still behoove most players to cooperate on sourcing and cross-offering key assets in several cases.

One instance is where there is a high quality asset in an asset class that is quite similar or virtually identical to ones already on the platform. Instead of saturating its own market, a platform may choose to list the asset on a partner platform in exchange for having similar arrangements extended to it, or just a share of the fees generated from primary and secondary offering. Another powerful strategic move is pooling assets and influence to secure a very expensive asset, which may be a good strategy to provide a unique product to users of both platforms, and an effective way of building and maintaining respective client loyalty for all players involved.

Individual account data: Creating clear and comprehensive account reports that can be used for tracking, reporting and analyzing absolute and relative performance is an essential feature of any trading related service. There need to be core tools for reporting portfolio composition, returns, performance attribution and trading history so that investors can periodically review their positions using tools and reports familiar to them from the traditional investment world.

Provision of standard trading risk management: One of the most important benefits of having a liquid market and extensive reporting and monitoring capabilities, is the ability to assess the risk profile of your portfolio, study areas of concentration, and mitigate downside by placing stop loss orders on shares to limit losses, as well as limit orders to acquire assets trending up.

Reference index creation: Indices are a classic and frequently used tool to reference a combined performance of a sector. Many indices exist for individual sub-asset classes, and while each has their known issues and biases, they can be used as pricing benchmarks and as metrics to estimate correlation, volatility and returns of their respective asset class. One of the ways platforms can enhance and augment the existing industry indices is by creating its own to enable transparent tracking of on-platform assets within and across asset classes.

Tradable index creation: While a reference index is useful to benchmark performance against the market, introduction of tradable indices allows for a much more nuanced investment and hedging strategy. Enabling functionality to buy and sell platform specific asset class and general indices on the platform itself, and eventually across platforms, allows investors to implement complex strategies such as buying an index of one platform while selling an index of another to benefit from perceived differences in asset quality selection or to engage in thematic investment by purchasing specific sub-asset indices across different platforms.

Derivative creation: Building on the risk management suite of tools, the introduction of simple derivative instruments like options on indices and individual assets will allow further customization of desired risk and return profiles and will make the fractional shares market closely resemble the normal stock market encouraging easy adoption.

Investor services

Along with establishing a solid trading support framework, providing a range of services designed to make the investor experience more effortless and complete will go a long way to generating credibility and comfort. In today's service oriented economy having a robust framework for addressing core customer needs is not a feature, but a necessity. There are multiple areas that are covered under this heading, among some of the more important ones are:

1. **Providing custody services**: Custodians play a key role in safeguarding assets. Their role is to hold assets separately from other assets, ensuring they are protected against theft or loss, as well as protecting investor's assets in case of an insolvency event. There are various ways to provide custody services for the fractional shares, such as self-custody by the platform, or third-party custody services, using traditional format or blockchain-based implementation.

2. **Proof of funds and escrow verification**: In times of exit events, where the asset originally acquired on the platform is being sold to realize the gain, making sure that the buyer has the funds to pay for his purchase and that they are committed and made available is an essential element in making the process function properly. Having a clear third party provider of escrow and proof of funds builds in yet another crucial element in making fractional platforms a trusted environment.

3. **Building a pre order book**: Currently when new assets are set to be offered on the platform, the process is conducted on first come, first served basis. As a result, unless an investor is able to be physically present during the first few minutes of the offering window, or has designed a custom auto-bid software, he will not receive any primary shares, which may negatively affect his overall strategy. Using an order book format, where indications of interest are taken from all investors to estimate and manage interest in a particular asset pre offer, and then allocate shares pro-rata at offering based on initial interest would make for a more orderly, convenient and fair way to ensure that the maximum amount of investors are involved, thus creating a deeper market and building goodwill.

4. **Value-added VIP services**: For the investor segment identified as VIP (with criteria varying by platform, but most likely tied to total invested amounts and /or number of transactions), an additional set of services can be created to encourage this most active group to

continue to be active investors and ambassadors for the platform. Getting the most dedicated and interested part of the investor base more engaged is a smart way to grow and expand the business. One area, closely related to building a pre-order book is providing early access to some of the drops and conducting exclusive private drops limited to the VIP community. Additional features to keep this group interested may be providing educational opportunities to learn from experts on a particular asset class, arranging meetings with artists featured on the platform, or arranging trips to see some of the prospective acquisitions or just stellar examples firsthand.

5. **Sharing additional income streams**: There are many avenues to generate incremental revenues from assets, so leaving them to sit in storage is a sub-optimal use of resources. Lending out items to be displayed at conventions and participating in exhibitions can garner a meaningful stream of fees. Another secondary income generating opportunity is by collecting branding or placement fees from third party service providers, such as insurance providers, luxury goods manufacturers, or travel providers who will be happy to pay for access to a pre-screened group of sophisticated investors with demonstrated discretionary investable assets. These additional dividend streams can be passed in part to investors, who will likely reinvest the proceeds back into the platform offerings, making this a win-win proposition.

6. **Rotational physical ownership of portable assets**: Ability for partial owners to display works on revolving basis, while not necessary in the paradigm of separating possession from ownership discussed before, can nonetheless generate extra interest and enjoyment from investing in collectibles. While not feasible for all assets, this may be possible for a small percentage of items, mostly in the painting and sculpture verticals. This extra feature will allow the fractional owners to experience the best of both worlds: liquidity of assets and the benefits that accrue from physical ownership such as status, prestige and

aesthetic enjoyment (subject to appropriate insurance, placement and transportation arrangements).

7. **Physical asset authentication**: Using technology to confirm assets' provenance, including authenticity is another useful feature providing not only peace of mind, but also value confirmation. One of the ways is by using a chip attached to the asset in a tamper proof way showing authenticity and provenance via embedded crypto token with removal protection. There are also blockchain based services that provide records to track and document the asset's critical history.

Financing services

1. **Self-listing on own platforms**: An alternative way to allow investors to benefit from using the platform, is to allow them to be both clients and shareholders. Allowing fractional ownership in the platform as an operational business provides a different take on the exposure to the collectible asset class, and makes for an interesting dividend yielding investment in the space. Provided legal issues allow, listing its own shares via the platform itself or on a partner platform makes for a creative way for company to quickly raise cash to improve and expand its operations and for users, who are the ultimate insiders of the service, to benefit from the growth should they so desire.

2. **Using current assets as collateral**: Leverage is a well-known and valid tactic to augment returns in situations where the expectation is for the upside to be much more probable and greater than the downside. This paradigm describes collectible space perfectly, and thus, it makes sense to utilize this strategy to provide additional returns to users. The framework for this is rather straightforward. If a pre-determined majority of fractional owners approve the use of owned asset as collateral for a loan, the platform will secure a lender

in the art or collectible space willing to advance funds against the object as collateral, and then use these funds to acquire additional objects. This approach provides increased profitability for fractional asset owners and growth of volume on the platform, among other benefits.

3. **Providing financing and term loans to asset owners**: As the core function of the platform is to accurately assess the value of collectible objects, it would make sense to utilize this expertise to generate an additional income stream for the firm and its shareholders. Providing prospective future asset sellers with the ability to pledge their assets against a revolving credit line, allows them to make additional purchases without needing to immediately liquidate assets and strengthens the relationship. Asset owners will be more likely to sell their objects via the platform with an existing relationship which provides them with this valuable service, making it a win-win strategy. Additionally, loans can be extended to dealers for inventory financing and to museums for important acquisitions under the same framework.

Portfolio construction

By this point in the book you know a great deal about a wide range of asset classes, including their history, returns, value metrics and best known examples. You understood and embraced the benefits of fractional ownership and have an excellent understanding of current and future functionality of platforms that enable the fractional ownership paradigm. Armed with this knowledge, the next step is to build a robust plan on how to incorporate these assets into your investment portfolio. The section below will explain the philosophy, portfolio design process, and allocation framework, tying together all the pieces into a clear and actionable analysis and investment plan.

Investment philosophy

Before diving into creating a portfolio of rare and valuable objects, the absolutely crucial first task is creating the right mindset with which to approach the process. It is important to understand the collector vs investor paradigm, where a collector caters to his passion and need to possess, while an investor is concerned solely with profit potential. The key is to completely abstract from any emotional attachment to the asset, especially since as a fractional owner you will not be getting any of the tangible ownership benefits, and view it purely as an investment opportunity that has its risks and profit potential to be researched, evaluated and acted upon solely on the basis of key value metrics and its fit into your investment plan.

Investment selection process:

Once the right mindset has been achieved and internalized, we need to approach the most important part of the process: selecting specific assets as candidates for investment and methodically evaluating their merits both on standalone basis and as additions to a portfolio.

Stage 1: Select exotic sub-asset classes that you are comfortable with and are knowledgeable about. After reading the material in Section 4, you have developed insight into multiple asset classes, and understand the range and specific application of various value metrics for each. While now you have more than passing familiarity with all the key asset types, you may be more comfortable with some than others, perhaps because you have personal interest that has caused you to do more in depth research on a particular topic or you have prior knowledge about some asset class from personal experience, studies or family connections. When you are just starting out, focus on a small number of asset classes in order to get comfortable with both the process and nuances of each individual sub-asset class without being overwhelmed.

Stage 2: Apply value driver framework to assess whether the investment has merit. Unlike financial markets, the value of art and collectibles is based on comparable objects rather than intrinsic economic value or replacement value. Objects must be readily identifiable to buyers and sellers and have characteristics that can be valued relative to core value metrics.

Step 1: Assign weights to value metrics

The weights to use for initial analysis are suggested in a table (below) for each asset class, but only represent the interpretation of the author based on his research and experience. These should be used as a starting point while you gain comfort and familiarity with the process.

Table 5:Combined metrics table:

Value metric	Paintings	Sculpture	Books	Manuscripts	Maps	Photographs	Cars	Motorcycles	Watches	Handbags	Wine	Whisky	Cognac	Champagne	Comics	Memorabilia	Trading cards	Stamps	Coins	Banknotes
Scarcity	x	x	x	x	x	x	x	x	x	x	x	x	x	x						
Rarity	x	x	x	x	x	x	x	x	x	x	x	x	x	x						
Provenance	x	x	x	x	x	x	x	x	x	x	x	x	x	x					x	x
Condition	x	x	x	x	x	x	x	x	x	x						x	x	x	x	x
Historical importance	x	x	x	x	x	x	x	x	x										x	x
Artist	x	x	x	x	x	x														
Quality	x	x		x																
Subject matter	x	x	x	x	x	x														
Size	x	x		x																
Brand							x	x	x	x	x	x	x	x	x	x	x			
Region				x							x							x	x	x
Vintage											x		x							
Age			x	x	x						x	x	x	x	x	x	x		x	x
Rating											x	x	x	x						
Batch												x								
Events			x	x												x		x		
Errors																	x	x	x	
Grade															x	x	x	x	x	x

Table 6:

Metrics weights table:

Value metric	Paintings	Sculpture	Books	Manuscripts	Maps	Photographs	Cars	Motorcycles	Watches	Handbags
Scarcity	15%	15%	10%	10%	10%	15%	15%	15%	10%	20%
Rarity	5%	5%	25%	25%	15%	10%	25%	25%	25%	35%
Provenance	10%	10%	10%	10%	5%	5%	20%	20%	10%	5%
Condition	5%	5%	25%	25%	20%	15%	15%	15%	20%	5%
Historical importance	5%	5%	5%	5%	5%	10%	10%	10%	10%	
Artist	25%	25%	10%	5%	10%	25%				
Quality	25%	25%			5%					
Subject matter	5%	5%	5%	5%	5%	20%				
Size	5%	5%			10%					
Brand							15%	15%	25%	35%
Region					5%					
Vintage										
Age			5%	10%	10%					
Rating										
Batch										
Events			5%	5%						
Errors										
Grade										
TOTAL	100%	100	100	100	100	100	100%	100%	100%	100%

Value metric	Wine	Whisky	Cognac	Champagne	Comics	Memorabilia	Trading cards	Stamps	Coins	Banknotes
Scarcity	15%	15%	25%	20%						
Rarity	15%	15%	25%	20%						
Provenance	5%	5%	5%	5%					5%	5%
Condition					10%	10%	10%	10%	5%	10%
Historical importance									5%	10%
Artist										
Quality										
Subject matter										
Size										
Brand	15%	15%	15%	15%	5%	5%	5%			
Region	10%	10%						5%	5%	10%
Vintage	20%	10%		20%						
Age	15%	20%	20%	15%	5%	5%	5%		10%	10%
Rating	5%	5%	10%	5%						
Batch		5%								
Events					5%	5%	5%	5%		
Errors								20%	20%	
Grade					75%	75%	75%	60%	50%	55%
TOTAL	100%	100%	100%	100%	100%	100%	100%	100%	100%	100%

Step 2: Assign value metrics values

Once the relative importance of each category has been defined, the next step is to take each category of the value metric and assign a numerical score from 1-10 to reflect the quality of each metric. This part of the process is somewhat subjective, but firmly grounded in the understanding of what values for each metric are most desirable (that can be reviewed in Section 4). Once these have been created, it is easy to see the relative potential of each asset within its own sub-asset class, but more importantly the "investability" scores can be compared across asset classes. Because the scores are normalized to base of 10, they are fully comparable across asset classes, allowing for a flexible, adjustable and rather accurate framework.

Table 7

Scoring example:

Value metric	Wine	Weight	Weighted score
Scarcity	7	15%	1.05
Rarity	7	15%	1.05
Provenance	6	5%	0.3
Brand	9	15%	1.35
Region	8	10%	0.8
Vintage	6	20%	1.2
Age	10	15%	1.5
Rating	8	5%	0.4
TOTAL	**8**	**100%**	**7.65**

Step 3: Select assets for inclusion

Once the assets have been ranked and we have obtained the weighted average investability score, we can review the opportunity set and select the ones we want to put into the portfolio. A good rule of thumb is to have at least 15-20 assets to get a good representation, as well as to mitigate the possibility of drastic impact from idiosyncratic risk of a single position.

Table 8

Asset	Score	Weight
Asset 1	9.5	10.00%
Asset 2	9.0	10.00%
Asset 3	9.0	10.00%
Asset 4	8.5	10.00%
Asset 5	8.0	10.00%
Asset 6	8.0	10.00%
Asset 7	7.5	10.00%
Asset 8	7.5	10.00%
Asset 9	7.2	10.00%
Asset 10	7.0	10.00%
Asset 11	6.5	
Asset 12	6.0	
Asset 13	5.0	
Asset 14	5.0	
Asset 15	4.0	
TOTAL	7.2	100%

Asset allocation framework

Asset allocation is the practice of dividing an investment portfolio among different types of assets. Selecting the right asset allocation helps ensure that a portfolio is ideally positioned to reach a goal. By investing in more than one asset category, you reduce the risk of losing money and your portfolio's overall investment returns will be smoother. If one asset category's investment return falls, those losses should be counteracted with better investment returns in another uncorrelated asset category. Allocation proportions change over time depending on a variety of different factors, with the key ones being investor's time horizon, risk tolerance, and liquidity needs. Thus an investment policy that explicitly addresses all three factors is a document that should be in place before any assets are purchased.

Time horizon estimation, expressed as a number of months or years until the financial goal is reached, is the primary factor driving asset allocation. An investor with a longer time horizon feels more comfortable taking on riskier and more volatile investments. In the case of collectible assets, although returns may come quickly, the main value may not be realized for years. Although fractional platforms afford the ability to liquidate in case of emergency, it is still best to have a 5-10 year time horizon in mind for these investments.

Risk tolerance is the ability and willingness to lose some of the original investment in exchange for greater returns. Aggressive investors may be willing to take on higher risk to get better returns, while conservative investors may stick with low-risk investments aimed more at capital preservation. There have been time periods when individual collectible objects and sub-asset classes have declined, but the asset class as a whole has done remarkably well in all environments.

Liquidity needs are an estimate of expected future cash flow requirements at certain dates in the future. In a traditional paradigm illiquid assets presented a rather significant challenge to managing liquidity, as there was no certainty as to the price and time they can be disposed of, and forced fire sales had the potential of seriously impairing portfolio value and returns. With liquidity provision being one of the core features and benefits of fractional platforms, the major risk of illiquid assets can be mitigated to a large degree, making it easier to effectively plan for future cash requirements.

An important point to keep in mind, is that while providing primary and secondary liquidity on a continuous basis is without a doubt functionality that most top platforms will have in the near future, the secondary market for fractional shares is only meaningfully present on Rally Road (although Otis and Masterworks have also launched their respective secondary trading functionalities in mid to late 2020, with Collectable launching its secondary market in early 2021).

Once the portfolio has been constructed, it is necessary to rebalance it either at regular time intervals or when the relative weight of an asset class in a

portfolio becomes more or less than a certain percentage band set in advance. This is necessary because, over time, the weight of some investments may get out of alignment with investment goals, and rebalancing ensures that the portfolio does not overemphasize asset categories, and stays at a desired level of risk. Ongoing monitoring of the portfolio with respect to composition and returns is a crucial element in making sure the portfolio remains true to the original design.

Once we have created the investment policy, crafted to reflect the considerations above, the next step is asset allocation itself. This process happens in two stages: first within the collectible portfolio, and then across all asset classes, as a properly constructed portfolio should be diversified at both of these levels: between asset categories and within asset categories.

Collectible portfolio

Armed with our list of selected assets ranked by their investability, we can begin to construct the strategic asset allocation for our collectible portfolio. This process should be as data driven as possible, although at the initial stages of the fractional platform evolution, quantity and quality of data may be somewhat sparse and not easily or readily accessible, especially for individual asset performance.

Step 1: Calculate values for asset class weights

We learned how to build a sub-portfolio in every selected asset class based on our analysis in the Investment Selection section. As a next step, we combine all collectible sub-portfolios into a master one, by using the weights derived from historical returns and correlations between individual asset indices. These values should be obtained from statistical analysis of the return time series, which is a subject beyond the scope of this book. With time, as platforms build increasingly deep and broad databases and include the ability to search the data across transactions on all platforms, the process of calculating weights will undoubtedly become easier and more accurate.

Step 2: Adjust weights via short term value metrics

The addition of new sub-asset classes as your comfort and understanding of the existing ones and the sector as a whole grows, will cause changes in the initial allocation due to requirements to maintain a balanced portfolio that fits the limits prescribed by the investment policy. However, asset allocation can also be augmented with tactical overlays. If a particular asset class is well positioned for a meaningful increase over the short term based on your analysis of secondary metrics, its weight in the overall portfolio should be increased to take advantage of this temporary dislocation. While it is possible to include an extra step of weighing each metric by its relative importance, this can also be directly expressed via value ranks.

Part 1: For each extrinsic value metric noted in Section 3, assign a rank based on your educated estimate of its near term importance (below is an example using a subset of asset classes discussed):

Table 9

Value metric	Paintings	Sculpture	Books	Manuscripts	Maps	TOTAL
Supply/demand imbalance	5	5	8	9	5	6.4
Globalization	7	7	8	9	3	6.8
Demographic trends	5	5	7	9	2	5.6
Affinity	4	5	6	8	4	5.4
Political uncertainty	5	5	5	8	3	5.2
Economic environment	6	6	6	8	5	6.2
Transaction motivations	7	7	7	8	4	6.6
Regulations	4	6	4	7	4	5
Media coverage	6	7	8	7	4	6.4
Pop culture references	4	6	6	6	3	5
Special events	4	5	8	6	3	5.2
Average	5.2	5.8	6.6	7.7	3.6	5.8
% global average	89%	100%	114%	133%	63%	100%

Part 2: Adjust the policy allocation to reflect the near term view expressed by your ranking in Part 1. The magnitude of the shift can be defined in a variety of ways and the absolute shift size should be capped at 10% so as not to encourage drastic deviations from long term views.

Table 10

Class	Base allocation	Shift	New allocation
Paintings	20%	-5%	15%
Sculpture	20%	0	20%
Books	20%	5%	25%
Manuscripts	20%	10%	30%
Maps	20%	-10%	10%
TOTAL	100%	0%	100%

Step 3: Monitor platform composition

Given the differences in availability of specific assets across different platforms, it is prudent to have the ability to deploy assets across multiple platforms in an opportunistic fashion. This strategy may increase concentration of exposure to a particular platform, presenting certain operational risks, but this course of action is perfectly acceptable on a short term basis, as long as it is understood, measured and managed appropriately.

Table 11

Platform	Policy weight	Actual weight	Difference
Platform 1	20%	35%	15%
Platform 2	20%	20%	0%
Platform 3	20%	15%	-5%
Platform 4	20%	20%	0%
Platform 5	20%	10%	-10%
TOTAL	100%	100%	0%

Balancing within sub-asset classes, across all collectible asset classes and keeping in mind possible concentration risks to individual platforms used to implement the strategy will produce a well-balanced collectible portfolio, positioned to perform in line with constraints and targets specified in the investment policy.

Overall portfolio

Properly implemented diversification strategy maximizes returns by investing in multiple areas that would each react differently to the same event. Although it does not insure against loss, diversification is the most important tool to reach long-range financial goals while minimizing risk. Once we have constructed our collectible sub-portfolio, the final step is to integrate this shiny new toy into the full asset mix. The core challenge is to determine the new addition's true volatility and correlation with other asset classes, as these metrics will directly affect the degree to which this asset class benefits the portfolio in terms of diversification, risk reduction and return enhancement.

While it may be difficult to arrive at the exact numbers before specific and general datasets are built up, using conservative estimates based on published studies can provide an appropriate initial set of data that can be used to assign a certain weight to the collectible portfolio, estimate and track its impact on ongoing basis, and adjust it periodically, as part of normal rebalancing activity. A sample allocation can look as follows:

Table 12

Asset class	% total
Stocks	35%
Bonds	25%
Real estate	10%
Gold	5%
Commodities	5%
Alternatives	10%
Collectibles	10%
TOTAL	**100%**

Conclusions

If there is only one thing you take away from this book, it should be a clear understanding of how to evaluate collectible investments and a genuine appreciation of why they are a solid addition to your investment portfolio. Summarizing the many features and benefits of including collectibles in the asset mix helps reinforce the concept and confirm that your decision to expand your horizons by expanding your investment universe is a wise one.

1. **Diversification:** Is the practice of spreading money among different investments to reduce risk, and traditional views of diversification tend to focus on asset classes themselves. The correlation of collectible sub-asset classes from cars and stamps to handbags and wine versus the broad stock, bond and gold indices has been close to 0 or negative not only historically, but also in recent times. Collectibles served as a great hedge during the 2008 crisis, with most holding steady or declining by a very small amount in the face of market meltdown. The returns of the asset class as a whole are in line with historical stock market averages of 6-8%, thus empirically reinforcing the theory that these assets should be actively included in any long term portfolio. While it may be imprudent to allocate a large percentage like 50% of your assets to collectibles, 10-15% allocation to the asset class is a reasonable amount to commit to this diversification enhancing area.

2. **Capital growth:** The value of collectibles is primarily driven by two forces: inflation and scarcity. Inflation has been on a positive trend,

and as long as society continues to grow, evolve and expand, it will continue its upward march. Real assets are a proven source of value in inflationary environments, and tend to work best for preservation of capital and providing a hedge from inflation. On top of that, the scarcity factor continues to be exacerbated by a combination of more investors worldwide seeking to acquire the same or, in some cases, shrinking pool of desirable assets, pushing the prices up.

3. **Income:** One of the unexpected benefits of a liquid collectible marketplace, is the ability to generate income in several ways. One is to enjoy the fairly well established discrepancy between the prices of objects on primary offering and the price they command in secondary trading. Empirically the vast majority of assets offered on the platforms (with the understanding that the sample is still rather limited) have provided positive returns. Another way stems from receiving dividends from the platform for a wide range of activities associated with owning assets, such as exhibition fees, interest generated from providing art lending services to whole asset owners and receiving a part of the payments from third party service providers made to engage with the platform investor base. In this sense, being a platform investor is like owning a high dividend paying stock, except that the timing of the dividend payments varies in time and amount.

4. **Absolute return:** This asset class, including its various sub-asset classes, has produced an annual return of around 6-8%. Regardless of how the economy is doing currently or is projected to be doing in five years, the notional returns from the asset class are unlikely to be impaired in any meaningful way. Most investments are judged on their return relative to a broad market index, but for an investor the fact that an investment only lost 20% while the market has lost 40% is small comfort, even if there has been tremendous outperformance of a market index.

5. **Accessibility:** The truly revolutionary aspect of fractional platforms is that they made a previously illiquid, non-transparent, and obscure asset class liquid and easily accessible to every investor, regardless of capital or connections. This paradigm, where anyone with a mobile phone and $25 can be a part owner of a rare car, coveted baseball card, or an impressionist painting, is a unique and powerful development in wealth management industry.

6. **Liquidity:** The ability to treat collectible investments as liquid is the core accomplishment of the new venues, as they successfully replicate the initial offering process (IPO) in the public markets that creates liquidity for assets. This course of action, and easily understood similarities to much more familiar stock markets help establish a large and growing investor base enabling deep and broad secondary markets across the entire range of assets.

7. **Asset class evolution:** The emergence of the fractional ownership paradigm, has done more than bring to light an obscure corner of the investment world. It has elevated a previously largely unexplored and underappreciated asset class to be on par with traditional asset classes in terms of investability, liquidity and accessibility. The asset class itself has entered mainstream, and with it started to receive much wider exposure, scrutiny and coverage than ever before. Variety of exotic sub-asset classes continues to grow and evolve, as emerging and futuristic asset classes become mainstream, broadening the range of what we consider to be investment grade collectible assets and constantly improving our understanding of what an alternative investment means.

Performance summary:

Core portfolio:

For most assets in this list, there are pricing indices published by various reputable sources that can be used to calculate historical performance and ascertain recent trends. While all these price series contain some bias, they are nonetheless reliable, verifiable and most importantly usable for creation of return profiles and cross-correlations among assets, which are necessary for creating an optimized portfolio. Increases in informational efficiency contribute to a decrease in price risk and an increasing population of art collectors has led to a reduced probability of having a low return realization.

Table 13

Asset	Pricing index	10 year return	1 year return	Historical annual return	Weight
Paintings	Artprice 100 / AMR All Art	64%	5%	5.1%	17.8%
Sculpture	Artprice 100 / AMR All Art	64%	5%	5.1%	17.8%
Books	Gibbons rare book index / Rare Book Hub	109%	2%	7.7%	1.4%
Manuscripts	Rare Book Hub	109%	2%	7.7%	1.4%
Maps	Antique Map Price record (AMPR) price guide	145%	5%	9.4%	1.1%
Photographs	Gordon's photography prices	64%	5%	5.1%	0.6%
Cars	HAGI Top Index / K500 by Kidston	289%	-7%	14.5%	27.9%
Motorcycles	Hagerty motorcyle index	289%	-7%	14.5%	2.8%
Watches	AMR	60%	2%	4.8%	2.8%
Handbags	AMR	108%	13%	7.6%	1.1%
Wine	Liv-ex Fine wine 100 / WO KF Fine Wine Icons	147%	1%	9.5%	2.2%
Whisky	Icon 100 (Rare Whisky)	564%	5%	20.8%	3.3%
Cognac	Saleroom auction price guide	147%	1%	9.5%	1.7%
Champagne	Liv-ex Champagne 50	105%	3%	7.4%	2.8%
Comics	Overstreet / GP Analysis price guides	276%	13%	14.2%	0.3%
Memorabilia	SMR Online	264%	12%	13.8%	0.6%
Trading cards	PWCC Top 100	264%	12%	13.8%	2.2%
Stamps	Stanley Gibbons / Linn's	64%	6%	5.1%	5.6%
Coins	Stanley Gibbons / PCGS3000	182%	3%	10.9%	5.6%
Banknotes	PMG Price Guide	182%	3%	10.9%	1.1%
TOTAL	Volume weighted average portfolio return	0%	0%	0.0%	100%

Opportunity portfolio:

For assets in this list, true reference pricing indices are almost non-existent, but some reliable estimates of returns can be gained from industry publications and other related sources. As for this portfolio of rather

idiosyncratic assets we are concerned mainly with the rarest and top performing examples, which by definition will be highly desirable and uncorrelated with each other, understanding the ballpark value of expected returns with reasonable certainty is sufficient to develop a sense of reasonable performance expectations.

Table 14

Asset	Reference index	10 year return	1 year return	Historical annual return
Gems	Fancy Color Research Foundation	77%	-1%	5.9%
Jewelry	AMRD	125%	-7%	8.4%
Guns		65%	5%	5.1%
Swords		65%	5%	5.1%
Autographs	PFC 40 Autograph Index	159.37%	10%	10.0%
Wooden decoys		159.37%	10%	10.0%
Cigars		235.00%	12.01%	12.9%
Game cards		417%	15%	17.9%
Vinyl		109%	2%	7.7%
TOTAL	Equally weighted average portfolio return	157%	5.7%	9.2%

By way of a general reality check, Knight Frank Luxury Investment Index (KFLII), a recognized barometer of the "luxury" investment space, was slightly negative in 2019, but up 141% on a 10 year basis, implying an annual 9.35% return over a 10 year period, good proxy for long term historical returns. KFLII tracks the performance of a theoretical basket of selected collectible asset classes using existing third-party indices, with each asset class weighted to reflect its relative importance and value within the basket.

Asset characteristics

An exercise to classify collectibles by a range of descriptive characteristics is a great way to gain an additional layer of understanding of intrinsic worth and function of various assets. This analysis is not likely to affect the investment decision, and its best to think of it as developing an additional layer of mental classification and further comfort and insight into the asset class. The categorization, although admittedly somewhat subjective, allows an investor to get a better feel for the physical characteristics of the assets to help guide the investment decision by providing additional insight into asset properties and scenarios under which they create incremental value on top of the standard metrics. Many assets possess more than one characteristic from the list below, inviting more nuanced ways to analyze them to extract the additional pockets of value represented by the metrics below. A more detailed framework for categorizing and grouping assets into below categories is described and discussed in the supplementary course materials at www.michaelfoxrabinovitz.com/courses.

Viewable: Generates incremental aesthetic value through being displayed and visually admired, which translates to financial value creation in cases of physical ownership or ability to lend for exhibitions or events.

Portable: Provides additional value to owners in cases of emergencies especially in times of political or economic upheaval. Indispensable characteristic, as it is often the only way to transfer and preserve wealth and thus becomes immensely valuable in certain geographies.

Consumable: Have a built in mechanism for increasing scarcity, and thus become more valuable with time as the supply is diminished through use. While most items of this caliber are bought for investment, there is an additional social value from being able to consume something that is rare, and thus there is a counterintuitive motive to destroy the value of highly produced objects by using them in the exact way for which they were originally intended.

Usable: Have additional utility to owners where the object may be used for practical purposes, while still retaining value. There is an unquestioned value to true collectors and enthusiasts from being able to enjoy using the object for the task it was made for.

Core portfolio:

Table 15

Asset	Viewable	Portable	Consumable	Usable
Paintings	x			
Sculpture	x			
Books	x	x		
Manuscripts	x	x		
Maps	x			
Photographs	x	x		
Cars				x
Motorcycles				x
Watches		x		x
Handbags		x		x
Wine			x	
Whisky			x	
Cognac			x	
Champagne			x	
Comics	x	x		
Memorabilia	x	x		
Trading cards	x	x		
Stamps	x	x		
Coins	x	x		
Banknotes	x	x		

Opportunity portfolio:

Table 16

Asset	Viewable	Portable	Consumable	Usable
Gems	x	x		
Jewelry	x	x		
Guns	x			
Swords	x			
Wooden decoys	x			
Vinyl	x	x		
Autographs		x		
Cigars		x	x	
Game cards		x		x

Highest priced objects by asset class

One of the best ways to gain an intuitive feel for the value of top tier objects within an asset class is to take a look at both absolute price levels, and relative magnitude compared to the prime examples in other asset classes. While the average value of investment grade objects is more useful to estimate the overall investment capacity of the asset class, as discussed in the next section, price of best examples provides an interesting insight into what acquiring best assets can do for a platform in terms of attracting capital, and for investors with respect to allocation and diversification. The tables below covers the top 10 objects vs top 5 lists in corresponding sections above. Top 10 list, updated as new records are set, can be viewed at http://www.michaelfoxrabinovitz.com/toplists.

Core portfolio:

Table 17

Highest value objects	Paintings	Sculpture	Cars	Manuscripts	Watches	Photographs	Books	Coins	Stamps	Maps
1	$450,000,000	$141,000,000	$48,000,000	$35,000,000	$31,000,000	$6,500,000	$14,000,000	$10,000,000	$9,500,000	$10,000,000
2	$179,000,000	$104,000,000	$38,000,000	$31,000,000	$18,000,000	$4,300,000	$11,500,000	$7,600,000	$3,800,000	$4,000,000
3	$170,000,000	$101,000,000	$30,000,000	$24,000,000	$11,000,000	$4,000,000	$9,300,000	$7,600,000	$3,000,000	$2,800,000
4	$157,000,000	$91,000,000	$30,000,000	$21,000,000	$9,000,000	$3,900,000	$7,500,000	$7,400,000	$2,300,000	$2,100,000
5	$142,000,000	$71,000,000	$29,000,000	$15,000,000	$5,900,000	$3,700,000	$6,000,000	$6,800,000	$2,000,000	$1,000,000
6	$140,000,000	$59,000,000	$28,000,000	$14,000,000	$5,700,000	$3,700,000	$5,400,000	$5,500,000	$2,000,000	$750,000
7	$120,000,000	$58,000,000	$23,000,000	$12,000,000	$5,000,000	$34,000,000	$4,500,000	$4,500,000	$1,600,000	$450,000
8	$115,000,000	$57,000,000	$22,000,000	$5,000,000	$4,600,000	$3,300,000	$2,500,000	$4,100,000	$1,500,000	$150,000
9	$111,000,000	$57,000,000	$21,000,000	$4,000,000	$4,000,000	$3,300,000	$1,500,000	$3,800,000	$1,000,000	$140,000
10	$110,000,000	$53,000,000	$20,000,000	$1,100,000	$3,900,000	$2,900,000	$662,500	$3,700,000	$619,500	$52,000
TOTAL	$1,694,000,000	$792,000,000	$289,000,000	$162,100,000	$98,100,000	$69,600,000	$62,862,500	$61,000,000	$27,319,500	$21,442,000

Highest value objects	Memorabilia	Trading cards	Banknotes	Comics	Whisky	Motorcycles	Handbags	Wine	Cognac	Champagne
1	$4,400,000	$3,120,000	$3,200,000	$3,200,000	$1,900,000	$929,000	$1,900,000	$558,000	$2,000,000	$275,000
2	$4,300,000	$2,880,000	$2,500,000	$1,100,000	$1,500,000	$852,500	$1,900,000	$551,000	$289,000	$49,000
3	$3,000,000	$922,000	$1,400,000	$1,000,000	$1,100,000	$715,000	$379,000	$500,000	$260,000	$43,500
4	$1,280,000	$750,000	$1,200,000	$936,000	$628,000	$704,000	$300,000	$311,000	$195,000	$42,000
5	$1,260,000	$717,000	$1,100,000	$850,000	$464,000	$492,973	$298,000	$305,000	$156,000	$34,000
6	$1,240,000	$716,000	$755,000	$567,000	$435,000	$480,000	$295,000	$275,000	$150,000	$21,000
7	$1,100,000	$700,000	$500,000	$507,000	$430,000	$463,847	$219,000	$230,000	$60,000	$19,000
8	$996,000	$667,000	$411,000	$492,000	$343,000	$450,000	$214,000	$225,000	$45,000	$14,000
9	$956,000	$660,000	$352,000	$450,000	$315,000	$434,000	$163,000	$168,000	$16,000	$11,000
10	$940,000	$612,000	$322,000	$375,000	$299,000	$423,000	$117,000	$117,000	$14,000	$6,500
TOTAL	$19,472,000	$11,744,000	$11,740,000	$9,477,000	$7,414,000	$5,944,320	$5,785,000	$3,240,000	$3,185,000	$515,000

Highest value objects	TOTAL
1	$755,000,000
2	$401,200,000
3	$362,700,000
4	$331,200,000
5	$282,400,000
6	$264,050,000
7	$263,050,000
8	$215,150,000
9	$206,740,000
10	$195,934,000
TOTAL	$3,277,424,000

We can see price discrepancies of orders of magnitude between top priced art and sculpture at $100MM+ and best motorcycles at $1MM+ (all top consumables are $500K and below), and draw a conclusion that acquiring a prized objet d'art may be a more worthwhile investment of time for the platform, as it can accommodate much greater amounts of investor capital on a single deal. On the other hand we can see that the prices of most other asset classes (with the exception of cars and watches) are more or less in the same ballpark, which suggests platforms should treat items from most asset classes interchangeably for purposes of prioritizing search and acquisition.

An interesting insight that can be gathered by looking at the value of a theoretical portfolio of top ten assets in each, is understanding what a "crown jewel" portfolio may look like and the size of it. The value of the portfolio would stand at $3.3B, with almost 75% of it coming from the art sector (paintings and sculptures). For a slightly different angle, a portfolio of only #1 ranked investments would be valued at $776MM, with art maintaining its 75% weight within that slice as well.

While this is a helpful exercise in developing additional intuition about relative magnitudes of price differences for top assets within each asset class, it is important to keep in mind that a large portion of a real life investment portfolio will likely come not from the top 10, but rather from the middle of the investment grade pack, where the price discrepancies will be much less drastic. Therefore, the review and discussion above is just another piece to help illustrate the asset class price levels and market sizes.

Opportunity portfolio:

Table 18

Highest value objects	Jewelry	Gems	Swords	Guns	Autographs	Wooden decoys	Vinyl	Game cards	Cigars	TOTAL
1	$250,000,000	$71,200,000	$7,700,000	$5,800,000	$9,800,000	$1,130,000	$2,000,000	$2,000,000	$1,000,000	$350,630,000
2	$200,000,000	$57,500,000	$6,500,000	$4,500,000	$5,000,000	$856,000	$790,000	$400,000	$507,000	$276,053,000
3	$100,000,000	$48,400,000	$6,000,000	$1,986,000	$3,700,000	$830,000	$300,000	$224,500	$115,000	$161,555,500
4	$55,000,000	$46,200,000	$3,300,000	$1,800,000	$388,000	$802,000	$290,000	$166,500	$54,000	$108,000,500
5	$27,400,000	$35,500,000	$2,100,000	$1,687,000	$200,000	$767,000	$150,000	$133,000	$30,000	$67,967,000
6	$20,000,000	$32,600,000	$1,600,000	$1,200,000	$191,000	$685,000	$125,000	$70,000	$18,000	$56,489,000
7	$16,260,000	$30,400,000	$1,240,000	$1,100,000	$75,000	$661,000	$120,000	$60,000	$15,000	$49,931,000
8	$15,760,000	$23,400,000	$718,000	$977,000	$63,000	$605,000	$46,300	$32,000	$7,500	$41,608,800
9	$14,000,000	$17,300,000	$542,000	$920,000	$52,000	$553,000	$37,100	$20,000	$4,500	$33,428,600
10	$13,000,000	$16,300,000	$418,000	$862,000	$41,000	$546,000	$32,000	$18,000	$500	$31,217,500
TOTAL	$711,420,000	$378,800,000	$30,118,000	$20,832,000	$19,510,000	$7,435,000	$3,890,400	$3,124,000	$1,751,500	$1,176,880,900

For illustrative purposes we note that a "crown jewel" portfolio is worth almost $1.2B, with jewelry and gems dominating the value at 92% of the total. We see similar patterns play out here as with the core asset classes, but in the case of the opportunity portfolio the absolute price is a more important metric, as the investment strategy here is to invest in a few exceptional objects as opposed to a larger number as is the case in the main portfolio. Allocating a $100M here could mean buying one piece of jewelry or thirty weapons, and understanding the implications of focusing on one asset class over another is important in assessing the concentration risk.

Investment universe market value estimation (supply)

As a final piece of viability analysis, we will review a rough estimate of the dollar volume of available assets as a way to confirm our premise that the asset class can and should be considered an integral part of every investor's allocation strategy. While the "crown jewel" portfolios gave us an interesting view into relative values of asset classes, the reality is that it will be next to impossible to obtain any of the items on that list, as due to their rarity they tend to change hands rather infrequently, and when on the market the competition to obtain them is intense, driving prices up and returns down. High to middle levels of investment grade spectrum for all assets is the area of focus for building an investment portfolio for the platform, and the analysis below aims to provide a better insight into the realistic volumes of assets that can be obtained on regular basis to meet the ongoing and likely increasing demand for the asset class. While it is tough to make a definitive statement on the size of the collectible market universe, an educated guess puts the total amount at around $200B, (summarized in table below), with 77% of that in art, cars, stamps, books and coins, and it is safe to assume that the investment grade level assets are around 1-5% of the entire pool (this percentage varies between asset classes), putting the yearly transaction volume of interest at $2-10B.

Table 19

Asset	Average IG item value	Yearly volume	Weight
Paintings Sculpture	$100,000	$64,000,000,000	36%
Books Manuscripts	$25,000	$5,000,000,000	3%
Maps	$10,000	$2,000,000,000	1%
Photographs	$10,000	$1,000,000,000	1%
Cars	$100,000	$50,000,000,000	28%
Motorcycles	$50,000	$5,000,000,000	3%
Watches	$25,000	$5,000,000,000	3%
Handbags	$12,000	$2,000,000,000	1%
Wine	$10,000	$4,000,000,000	2%
Whisky	$15,000	$6,000,000,000	3%
Cognac	$5,000	$3,000,000,000	2%
Champagne	$2,500	$5,000,000,000	3%
Comics	$50,000	$500,000,000	0%
Memorabilia	$50,000	$1,000,000,000	1%
Trading cards	$25,000	$4,000,000,000	2%
Stamps	$10,000	$10,000,000,000	6%
Coins	$10,000	$10,000,000,000	6%
Banknotes	$10,000	$2,000,000,000	1%
TOTAL	$28,861	$179,500,000,000	100%

The number above does not take into account the value of assets that are not traded yearly but are held in collections without being shown or brought to market. The size of this unseen volume dwarfs the yearly traded numbers: only for art this stands at $3T, or about 50x the yearly volume. It is hard to estimate what percentage of this may start trickling into the

market as fractional platform proliferation makes it easier and cost effective to dispose of these previously illiquid assets, but even assuming that just an additional 1% gets released yearly, this translates to an additional $30B for art alone, with likely a similar volume across all the other collectible asset classes.

Assets to be deployed (demand):

As we have discussed in Section 6, we make an educated assumption that the main categories of buyers are retail investors, UHNW investors and family offices. The methodology below outlines how we arrive at a rough estimate of assets that can flow into the collectible investment universe.

Estimation of assets investable into collectibles:

Individual investors: To estimate assets available for investment by retail investors we make the assumption that retirement assets, which are generally long term in nature, are the best source of funds for this group to allocate to this asset class. While personal savings can be used for investment as well, an average person considers this amount (which is on average $10,000) as emergency funds, and thus not suitable for speculative investments. A portion of higher income investors likely have higher personal savings that they can and do use for investments but for the sake of keeping the numbers on the conservative side we will make the assumption that these discretionary investment funds are not readily available for speculative investment purposes.

Methodology individual:

1. Start with number of workers in USA

2. Separate by age cohort

3. Assume % interest in subject in each age cohort

4. Use data on total mean and median savings overall and per year to see two different slices

5. Assume % portfolio that can be allocated to collectibles

6. Calculate investment potential overall and on yearly basis

Table 20

Age cohort	% in cohort	People in cohort	Interested %	Interested people	Mean savings	Per year	% to collectables	$ overall	$ yearly
20-29	15%	22,500,000	25%	5,625,000	$12,000	$2,000	15%	$10,125,000,000	$1,687,500,000
30-39	20%	30,000,000	20%	6,000,000	$42,000	$4,000	10%	$25,200,000,000	$2,400,000,000
40-49	25%	37,500,000	20%	7,500,000	$102,000	$7,500	10%	$76,500,000,000	$5,625,000,000
50-59	25%	37,500,000	10%	3,750,000	$174,000	$10,000	10%	$65,250,000,000	$3,750,000,000
60-69	15%	22,500,000	5%	1,125,000	$195,000	$10,000	5%	$10,968,750,000	$562,500,000
TOTAL	100%	150,000,000		24,000,000				$188,043,750,000	$14,025,000,000

Age cohort	% in cohort	People in cohort	Interested %	Interested people	Median savings	Per year	% to collectables	$ overall	$ yearly
20-29	15%	22,500,000	25%	5,625,000	$5,000	$1,000	15%	$4,218,750,000	$843,750,000
30-39	20%	30,000,000	20%	6,000,000	$20,000	$2,000	10%	$12,000,000,000	$1,200,000,000
40-49	25%	37,500,000	20%	7,500,000	$35,000	$5,000	10%	$26,250,000,000	$3,750,000,000
50-59	25%	37,500,000	10%	3,750,000	$60,000	$7,500	10%	$22,500,000,000	$2,812,500,000
60-69	15%	22,500,000	5%	1,125,000	$65,000	$10,000	5%	$3,656,250,000	$562,500,000
TOTAL	100%	150,000,000		24,000,000				$68,625,000,000	$9,168,750,000

HNW investors: To estimate assets available for investment by UHNW investors we make the assumption that the assets to be allocated are part of their core portfolio, and not retirement funds. Furthermore we will define as HNW for the purpose of this analysis as someone whose net worth is $10M, and UNHW as those with a net worth of $30M.

Methodology HNW:

1. Start with count of HNW and UHNW individuals
2. Assume net worth numbers per class member
3. Derive total wealth as count x net worth
4. Obtain yearly income from data
5. Assume a % of investable assets as % of total wealth
6. Assume % allocation to collectibles
7. Calculate overall investment potential for HNW and UHNW segment combined

Table 21

Category	Count	Net worth	Total wealth	Yearly income	% in investable assets	Investable assets	% to collectables	Overall	Yearly
HNW	350,000	$10,000,000	$3,500,000,000,000	$1,000,000	50%	$1,750,000,000,000	10%	$175,000,000,000	$35,000,000,000
UHNW	80,000	$30,000,000	$2,400,000,000,000	$5,000,000	25%	$600,000,000,000	10%	$60,000,000,000	$40,000,000,000
TOTAL	**430,000**		**$5,900,000,000,000**			**$2,350,000,000,000**		**$235,000,000,000**	**$75,000,000,000**

Family offices: To estimate assets available for investment by family offices we look at assets to be allocated as part of their core portfolio, and not retirement funds, as on this level tax retirement and succession planning are a separate area of financial life. There are around 5,000 family offices in the USA, and as family offices cost at least $1M / year to maintain, they generally make financial sense only for families with $100M or more in assets.

Methodology family offices:

1. Start with count of family offices from data
2. Assume net worth numbers per class member
3. Derive total wealth as count x net worth
4. Obtain yearly income from data
5. Assume % of investable assets as % of total wealth
6. Assume % allocation to collectibles
7. Calculate overall investment potential for family offices

Table 22

Category	Count	Net worth	Total wealth	Yearly income	% in investable assets	Investable assets	% to collectables	Overall	Yearly
Family office	5,000	$100,000,000	$500,000,000,000	$10,000,000	75%	$375,000,000,000	15%	$56,250,000,000	$7,500,000,000
TOTAL	**5,000**		**$500,000,000,000**			**$375,000,000,000**		**$56,250,000,000**	**$7,500,000,000**

Table 23

Total assets:

Category	Overall	Yearly
Individual	$188,043,750,000	$14,025,000,000
HNW	$235,000,000,000	$75,000,000,000
Family Offices	$56,250,000,000	$7,500,000,000
TOTAL	**$479,293,750,000**	**$96,525,000,000**

We can compare the amounts of assets potentially available for investments with results for the investable pool of assets we analyzed in previous section in order to get a feel for the level of imbalance between the two, and what that says about the usefulness of the asset class. Total assets available for investment on yearly basis is $100B, and the amount of available top level collectibles is $5B yearly. The key conclusion here is that the potential demand in the market is multiples of currently available supply, which means that existing yearly volume can not only easily be absorbed by the investment market, but due to a fairly large supply demand imbalance there is a high likelihood that the prices will be pushed up, as the same amount of material will be chased by many more interested parties, creating a favorable trend for investors. In the future, as more asset classes are added to the investment universe, and more currently dormant assets are released into the marketplace (as discussed above this number potentially stands at an additional $30-50B yearly), the ability of the collectible space to accommodate more and more demand will grow, further increasing its importance.

Implementation and analysis challenges

For many investors, the material presented and explained in this book is enough to gain a good initial understanding and appreciation for the asset class, as well as develop basic knowledge on how to implement the strategy and incorporate it into their financial plan. Detailed review of concepts with quizzes, case studies and examples, as well as additional perspectives would be beneficial to most, and can be gained via taking an online course designed to accompany and augment this book. Those who are serious about growing their understanding of collectibles, actively developing an alternative finance investment plan and, most importantly, responsibly managing their wealth would find the additional material and detailed examples indispensable to taking their expertise and efficiency to the next level. The course information is available via the Course tab on the main author page at www.michaelfoxrabinovitz.com/courses. As an extra incentive to evaluate taking the course, I have included a free set of reference charts at www.michaelfoxrabinovitz.com/ to help you better plan and organize your thoughts and analysis. Insightful blogs on the topic of investing in a variety of unique fractional income streams can be read on www.michaelfoxrabinovitz.com/blogs, and keep an eye out for a second book in the series that deals with fractional revenue investment opportunities. I am excited at the opportunity to help you grow as an investor and a well-rounded individual and look forward to welcoming you as a student and a reader of my blogs and subsequent book releases.

For HNW individuals, family offices, and institutional investors, whose investment strategies and planning needs require a much more involved, customized and ongoing support, a wider range of issues addressing the main pain points needs to be considered.

Key areas to be addressed separately or as part of an integrated strategy are:

1. Asset management, including
 i. crafting an **investment policy** to set the philosophy and rules governing the addition of the asset class to the portfolio;
 ii. building an **asset selection framework** to formalize decisions and codify the process;
 iii. constructing an **integrated portfolio** matching all the needs and constraints of the client.
2. Risk management, including
 i. creating **heat maps** showing both the marginal risk improvement from existing collectibles in the portfolio, as well as incremental risk reduction benefits from adding additional assets;
 ii. designing and implementing a **rebalancing strategy** for the collectible sub-portfolio to ensure ongoing compliance with strategic asset allocation;
 iii. performing **correlation studies** on ongoing basis to detect any shifts in diversification benefits from each sub-asset class.
3. Research, including
 i. conducting **custom studies** on existing portfolios to evaluate their robustness and to investigate the range of benefits from addition or expansion of collectible investments;
 ii. preparing **in-depth research** on specific sub-asset classes that have either been identified to be of interest from prior

analysis or have been flagged by the investor as interesting and requiring closer review and analysis;

 iii. identifying a set of appropriate platforms for **strategy implementation** based on the desired asset class mix, liquidity of market and volumes transacted.

4. Operational tasks, including

 i. monitoring **asset performance** within and across platforms, creating and generating reports and identifying areas of concern;

 ii. developing comprehensive automated **execution strategies** across platforms taking into account investment sizing, frequency and speed of execution required;

 iii. integrating data flow generated from collectible investments into master databases used for calculation of whole **portfolio performance and risk metrics.**

5. Educational tasks, including

 i. delivering **training programs** on investing into collectible assets;

 ii. creating customized **training materials** based on the book and the course;

 iii. giving **speeches** on a range of topics at corporate or industry events.

More information on consulting services can be found on the main author page at www.michaelfoxrabinovitz.com/consulting.

Final thoughts

Now that you had a chance to catch your breath, I want to thank you for your interest in what I believe is a very timely and engaging subject. I am very happy to be able to share with you my view on this major emerging opportunity in the wealth management space, and hope that you will take the next step in learning more about the subject matter, and of course, implement this profitably into your long term financial plan. I would love to keep you updated on my ongoing research and projects, as well as send periodic items of interest, so you can continue learning and engaging and also keep you informed about my next book and other developments. You can opt-in to my list to keep updated of new releases here: www.michaelfoxrabinovitz.com/ or express interest in taking a course here: www.michaelfoxrabinovitz.com/courses. If you enjoyed the book and found it useful please consider leaving a review on www.amazon.com/dp/B08QB9KRFX

Your feedback and comments are very valuable and it would thrill me to hear that you thoroughly enjoyed the material and the way it was presented. Thank you for being a great reader, and look forward to having you join me on the next literary adventure.

Acknowledgments

It is a pleasure for me to acknowledge the key people who have made this book possible.

First of all, I want to thank my parents, Michael and Marina, whose constant and unwavering support and encouragement made this book possible.

My debt of gratitude goes to my friend and long-time business partner Lev Grzhonko, who has been insisting that I write this book for many years, and I am glad that he finally persuaded me to do so.

Special thanks my editor Martin Foner who was an invaluable resource both as an amazing editor and a subject matter expert.

I owe a special debt to Christopher Bruno from Rally Rd and Nigel Glenday from Masterworks, who took the time to speak with me and to share their vision, experiences and wisdom.

Author Biography

Michael is currently a partner with Chartwell Capital providing investment management services and is planning to continue his role there as well as expand his involvement in providing investment advice and consulting services in the collectible investment field. He is an active investor in the collectible space across most of the major platforms.

Previously, he was a partner with Capricorn Partners, delivering a range of risk management, portfolio review and data analysis solutions to premier players in the financial industry.

Over the last 25 years he held a variety of roles that allowed him to gain an appreciation of the art of investing from multiple angles: launching two hedge funds in alternative fixed income space, actively managing assets across multiple strategies, creating portfolio evaluation tools, implementing asset allocation and portfolio construction programs for multiple UHNW families, and serving as a trusted advisor to top US and global financial players.

Michael holds a B.S in Economics from Wharton School of Business and an MBA from Columbia University Business School. He is also a holder of Chartered Financial Analyst (CFA), Chartered Alternative Investment Analyst (CAIA) and Financial Risk Manager (FRM) designations.

His hobbies, apart from his passion for collectibles, include travel, poker, scuba diving, playing guitar and writing poetry.

Made in United States
North Haven, CT
02 May 2022

18798877R00173